IMAGES
*of America*

# APTOS

# Aptos History Museum

A full 100 percent of the author's royalties from this publication will go to the Aptos History Museum. Please visit us at www.aptoshistory.org. (Courtesy of the Aptos History Museum.)

ON THE COVER: Seacliff State Beach in 1930 was a very popular spot. To escape uncomfortably warm weather, tourists would come to Aptos where a brand new 22-room resort-style hotel had just opened on the bluffs overlooking the beach. They would spend their days in the Rio Del Mar Bathing Pavilion, known as "the world's largest freshwater swimming pool," and their evenings dancing in the Rainbow Ballroom on the amusement ship SS *Palo Alto*, which is often referred to as "the cement ship." (Courtesy of Carolyn Swift.)

IMAGES
*of America*

# APTOS

Kevin Newhouse and
the Aptos History Museum

ARCADIA
PUBLISHING

Copyright © 2013 by the Aptos History Museum
ISBN 978-1-53166750-4

Published by Arcadia Publishing
Charleston, South Carolina

Library of Congress Control Number: 2012951970

For all general information, please contact Arcadia Publishing:
Telephone 843-853-2070
Fax 843-853-0044
E-mail sales@arcadiapublishing.com
For customer service and orders:
Toll-Free 1-888-313-2665

Visit us on the Internet at www.arcadiapublishing.com

*This book is dedicated to the memory of Amelia Arano, whose
hard work and caring heart make me proud to be from Aptos.*

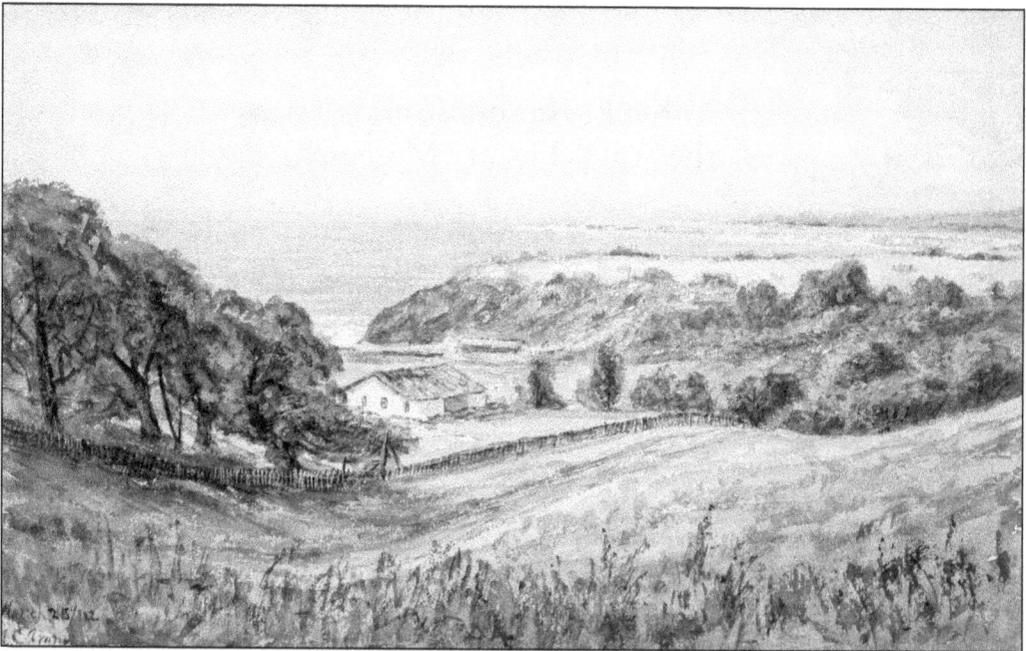

This watercolor was painted by Amelia Arano in the early 1890s. It depicts the then sparsely
populated area of Aptos now known as Hidden Beach.

# CONTENTS

# ACKNOWLEDGMENTS

I would like to acknowledge and thank everybody who knowingly and unknowingly contributed to the contents of this publication. The research started long before I was even alive. The stories, photographs, and artifacts that have been donated to the Aptos History Museum have all played a part in this book.

I would also like to thank the following people, without whose guidance, knowledge, and friendship this book would not exist: John and Karen Hibble, Carolyn Swift, Sandy Lydon, Karl Mertz, and the Aptos History Museum committee. I truly could not have done this without you.

Last but not least, I would like to thank my wife, Jennifer, who has had to listen to me recite the history of every street, building, and landmark in Aptos over the past eight years. Your love and support have been nothing less than remarkable.

Unless otherwise noted, all images appear courtesy of the Aptos History Museum. Other photograph contributors are acknowledged in the courtesy lines that follow each caption.

### The Aptos History Museum Book Committee

Kevin Newhouse
John Hibble
Karen Hibble
Dick Garwood
Heidi Heath-Garwood
Karl Mertz
Bob Wall
Nels Westman
Chuck Carlson
Carolyn Swift
Mary Russell
Bob Murphy
Grace Mundy
Mark Hucklebridge

# INTRODUCTION

Aptos is an unincorporated town in Santa Cruz County, California. Aptos can be broken down into many different areas, or subcommunities, including Rio Del Mar, Seacliff, Seascape, Aptos Hills, Downtown Aptos, and many others depending on who you are speaking to. The pronunciation of Aptos is debatable between three versions: "ap-toss," "ap-tose," and "ap-tiss."

There is no definitive evidence of the true meaning of Aptos; however, all sources agree that it is derived from an Indian word. The most common belief is that Aptos translates to "the meeting of two streams" or some variation of that phrase. The two bodies of water the name describes are known today as Valencia and Aptos Creeks. These come together at a point below today's Highway 1 overpass over Spreckels Drive, which is close to where the original people of this area lived. Some examples of variations of the word and its origin are Owatos, Awotos, Abtos, and Avtos.

A different explanation of the origin of the word comes from the story of a famous Costanoan Indian chief whose name was Aptos. He was supposedly over six feet tall—very tall for an Indian of those days—and so fast he could shoot an arrow over the tops of redwood tree grooves and catch it before it touched the ground.

On April 8, 1880, the Watsonville *Register-Pajaronian* printed a clip claiming that Aptos was named after "the last Indian who trod these fields before going to his new, happy hunting grounds. Aptos was said to be upwards of 120 years old and the last descendant of the first families of California." Alfred Kroeber, writing in 1916, said Aptos might be derived from the Spanish word *apto*, meaning skillful. We may not ever know the true meaning of Aptos, but what is known is that Aptos is one of just three contemporary place names in Santa Cruz County that can be traced back to local Indians. The others are Soquel and Zayante.

In 1769, Gaspar De Portolá, together with Father Crespi, lead the first overland expedition through Santa Cruz County and although they discovered signs of the native peoples, they never actually saw the "heathen." However, in 1774, Capitan Don Fernando Javier De Rivera y Moncada, the second governor general of California, together with Father Palou, passed down the coast from San Francisco to Carmel and on December 11 discovered the Aptos Indian village of 11 huts above the river.

In 1833, Rafael Castro was granted approximately 5,500 acres of land but would eventually end up with 6,686 acres. This land grant, known as Rancho Aptos, spanned roughly from where Cabrillo College is today to right around Seascape. His father Joaquin Castro's land grant of Rancho San Andreas and his sister Martina Castro's land grant of Rancho Soquel and Soquel Augmentation were the bordering grants. Also bordering a portion of the Rancho Aptos was Rancho Calabasas, which was granted to Filipe Hernandez in 1835. By the 1840s, over 250,000 acres of land in Santa Cruz County were owned by various members of the Castro family. Although lawsuits and attorneys' fees reduced a significant portion of some of the grants, Rafael successfully defended his claim to his Mexican land grant after the Unites States annexed California in 1848.

The Castro family continued to grow, and it was family policy to gift portions of their land grant to their children when they matured, married, or had their first baby (whichever came first).

In 1872, Claus Spreckels, the very wealthy "sugar king" of San Francisco, bargained to buy the portion of Rancho Aptos that had not already been gifted or sold to someone else. All of Rancho Aptos, except for the Castros' 15-acre homesite and an 83-acre farm strip, was sold for $71,900. This purchase marked the end of the Indian-Spanish-Mexican dominance and was the first step toward the Aptos we know today.

In his 1890 *Santa Cruz County: A Faithful Reproduction in Print and Photography of its Climate, Capabilities and Beauties*, Phil Francis described Aptos as "simply a small village, containing a few stores, hotel, etc., but a shipping-point of considerable importance, being connected by rail with the large lumber mills of the Loma Prieta Company and the F.A. Hihn Company." The peacefulness was emphasized by Edward Sanford Harrison's description in his 1892 *History of Santa Cruz County California*: "The canon of the Aptos is picturesque its whole length, and where the creek flows through the village, its deep gorge is filled with tall redwoods almost down to the bay itself."

The main industries in Aptos began with the tanning of animal hides and farming. In fact, the most attractive land grants were those with flat, open land with a minimal amount of trees or forest. However, the next big industry, timber, would prove the land grants with more forest would be the most attractive land to own. After the timber industry slowed down, the apple industry picked up. While farming, timber, and apples helped Aptos build and establish its town, today's main industry is tourism and commerce.

Today, the coastal town of Aptos has state-owned beaches, a federally protected redwood forest, shopping centers, a golf course, and more. Aptos has three elementary schools, one junior high, one high school, and a fine community college. It is home to the self-proclaimed "world's shortest parade," which takes place every Fourth of July and travels a distance of approximately six tenths of a mile.

The population is rapidly increasing, and the town is adapting to accommodate. While growth and finance are important to maintaining the prosperity of a town's infrastructure, I believe it is also important to recognize, preserve, and teach the town's history so we can remember why Aptos is such a special place.

# One

# An Ancient Village
## The Early Days of Aptos

Although it is impossible to know how many thousands of years the original local peoples of Aptos had been living in the area, the first documentation of the land by an outsider was part of a sailing expedition in 1602 led by Sebastian Viscaino, a Spanish mariner. He noted the mapping coordinates, described the landscape, and, although he never set foot on the land, proclaimed it as Spain's new territory. There was no other expedition until one led by Gaspar de Portolá in 1769. This expedition was done on land in an effort to colonize Alta California, building missions along the way. On October 17, 1769, after first traveling too far north and eventually turning around to backtrack, the Portolá expedition camped on the banks of the San Lorenzo River and declared that Mission Santa Cruz would be built in that area.

The Indians who were living along the coast of the bay are generally referred to as Costanoan, though the name Ohlone is also often used. There were many different sub-tribes in the area, with each acting as an autonomous nation with its own leaders and languages. The language spoken in the Aptos area is known as Awaswas and is now a lost language. Diet consisted mostly of acorns supplemented by a variety of other nuts, seeds, berries, and roots. Land and sea animals were also used for food as well as for trade. Skins and furs were used for blankets, bedding, and clothing. Bones were used as tools, and shells were used as jewelry.

In 1821, Mexico gained independence from Spain. In 1833, Rafael Castro was granted 5,500 acres and became the first private landowner in Aptos. This was the beginning of the next chapter in Aptos history. Unfortunately, this was also the beginning of the end for the original Aptos locals.

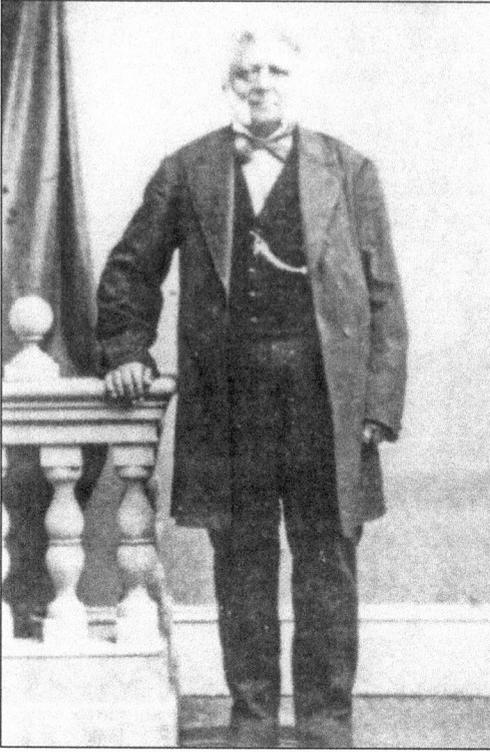

Rafael Castro, one of 14 children, was born October 15, 1803, at Villa de Branciforte, across the river from Mission Santa Cruz. His father was Jose Joaquin Castro, who, at the age of five, traveled with his parents to Alta California with the Anza expedition. In 1833, Rafael was granted 5,500 acres of land, which became known as Rancho Aptos. This was the first private ownership of land in the community. Castro passed away at the age of 74 on May 14, 1878. (Courtesy of Vincent T. Leonard.)

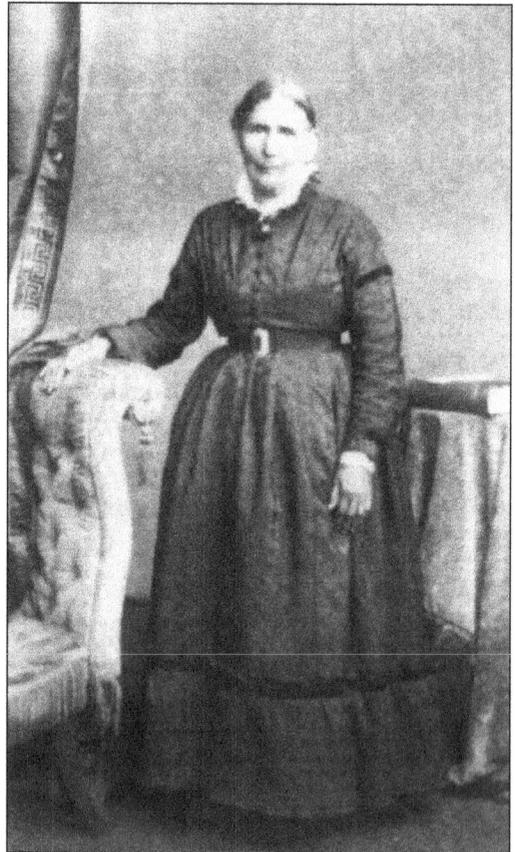

When Rafael was 20 years old, he married 15-year-old Soledad Cota at the Santa Cruz Mission. Their marriage was not an easy one. They filed for divorce, which was very rare in those days, three times; however, they never completed the process. Together, they raised 12 children, one of them being an adopted daughter, and their grandchildren numbered more than 40. Soledad died in the Bay View Hotel on April 15, 1889, at the age of 83. Soledad was always kind to the poor and was noted for her hospitality. Rafael and Soledad are buried next to each other in the cemetery next to Resurrection Catholic Church. A 12-foot-high monument, visible from the street, marks the Castro family plot. (Courtesy of Vincent T. Leonard.)

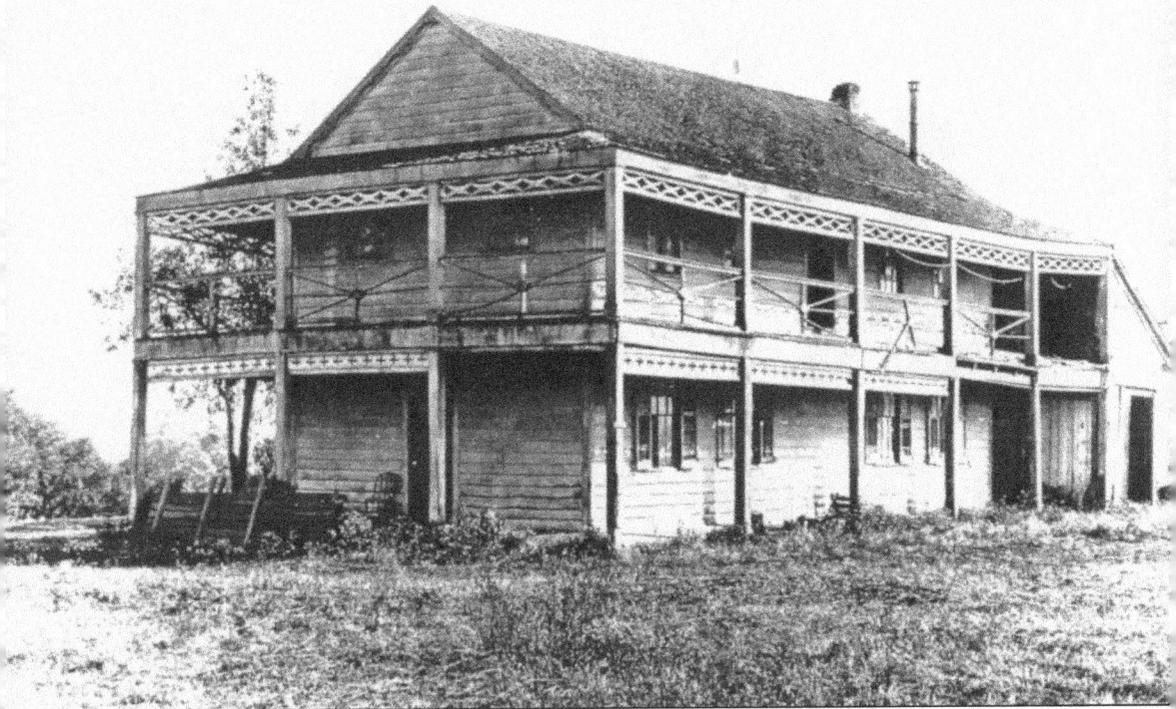

Rafael and Soledad Castro built their huge two-story ranch home in 1840 on a ridgetop off Wharf Road, just a few hundred yards south of today's Rancho Del Mar shopping center on Soquel Drive. The hacienda was occupied into 1915 by the C.C. Rhodes family but fell into disrepair and sadly burned to the ground in 1920. The site was cut into during the construction of Highway 1. (Courtesy of Vincent T. Leonard.)

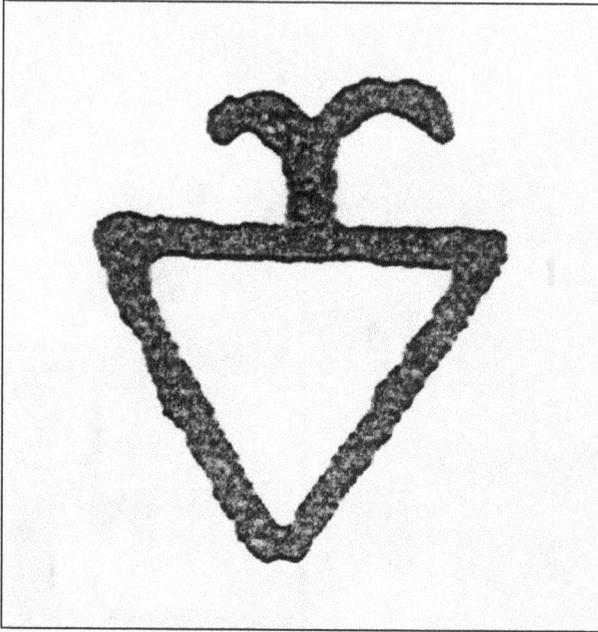

Rafael Castro was a businessman in many fields but he was primarily a cattle rancher. His cattle brand, seen here, was registered on April 10, 1853. Castro did not concern himself with containing his cattle. His father, Joaquin, owned the land immediately down-coast, and his sister Martina owned the land immediately up-coast and inland. Their branded herds intermingled from time to time but stayed within the family!

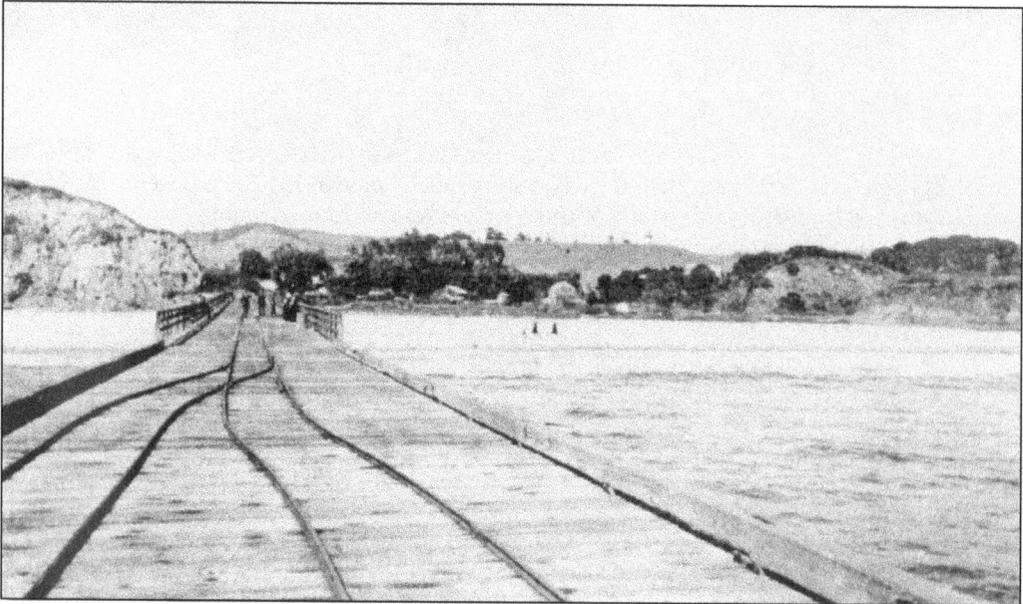

Rafael Castro built the first wharf in Aptos in the early 1850s. It was originally 500 feet long but was extended to 1,000 feet in 1867 by Titus Hale, who had leased the wharf from Castro. Later in 1880, the wharf was expanded to its maximum length of 1,300 feet by Claus Spreckels, who purchased the bulk of Castro's property in 1872. However, the ocean took out sections of the wharf, and by 1889, it was only 600 feet long. By the early 1900s, the wharf had fully collapsed. Originally used to ship hides, flour, and redwood lumber, the wharf was eventually used to ship agriculture and oak firewood. Aptos Wharf Road served as the connection between the pier and the town of Aptos. It was the area's first commercial street and still exists today as the shortest road in Aptos. Its direct access was cut short when the Highway 1 freeway was built in the late 1940s. (Courtesy of Vincent T. Leonard.)

12

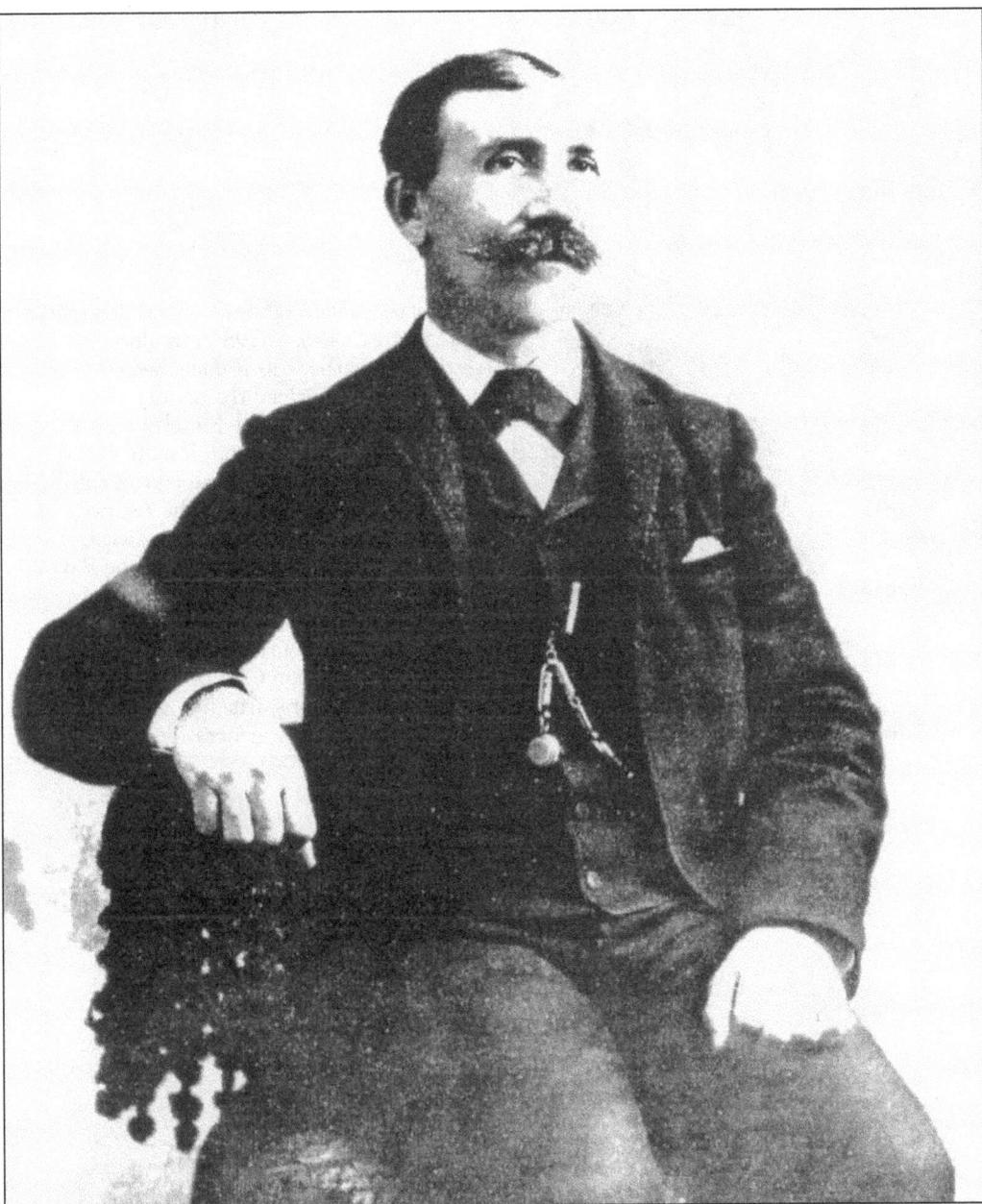

Joseph Arano was born in France in 1837 and immigrated to Cuba, then New Orleans, and ended up in Aptos sometime before 1850. He built a general store on a piece of land purchased from Rafael Castro. By 1870, he was married to Rafael Castro's daughter, Augustia. The profits from operating their general store would later be used to open the Anchor House, which would later be known as the Bay View Hotel. Joseph prospered as the hotel's bartender and bookkeeper. The hotel became famous for its Spanish dinners. Things were going good for the Arano family until one day, in November 1890, Joseph disappeared with the $3,000 proceeds of a land sale to Peter Larson, the manager of Spreckels's Ranch. He would remain missing until November 1900, when his daughter Amelia tracked him down and brought him back to Aptos where he worked at the hotel until his death in 1928.

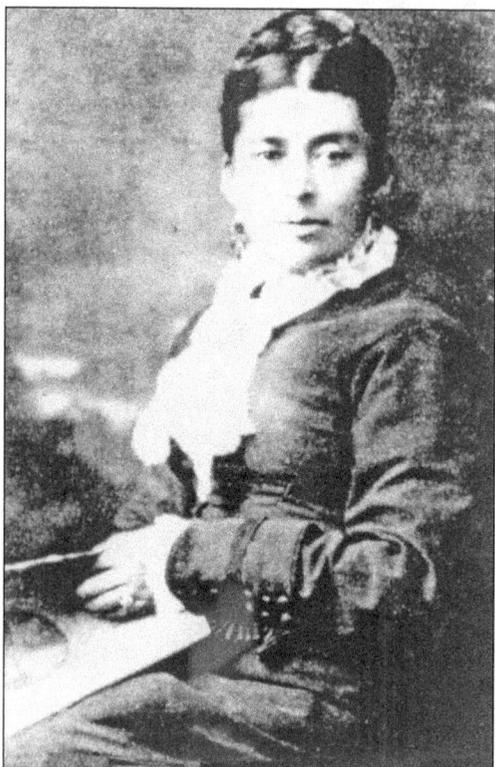

Augustia Maria Arano is the granddaughter of Joaquin Castro, a 1798 Branciforte settler. Her father was Rafael Castro, who, in 1833, received the county's first Mexican land grant, the Rancho Aptos. Augustia and her husband, Joseph, raised eight children. Augustia helped run the Bay View Hotel, which was the Arano family's home and business. She died in February 1896 at the age of 52 in the Bay View Hotel while Joseph's whereabouts were still unknown. While she and her husband are now buried in the cemetery next to Resurrection Catholic Church, it is rumored that their spirits live on in the hotel, welcoming each new generation of guests.

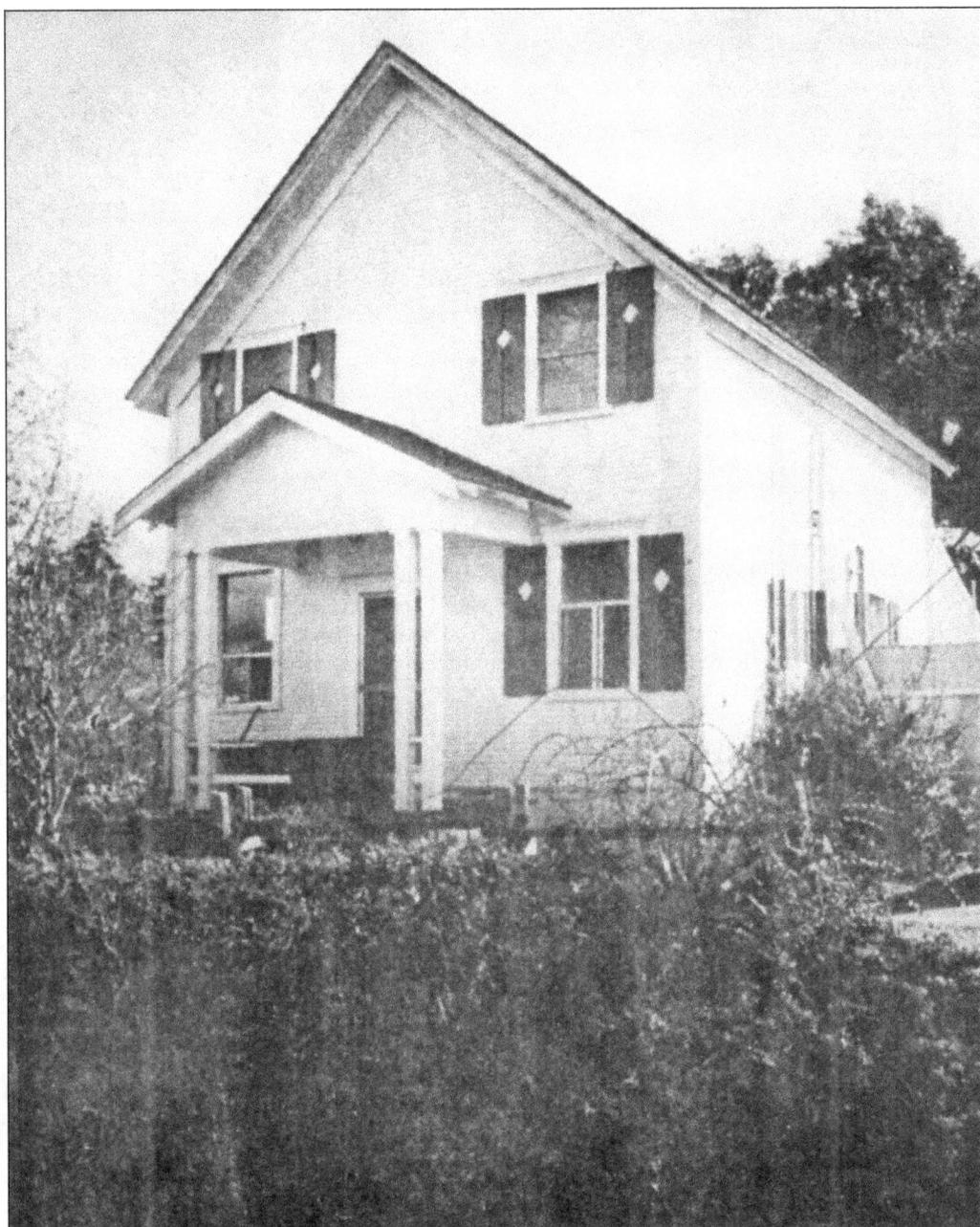

Located at 7996 Soquel Drive, the home of Joseph and Augustia Arano was constructed around 1867. The two-story home was built to serve as a grocery store on the bottom floor with living quarters on the second floor. In 1870, it served as the town's first post office with Joseph acting as the town's first postmaster. The profits from this store were used to build the Anchor House, which eventually became known as the Bay View Hotel. Joseph and Augustia's daughter Amelia Catherine Arano was born in this house on May 24, 1863. She became active in the family's hotel business and eventually took total charge of the Bay View Hotel after her mother, Augustia, passed away. The Arano family home and grocery store is now a private residence and is currently the oldest standing building in Aptos.

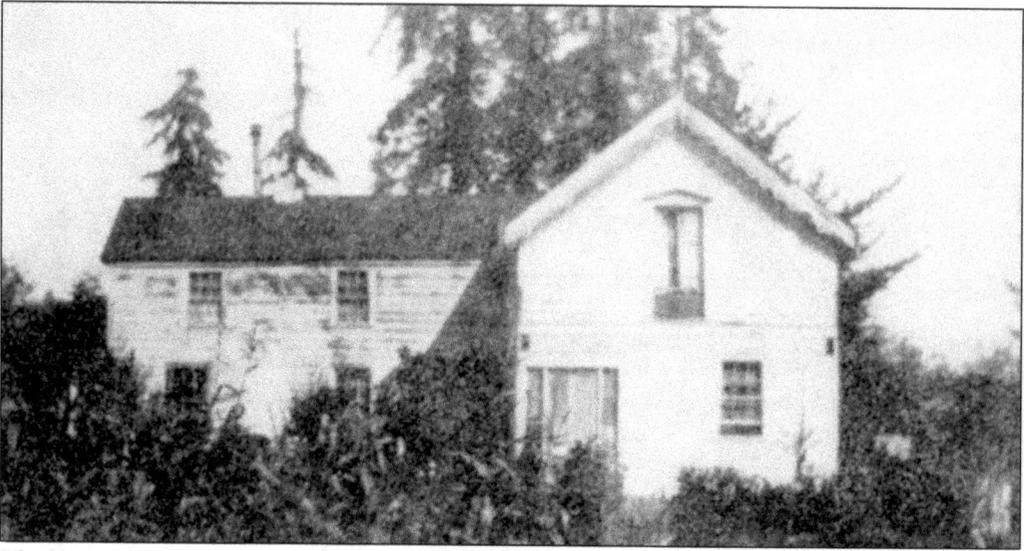

The Vicente Castro house was built in the mid-1870s on a 7.5-acre piece of land he purchased from his parents, Rafael and Soledad Castro. Vicente was a well-known rancher and turned a profit on the apple orchard he had planted on his property. There have been many owners/residents of the house over the years including Claus Mangels, who was Claus Spreckels's business partner, and Bartley Crum. Crum was a prominent San Francisco attorney who served as counsel for the Hollywood Ten, the screenwriters and directors who were blacklisted for refusing to testify before the House Un-American Activities Committee. Because of Crum's association with Hollywood celebrities, well-known guests often attended the parties thrown by his family. The house is currently located at 7839 Soquel Drive and is the second oldest standing building in Aptos.

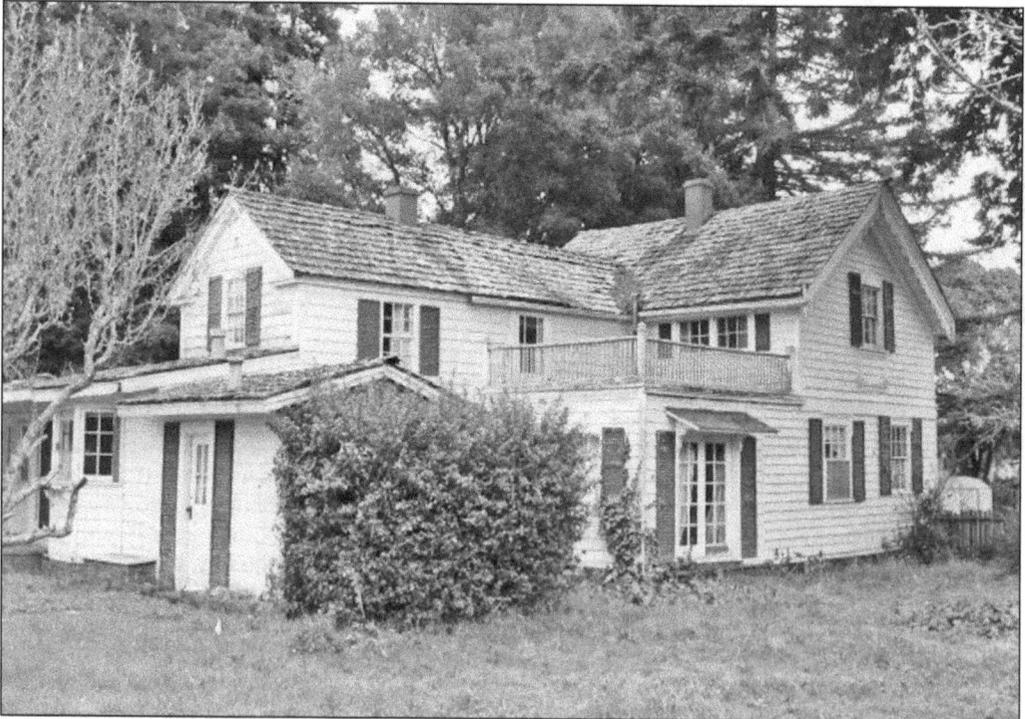

# Two

# INDUSTRY
## TRAINS, TIMBER, AND APPLE TREES

Before the Spaniards came to Central California, the Ohlone tribe of Native Americans was the only group of people in the area. They lived by hunting and gathering and are known to have produced some of the finest and most rare baskets in the world. It was a communal society where giving, not having, was the definition of wealth. In 1833, the government of Mexico granted Rancho Aptos to Rafael Castro. Castro, the first businessman of Aptos, made his fortune raising cattle for their hides. Early passersby were permitted to kill the cattle for meat, so long as they left the hides for Castro.

After California became a state in 1850, Castro leased his land to Yankees for industrial developments. By 1872, Claus Spreckels began buying land from Castro. He built a hotel near the beach and helped finance the Santa Cruz Railroad, which opened in 1876. With the coming of the railroad, the town moved to the other side of Aptos Creek, and redwood timber harvesting became the major industry. The Loma Prieta Lumber Company logged the area now known as Nisene Marks State Park. The Valencia Mill logged to the east. Within 40 years the hills were bare, and apples became the next industry.

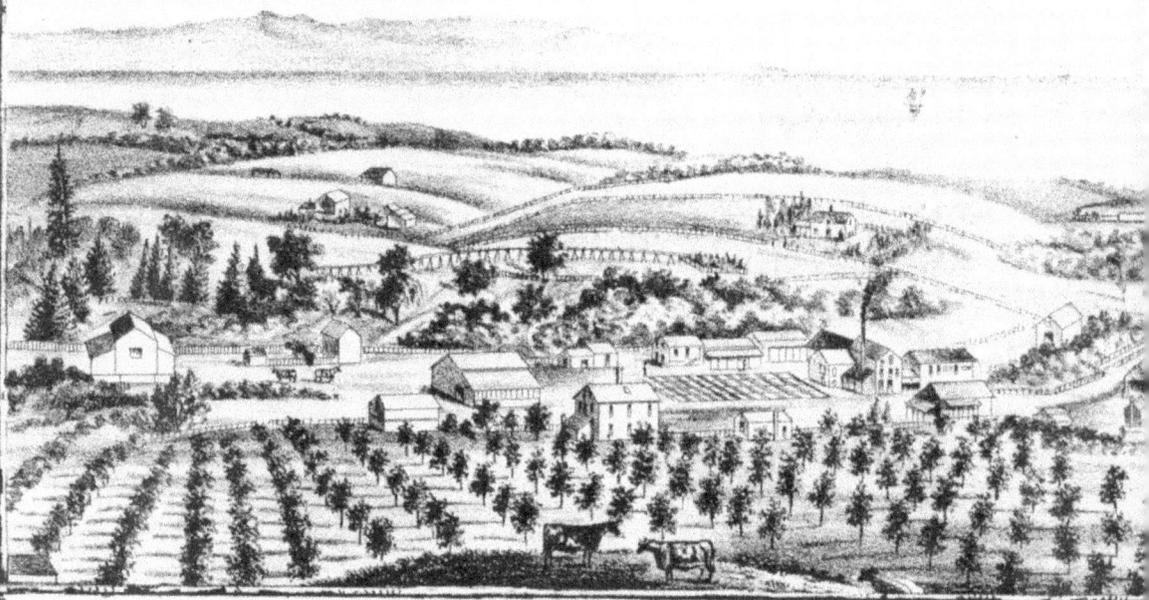

C.K & B.F. PORTER'S TANNERY, SOQUEL SANTA CRUZ CO. CAL.

The tanning of hides was the first industry in Aptos, pursued most notably by Rafael Castro. His sister Martina was granted Rancho Soquel and Soquel Augmentation, which bordered the Rancho Aptos land grant. Martina divided her land amongst her children. Her daughter Luisa was married to Jean Richard Fourcade, known locally as Juan Ricardo. In 1853, the two of them established their own tannery. The gulch on which this tannery was built became known as Tannery Gulch. In 1854, George and Benjamin Porter, cousins who came from New England, purchased and enlarged the tannery. Their name stuck, and Tannery Gulch became Porter Gulch. George built his home in the early 1870s at the tannery, which would later be known as the Apple Lane Inn Bed-and-Breakfast. Benjamin built his house just south of the tannery where the Porter-Sesnon House now stands as part of Cabrillo College.

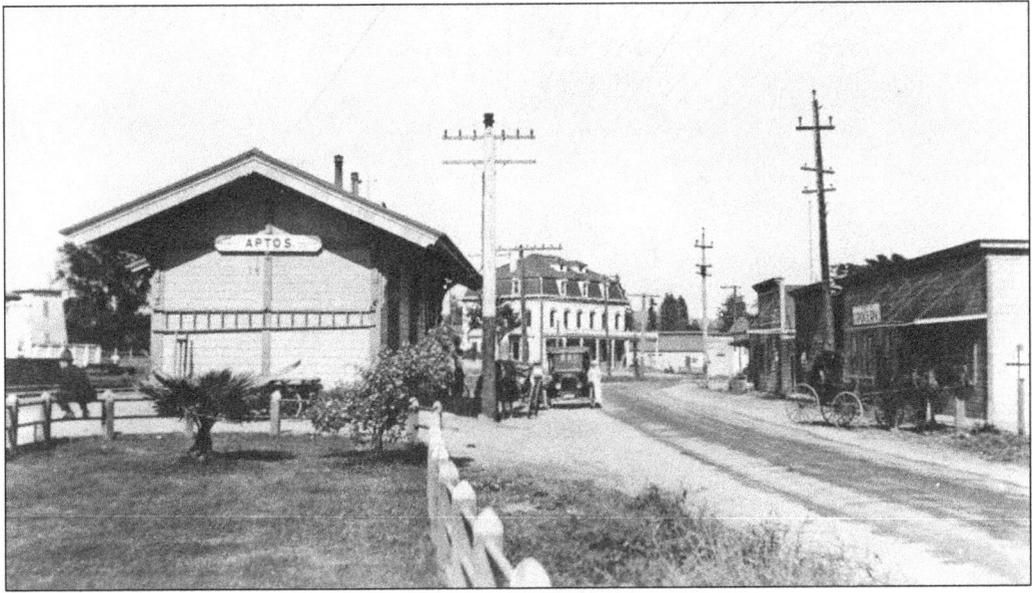

The addition of railroad lines to Aptos greatly encouraged lumbering in the Aptos hills and gave birth to the town's first modern industry. The Aptos Station was built in 1875 to serve the former Santa Cruz Railroad, which was acquired by the Southern Pacific Railroad in 1881. From 1882 to 1899, Aptos Station also served the Loma Prieta Railroad, a branch of the Southern Pacific that went up Aptos Creek Canyon. The train last served passengers in 1962. The tracks were still used to ship freight, with no stops in Aptos, until 2010. In November 2012, Iowa Pacific began operating on the 32-mile branch rail line in Santa Cruz, which passes through Aptos Station. They will operate as freight transportation and passenger service. The Aptos Station house no longer exists, but the name is preserved through the Aptos Station shopping center. (Courtesy of Santa Cruz Museum of Art & History.)

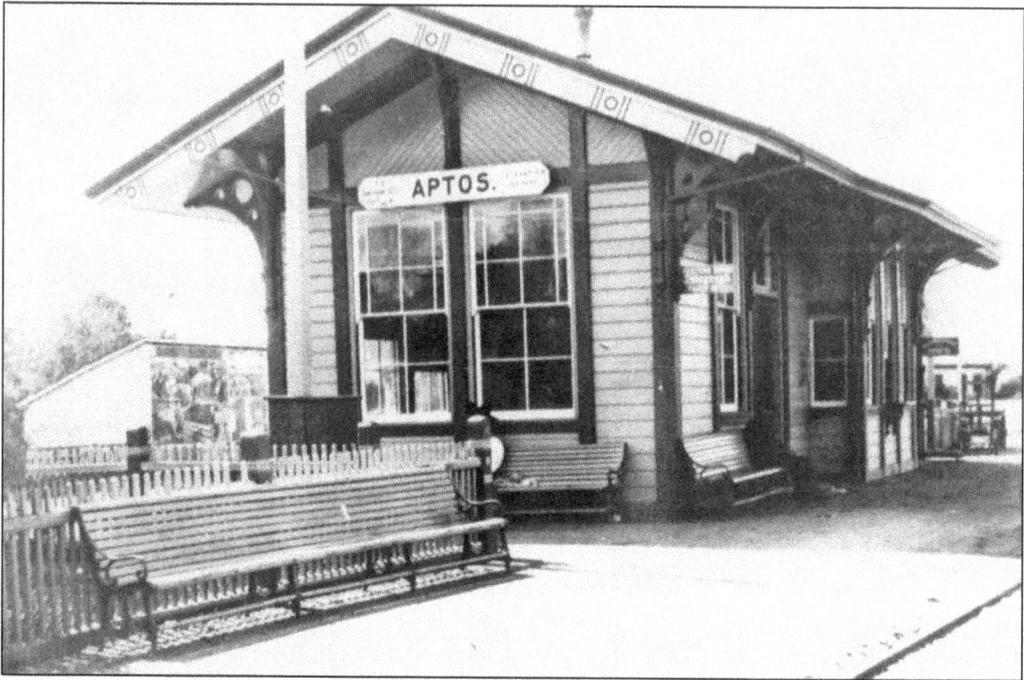

In the early days, travel to Watsonville was difficult. The county road (Soquel Drive) wound down and through the creeks. The current site of Aptos village was isolated until bridges were built in 1860. Frederick Hihn, Claus Spreckels, and other investors built the Santa Cruz Railroad and brought it inland across two creeks to connect all the land Hihn owned in what is now Aptos Village and Valencia. The first trains ran from Santa Cruz to Aptos in May 1875. The fare was 50¢. The line was completed to Pajaro the following year. On May 22, 1876, trains left Pajaro and Santa Cruz and met in Aptos for the grand opening of the line. (Above, courtesy of Vincent T. Leonard.)

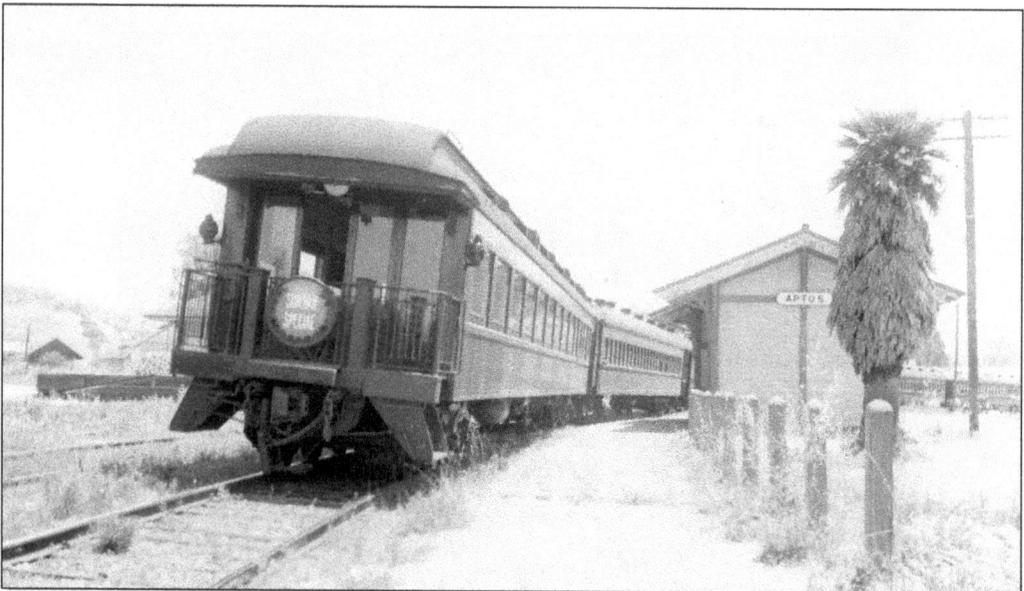

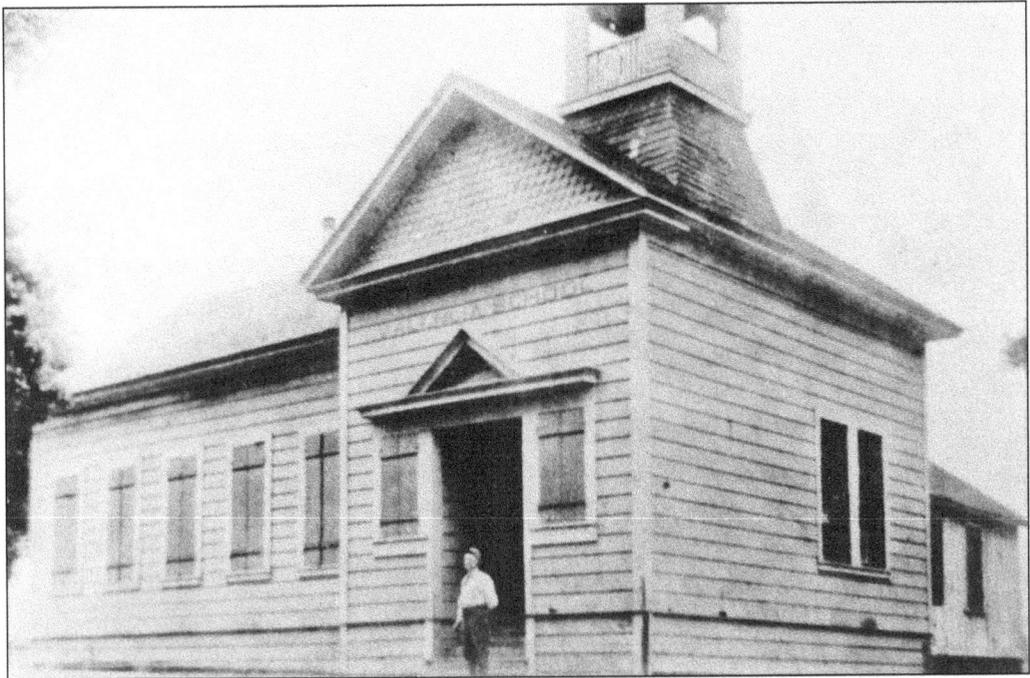

Valencia Hall and the post office were built in 1881 to serve Fredrick Hihn's lumber mill town of Valencia as a place for the community to gather for a variety of events. In 1898, Valencia Town School (above) was built just down the road. The post office was used as a stagecoach stop and a general store. The lumber business in Valencia was worn thin by the 1930s, and in 1931, the school was officially closed. It was not until 1968 that an Aptos school would once again be known as Valencia, when Valencia Elementary School was built a few miles down the road. The Valencia Hall (below) and historic general store and post office are the last two remnants of Frederick Hihn's logging community of Valencia. They were officially certified as a historic location on September 20, 1984. (Courtesy of Vincent T. Leonard.)

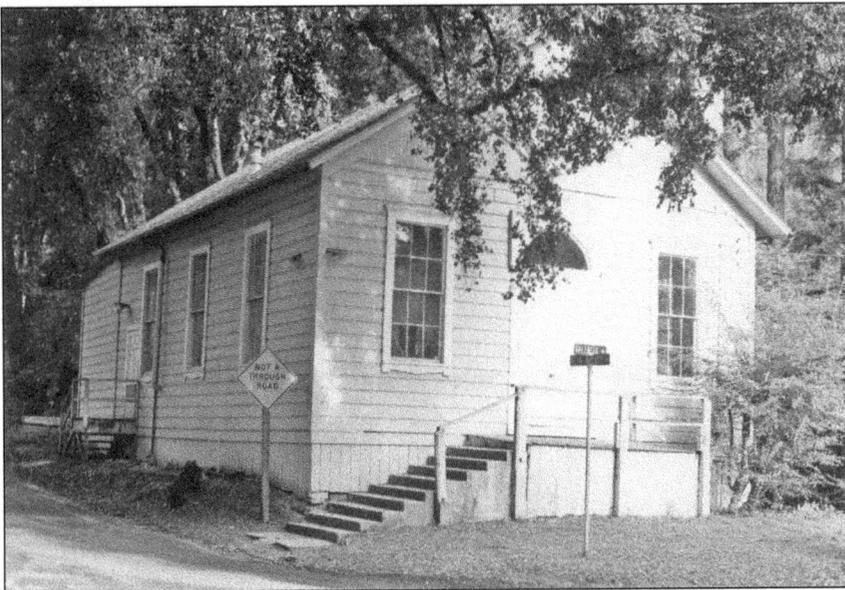

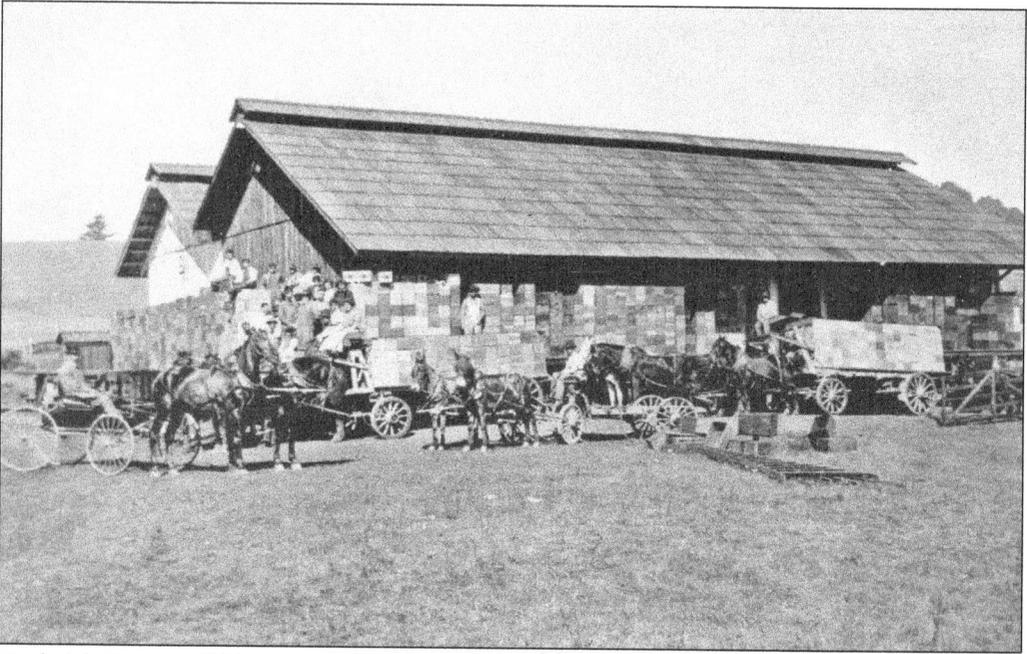

Frederick Augustus Hihn constructed his apple-packing barn in Aptos Village in 1890. The self-made millionaire planted apple orchards after the logging industry had dramatically slowed down at the turn of the 20th century. He then sold the orchards to the unemployed lumberjacks and built the barn that would house and process the apples before they were shipped by rail. Today, it is the site of Village Fair Antiques, as seen below. (Courtesy of Paul Johnston.)

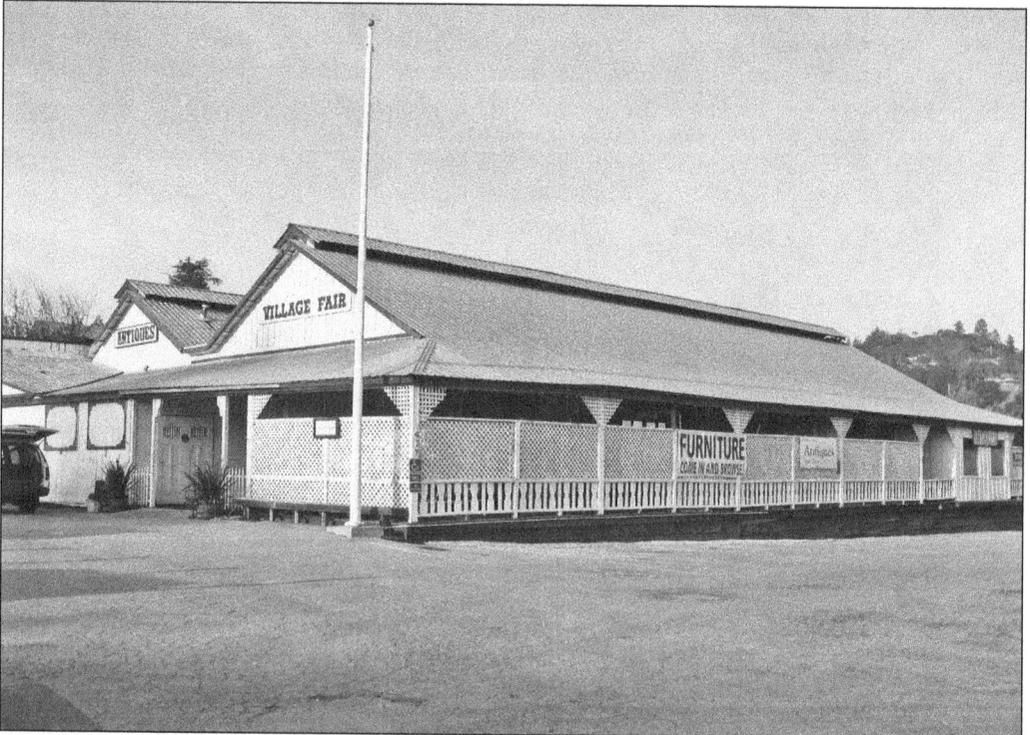

PRODUCE OF U.S.A.

APTOS
BRAND
MOUNTAIN GROWN
APPLES

CONTENTS ONE BUSHEL
GROWN, PACKED
AND SHIPPED BY

APTOS FRUIT CO., INC., WATSONVILLE, CALIFORNIA

"APPLES ALL THE TIME"

Aptos apples were not the only product to find a successful home in Hihn's apple-packing barn. For many years, dealers of antiques and collectibles have found success as retailers operating inside the barn. In 1944, Fred Toney and his wife, Babe, purchased the Bay View Hotel. Babe had begun her antique and gift shop business from inside the hotel. After some success, she had decided to move it to the barn. To this day, the building still operates as Village Fair Antiques.

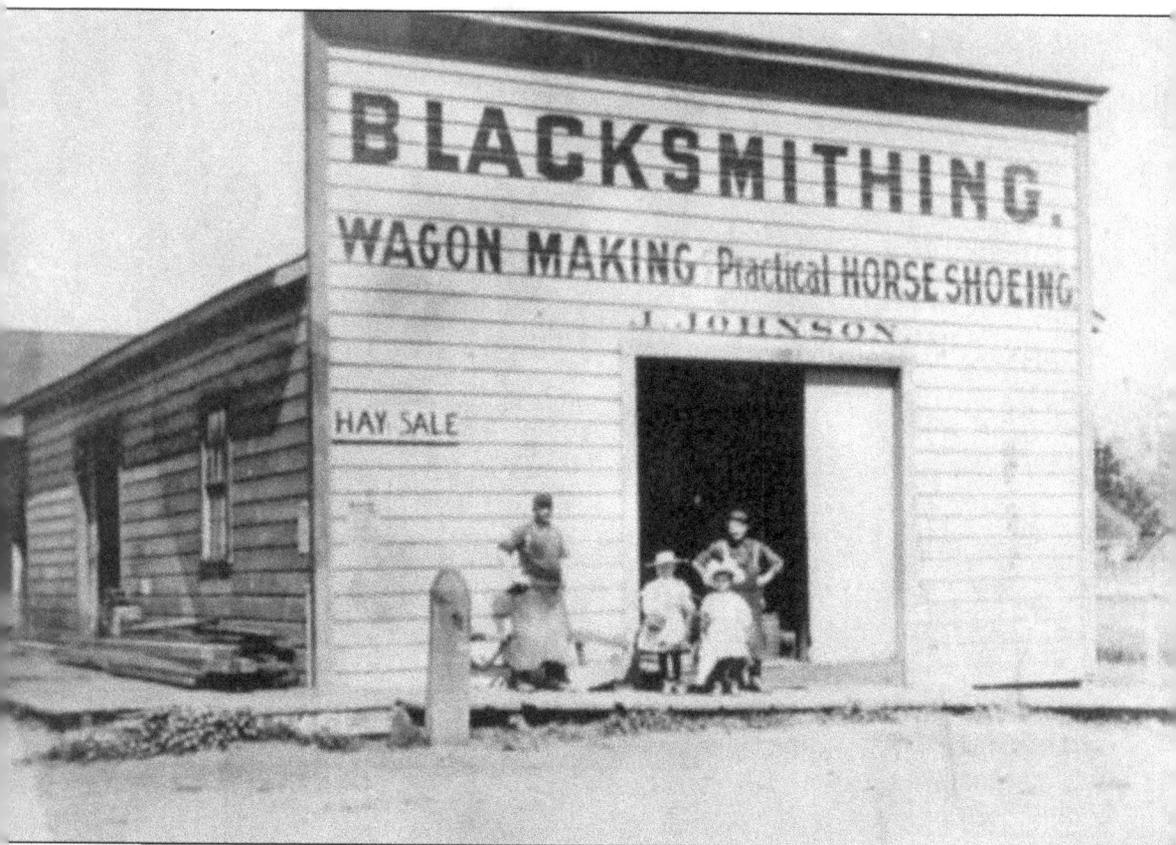

Pictured from left to right in this 1904 photograph are Julius Johnson, Norma Larsen, Virginia Oreamuno, and Eugene Spaulding. Julius Johnson changed his last name from Johanssen when he and his brother Frederick refused compulsory service in the German armed forces and escaped to the home of their sister, Norma, who was married to Peter Larson, Claus Spreckels's Aptos Ranch manager. Julius had set up his blacksmithing shop in Aptos Village facing the county road (Soquel Drive), on the opposite side of Trout Gulch Road from the Bay View Hotel. Since the farmers who had formerly relied on Soquel blacksmiths could have their mechanical needs met closer to home, within a year there was more than enough work for Julius to hire Eugene Spaulding as his assistant. Spaulding was a smaller man and could only take a few years of blacksmithing before leaving to set up the village's first cobbler's shop. Charles Winslow was his replacement. Julius died in 1920, leaving the shop to Winslow, who closed it and retired before 1940.

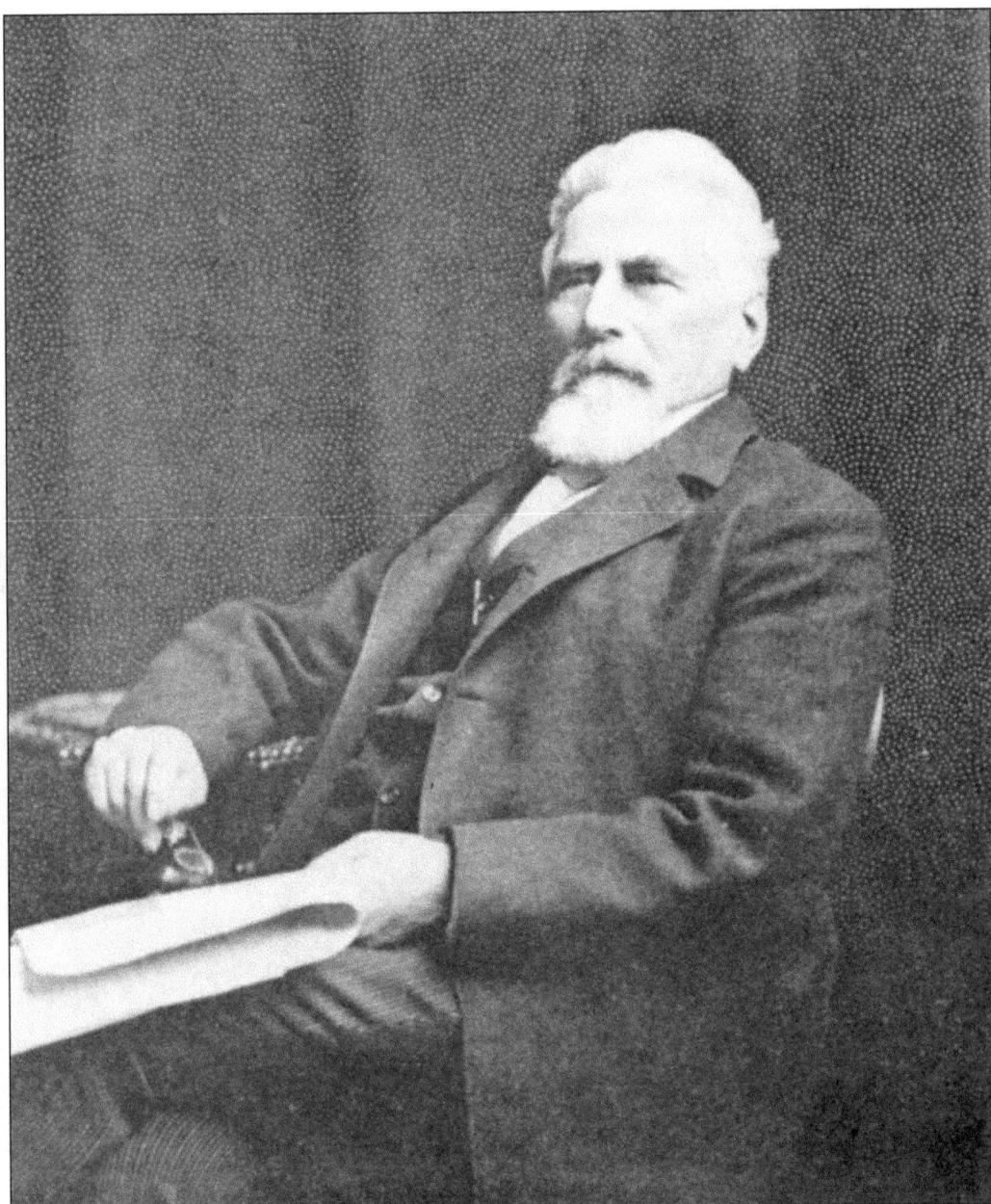

Frederick Augustus (F.A.) Hihn (pronounced "Heen") became Santa Cruz's first self-made millionaire. He was once described as the most important individual in Santa Cruz County until his death in 1913. He was a pioneer merchant, lumber mill owner, and agriculturist. He built the original Camp Capitola and the Santa Cruz Railroad to Watsonville. Hihn was born in Germany in 1829 and came to California during the gold rush. Floods and fires prevented him from succeeding in gold country, and he decided San Francisco would be the next stop. He tried many different ventures but fell short of success once again. By 1851 he found himself in Santa Cruz, where he finally found success in the mercantile business, and married Therese Paggen in 1853. Hihn turned over his mercantile store to his brother Hugo and went on to amass a fortune in real estate. At one point, he owned one-sixth of the entire county.

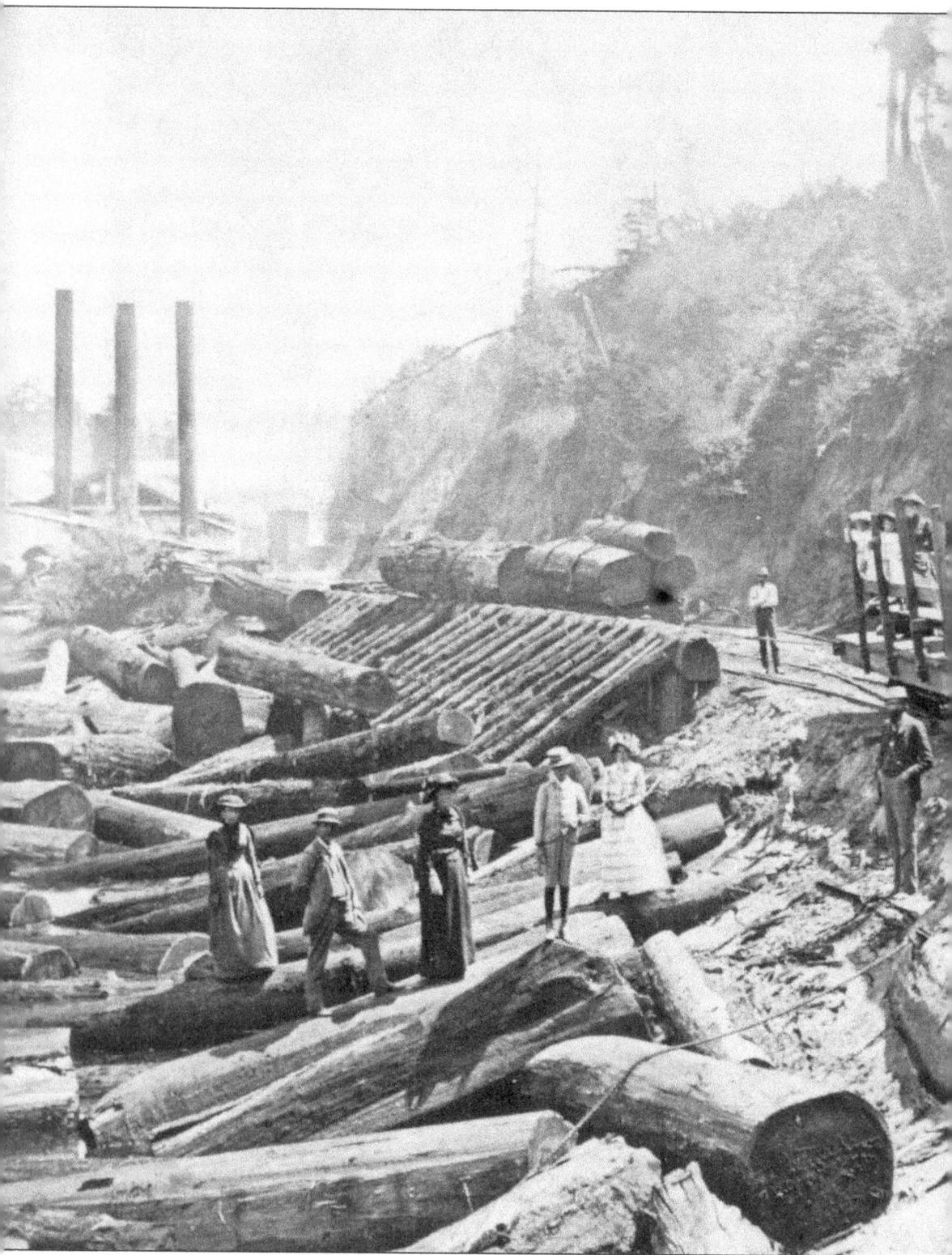

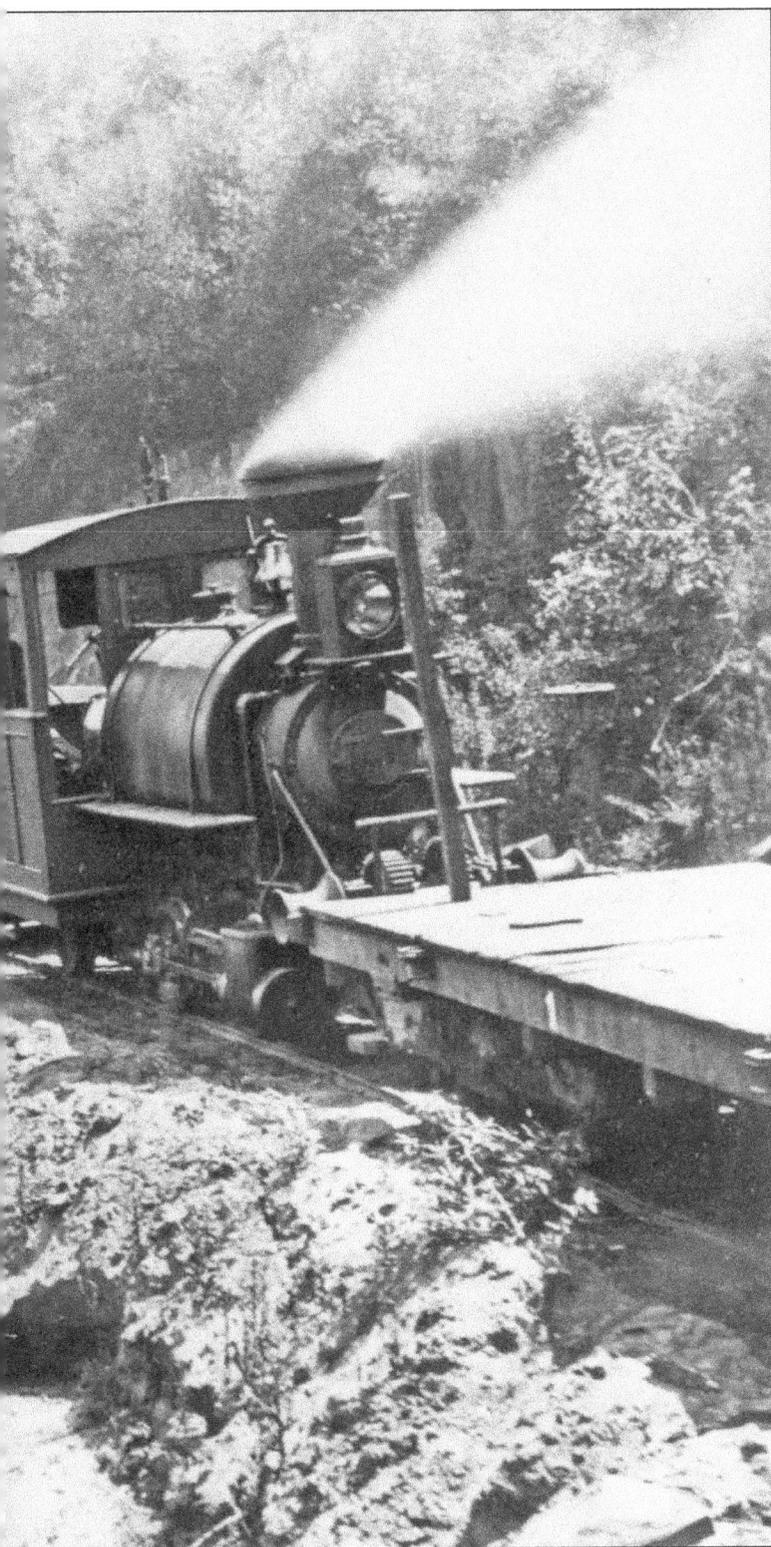

F.A. Hihn opened lumber mills in the San Lorenzo Valley as well as the Valencia lumber mill. He refurbished the Valencia Town Hall and gave it to the mill town of Valencia. When all the trees had been cut down, he paid his lumberjacks to plant apple orchards and then sold these orchards to the lumberjacks, who would acquire 10 percent per year. If a lumberjack died before full ownership, the lumberjack's widow would own the land free and clear. His business ventures benefitted his company and also the other parties; for example, the apple farmers needed Hihn's railroad to get apples to Aptos and needed Hihn's packinghouse to get the apples packed and shipped out. Hihn was involved in countless other enterprises including a telegraph company, waterworks, banks, brick making, gas wells and a gas company, and gold mining. He was a school trustee, a county supervisor, and served in the state assembly. He worked on behalf of libraries, stray animals, and civic beautification through landscaping. (Courtesy of Carolyn Swift.)

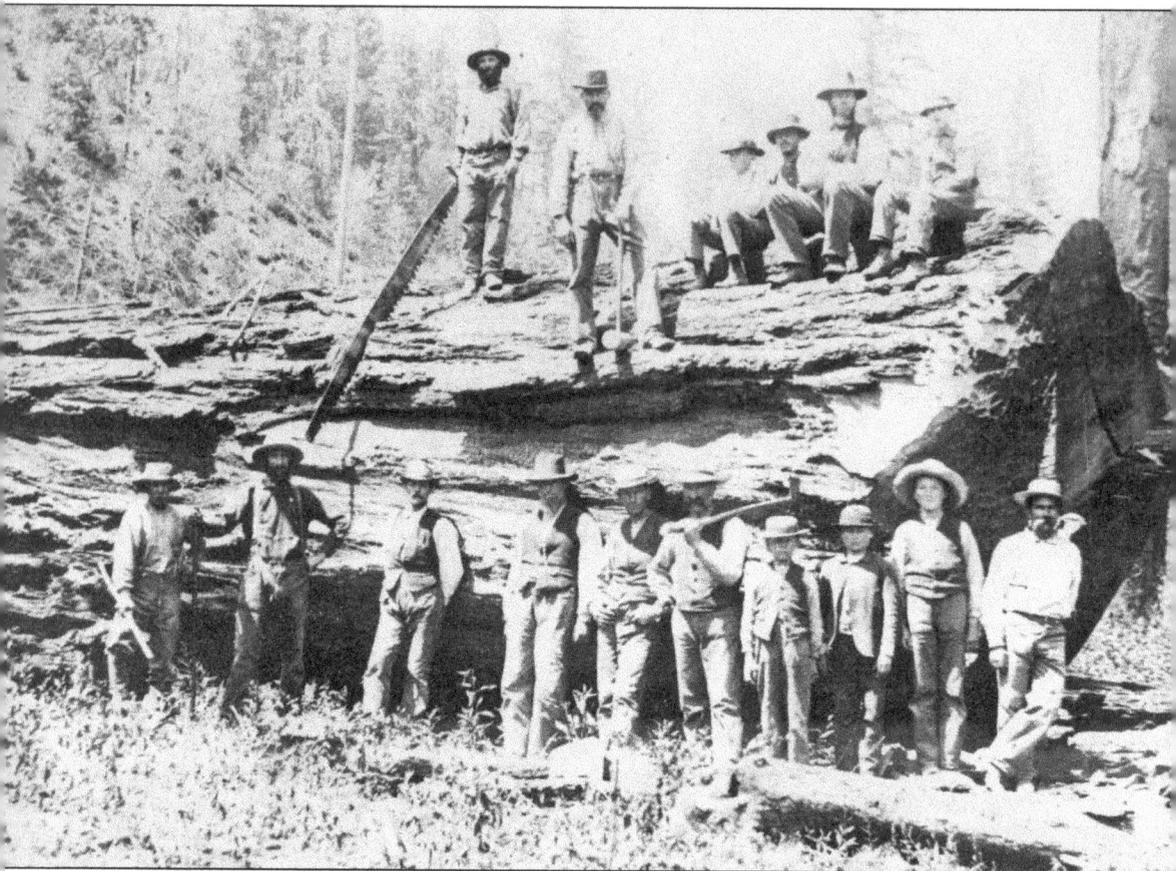

In 1880, just a few miles up Valencia Creek, Hihn built a huge logging camp and sawmill. The narrow-gauge railroad spur line was constructed with Chinese labor and connected the town of Valencia with Aptos Village. The Valencia Meeting Hall served as a community center, and just down the way on today's Valencia School Road was one of the area's earliest schools, not to be confused with Valencia Elementary School, which was built down the creek in the late 1920s.

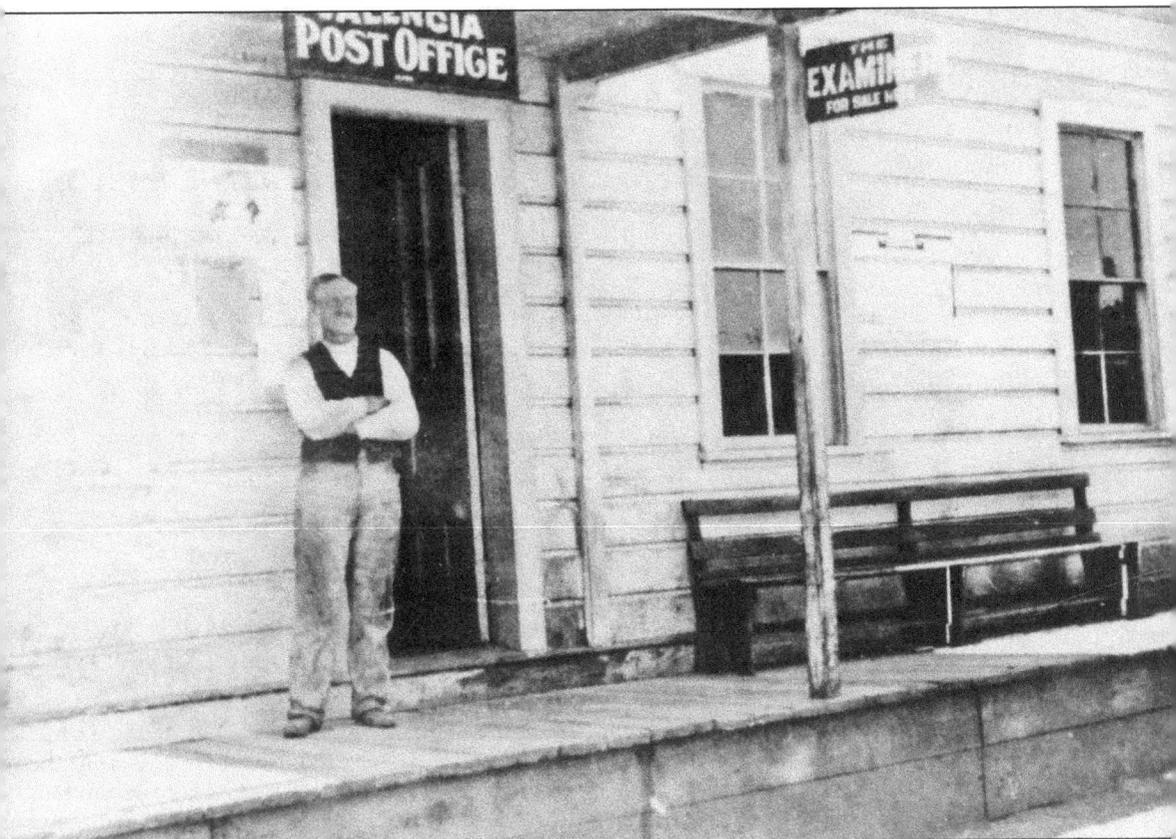

The town of Valencia had a community meeting hall and post office (which also functioned as a stagecoach stop and general store). Both buildings have been restored and moved across the street from their original location.

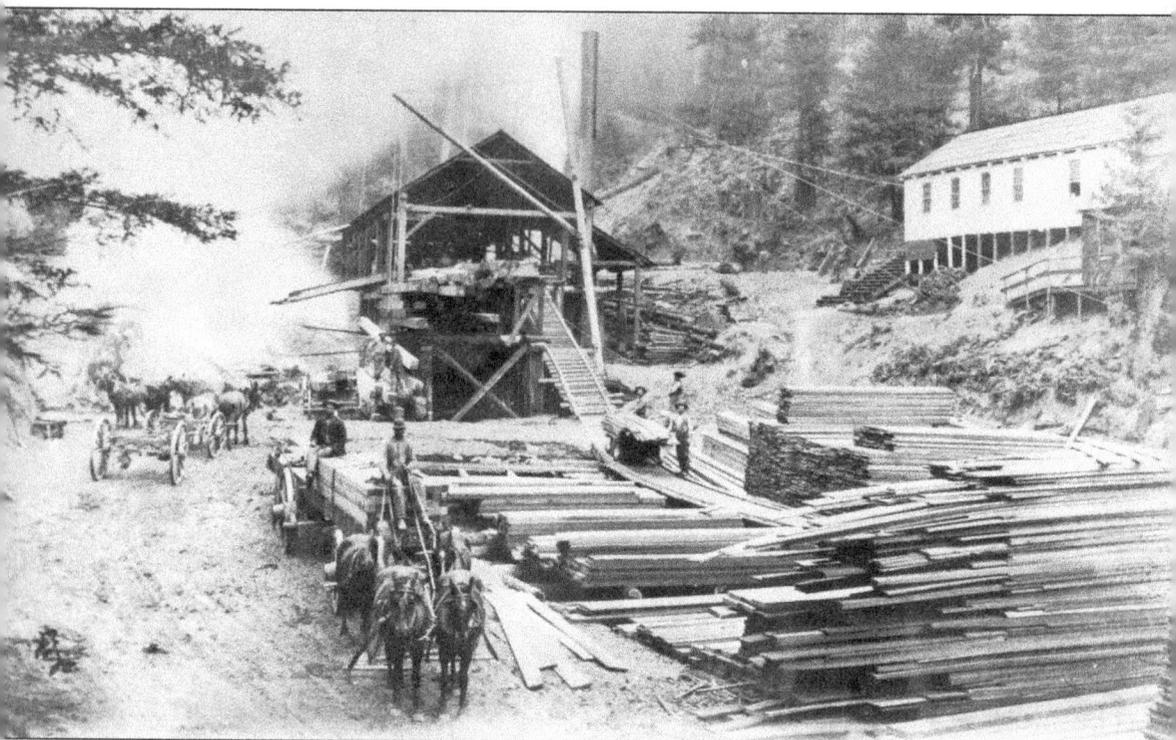

Hihn also owned huge land tracts in San Francisco, Tennessee, and Texas. At one point, he used his own funds as earnest money to acquire the land he had selected for Cal Poly in San Luis Obispo. In a letter dated December 7, 1901, Hihn wrote to the chief forester of the United States under Pres. Theodore Roosevelt advising him that government control was probably the only way to save California's forests. His exact words were: "Unless protected, in twenty years all the original redwood and oak forests will be cut." Some may consider this ironic given Hihn's history of vast lumber enterprises. This photograph shows the Valencia lumber mill, which, between the years of 1884 and 1892, had the capacity for producing 30,000 to 70,000 board feet per day. It was not long before the available timber had been consumed, and the mill was closed.

# Three

# Development
## Building a Town

Aptos was originally a rugged place to live. Claus Spreckels and F.A. Hihn, the two biggest purchasers of land from Rafael Castro, were major players in the early stages of the town's development. Hotels were built. The railroad tracks were laid. Communities were formed. Industry led development, and the major industry at this time was harvesting redwood timber. This was not an easy life and it required a rough and tough group of individuals to make it successful. The logging industry had nearly come to an end by the 1920s, and as their communities began to split apart, the development of Aptos Village began to pick up. A news article in early 1925 summarized the activity: "Aptos can boast that there are no idle men here, as all are busy clearing up property, building roads or homes." In 1929, the subdivision called Seacliff Park was developed by a group of businessmen from Utah, Nevada, and California who formed the Cal-Neva Stock Company. Rio Del Mar was developed, and the newly renovated SS *Palo Alto* (the cement ship) had opened up as an amusement center. What had started as a village of rough-and-rugged loggers just a few decades earlier had become a destination spot for those who were seeking rest and relaxation.

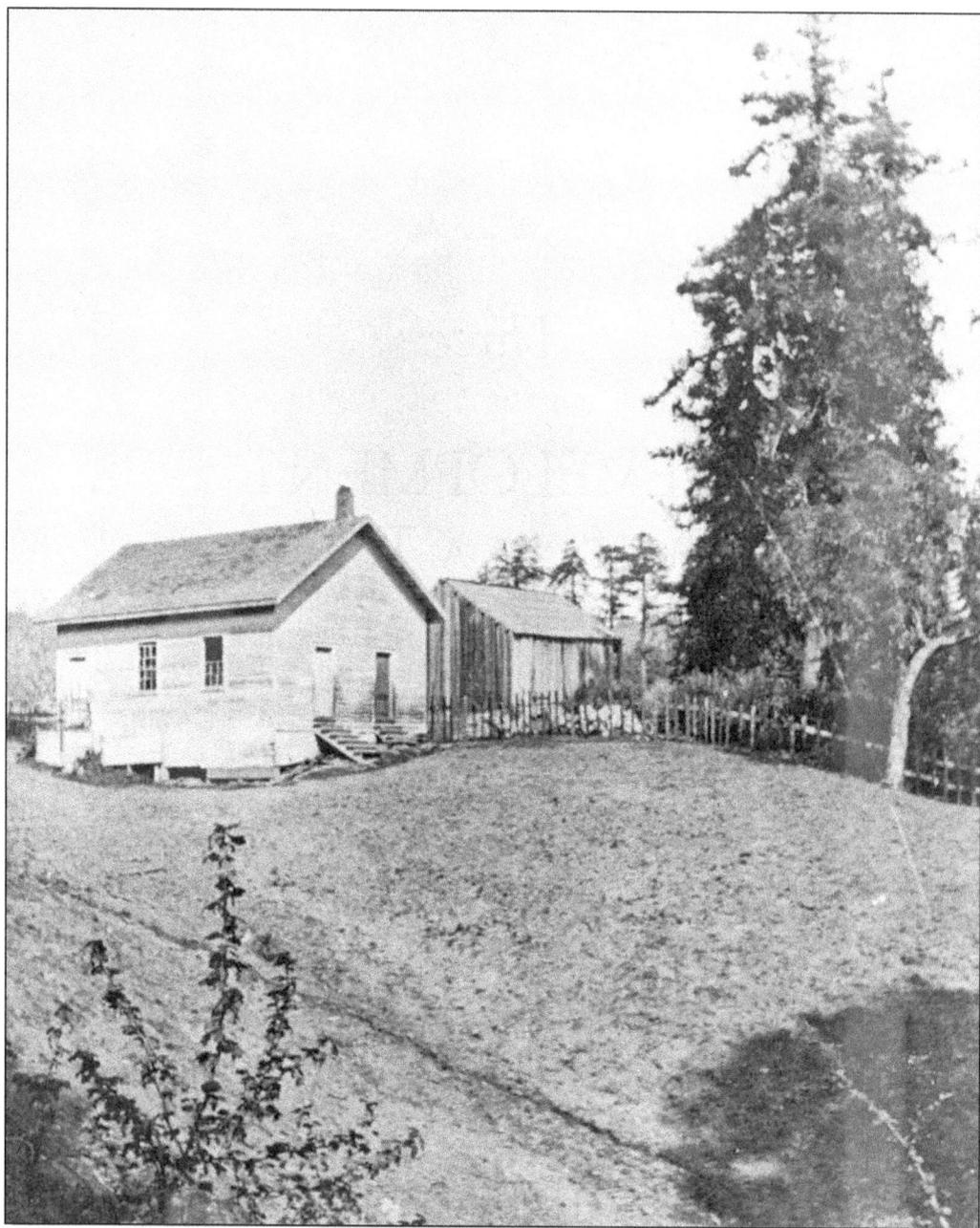

The Aptos School District was established in 1867 even though there was no official schoolhouse in Aptos. In 1869, Jennie Fallon taught classes in an ex-saloon, which had been converted into a one-room house. In 1870, Rafael Castro's eldest son, Vicente, provided classroom space at his home across the street from the current site of Rancho Del Mar shopping center. The second floor was occasionally used as a classroom. The first official Aptos School (pictured) was a one-room schoolhouse built in 1871 on land donated by Rafael Castro. It was located just off the county road at 7851 Soquel Drive. Since the school had no clock, and the teacher could not afford a watch, students used to be sent to the Arano general store to get the time. (Courtesy of Vincent T. Leonard.)

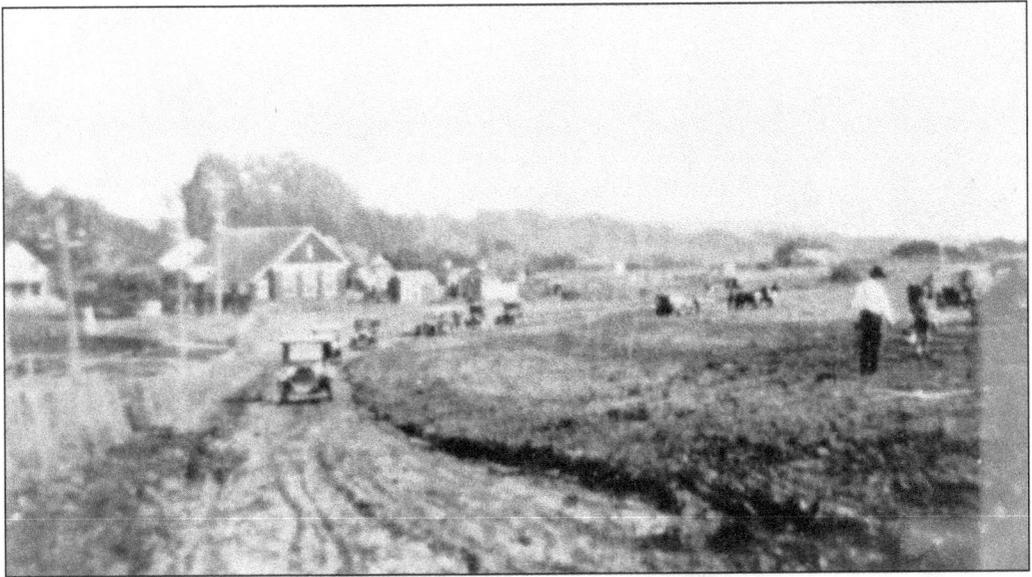

Claus Spreckels purchased much of the Aptos land grant from Rafael Castro in 1872 and paid for the construction of the second Aptos School, which was built in 1899. In 1928, a new Aptos School was built on Valencia Road, and the old school became the village assembly hall. It was then sold to the Assembly of God and became the congregation's Aptos church. The school, which no longer stands, was located in the current Aptos Village Square. The white building left of the schoolhouse is the old Arano general store and is currently the oldest building in Aptos. The open field is the current site of the Rancho Del Mar shopping center. (Above, courtesy of Paul Johnston; below, courtesy of Vincent T. Leonard.)

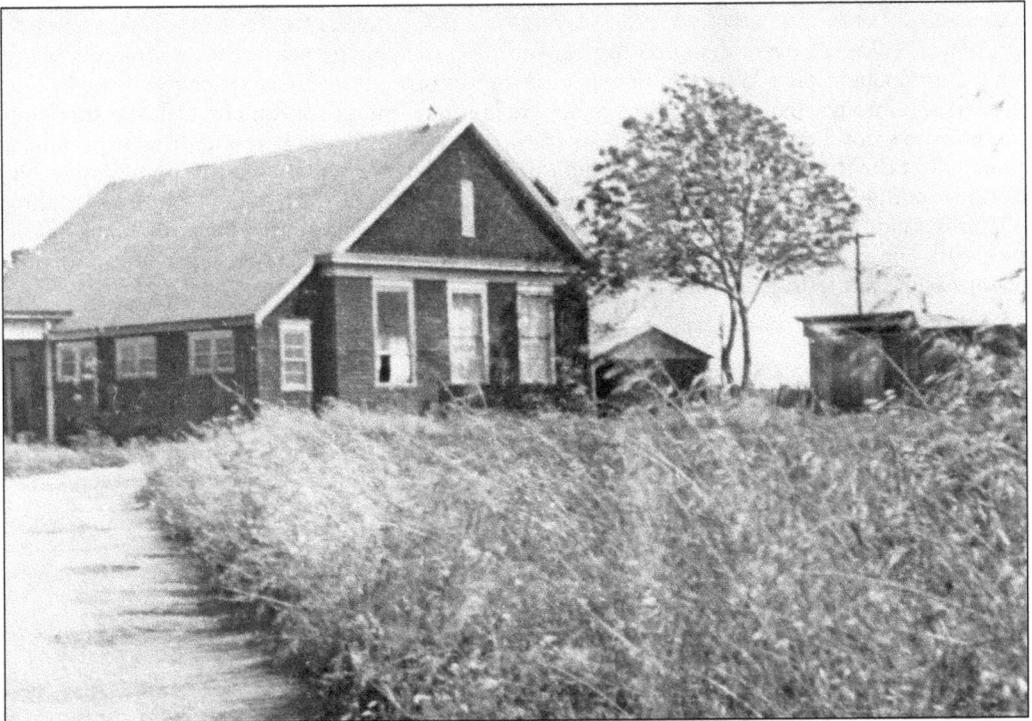

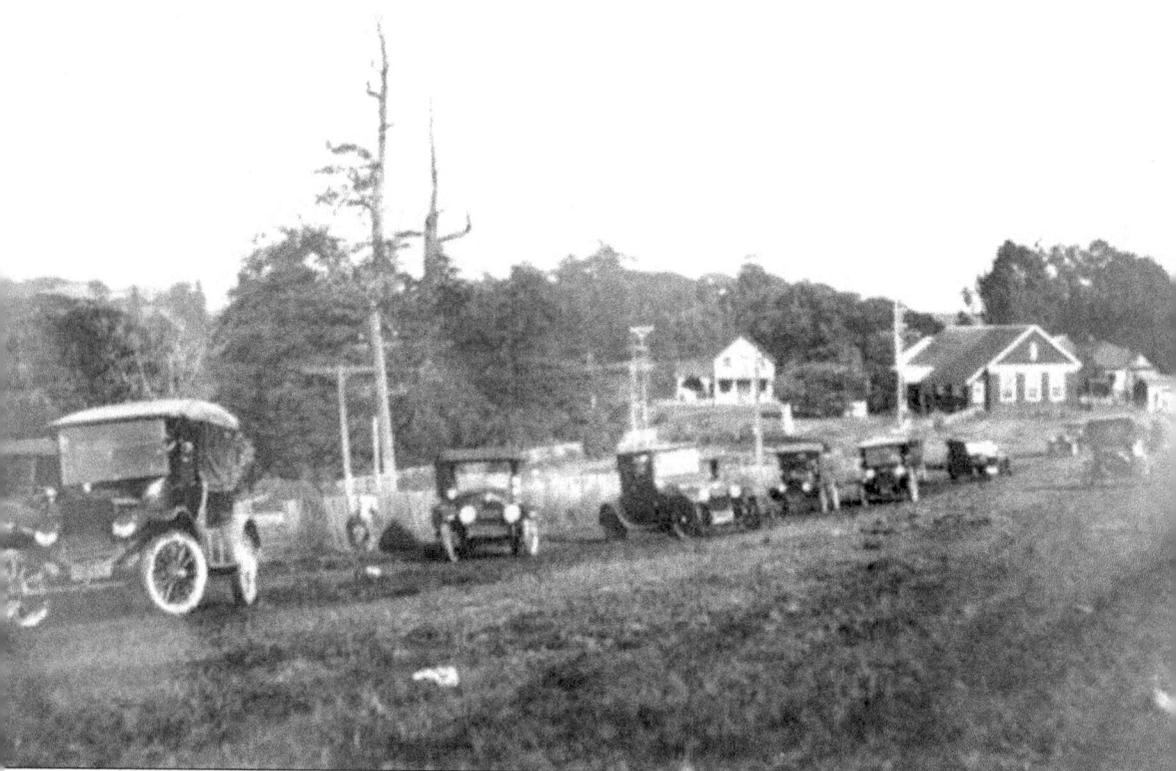

On May 1, 1915, cars were detoured to the Aptos School playing field while paving was being poured on Soquel Drive. When an unexpected shower turned the field to slick mud, one by one the cars slid into the fence. The Aptos School field is now the site of Rancho Del Mar shopping center. The second Aptos School, built in 1899, is visible in the background. It later became a church after the third Aptos School was built in 1928. The only building in this photograph that is still standing is the white building to the left of the school. It is the oldest standing building in Aptos and is located in Aptos Village Square. It was the Arano store and family home before they built the Bay View Hotel down the road in Aptos Village. It is now a private residence. (Courtesy of Paul Johnston.)

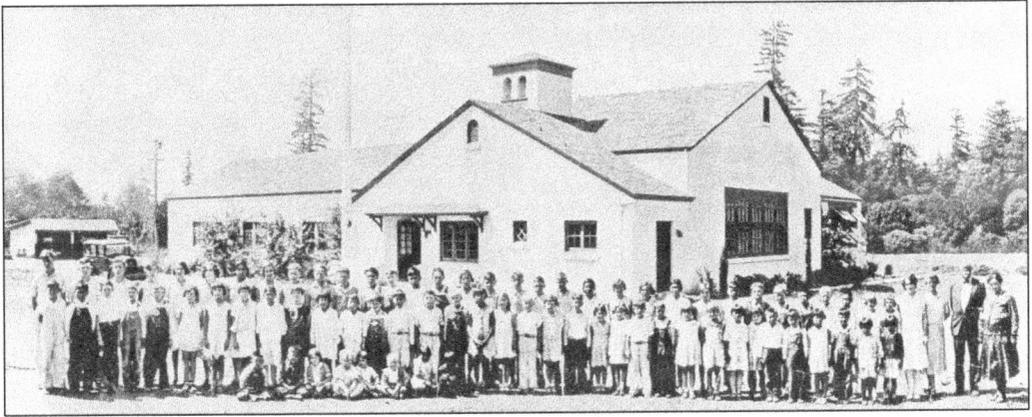

In 1928, the firm of Monroe, Lyon & Miller, also known as Peninsula Properties, gave the school district seven acres of land for the third Aptos School. The land was formerly the farm of Thomas J. Leonard and was part of the 1,750 acres of land purchased during the 1920s by Peninsula Properties. The stucco building, which was paid for with funds from the Aptos School District, had hardwood floors and contained three classrooms, an auditorium with dressing rooms, a library, kitchen, restroom, two large corridors, and lavatories. The original building still stands today, as seen below, as part of Valencia Elementary School on Aptos School Road. (Courtesy of Ralph Mattison.)

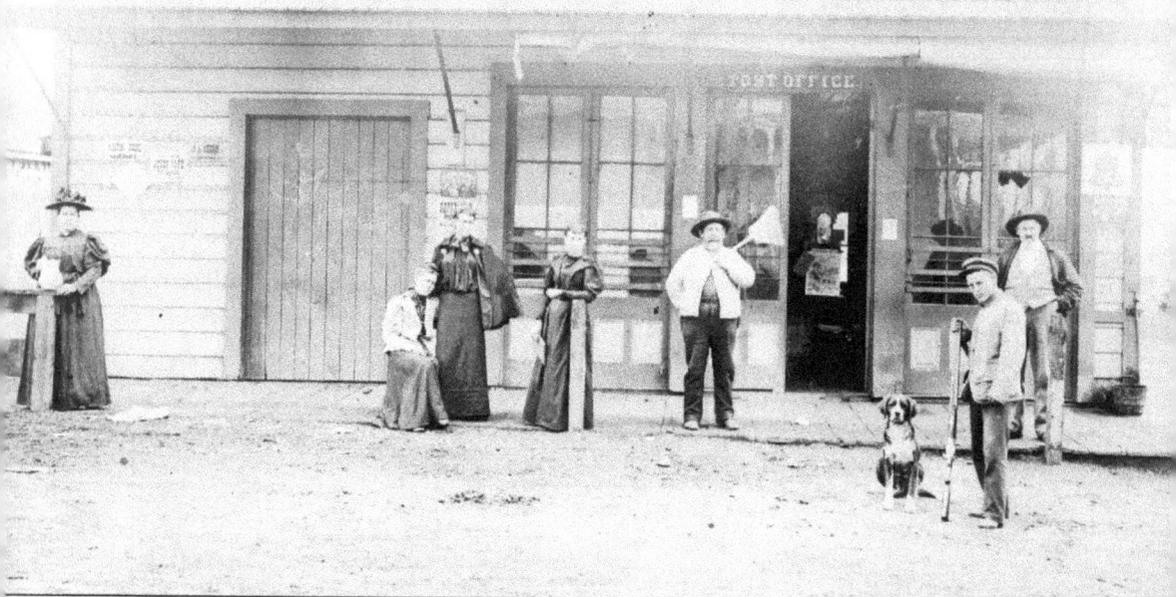

The Aptos Post Office was established February 25, 1870, with Jose Arano as postmaster. The first location was in the Arano store on Aptos Wharf Road but it was later moved to the Bay View Hotel. In 1898, the post office was moved to the Leonard Store where the boxes were very fancy polished oak with combination locks. That same year the store burned and nothing was saved. In 1899, the post office was located in a large general store built by James Leonard and his son Thomas about 150 feet to the west of the Live Oak House. That building still stands today and is the home of Café Sparrow. Other locations the post office has moved to include the Aptos Market, Trout Gulch Road, Post Office Drive, Rancho Del Mar shopping center, and its current home since 1977, Cathedral Drive.

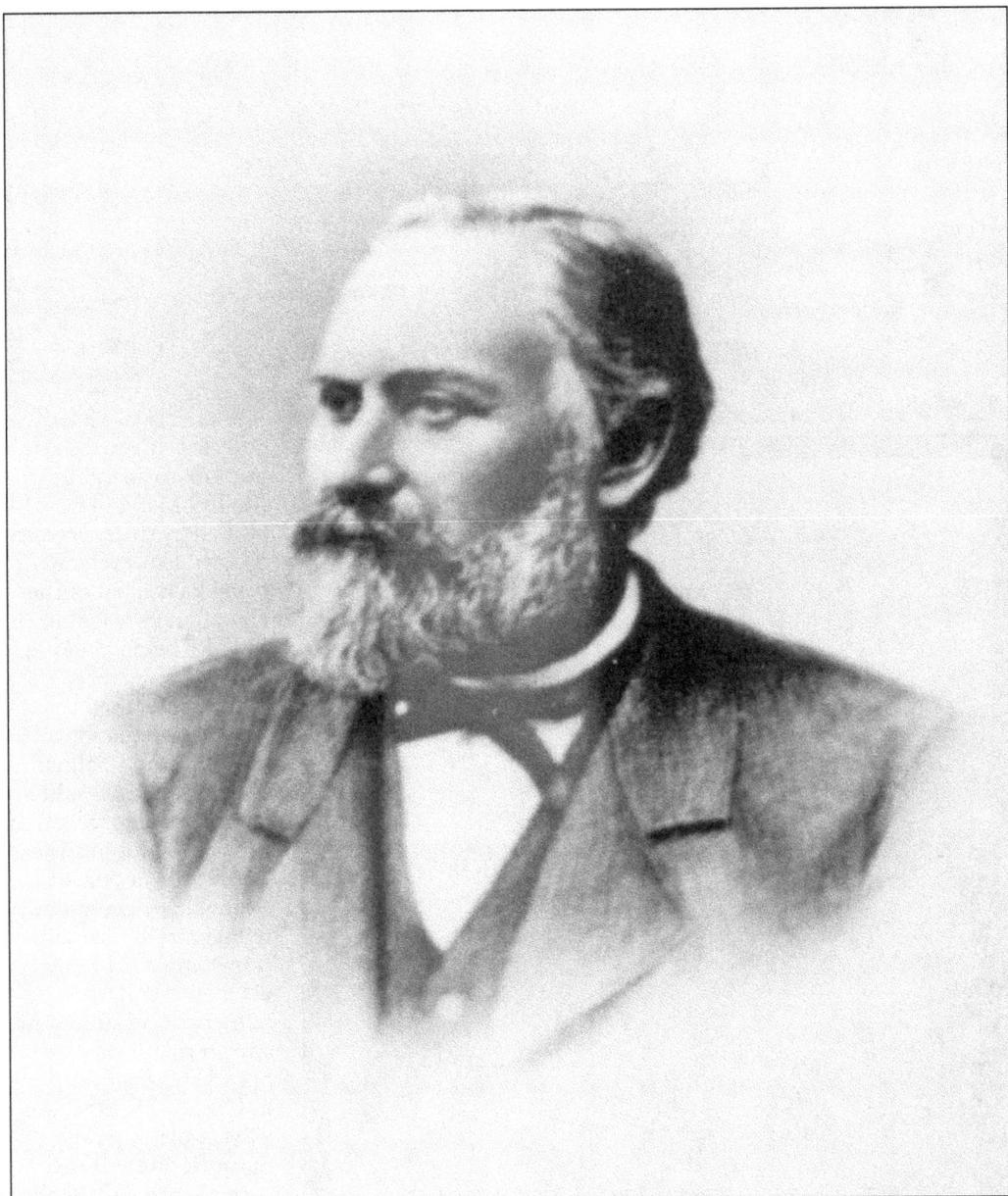

Claus Spreckels, widely known as the "sugar king" of the Pacific coast, was born in 1828 and was raised in the town of Lamstedt, in the independent kingdom of Hanover. He came to New York at the age of 17 and very quickly learned to speak English fluently. He worked in the grocery business and eventually bought a store and went into business for himself. His future wife, Anna Christina Mangels, came to America in 1849. They found each other, married in 1852, and had their first child, John, in 1853. Together they would have 13 children, but only five lived to maturity. They headed for California in 1856 and opened another grocery store in San Francisco. Claus Spreckels also started a brewery in 1857. In 1863, he sold his store and brewery and organized the small Bay Area Sugar Refinery in San Francisco. His success was booming, and his interest in producing sugar from beets, rather than cane, undoubtedly had much to do with his purchase of ranch property in Aptos in 1872. (Courtesy of the California State Historical Society.)

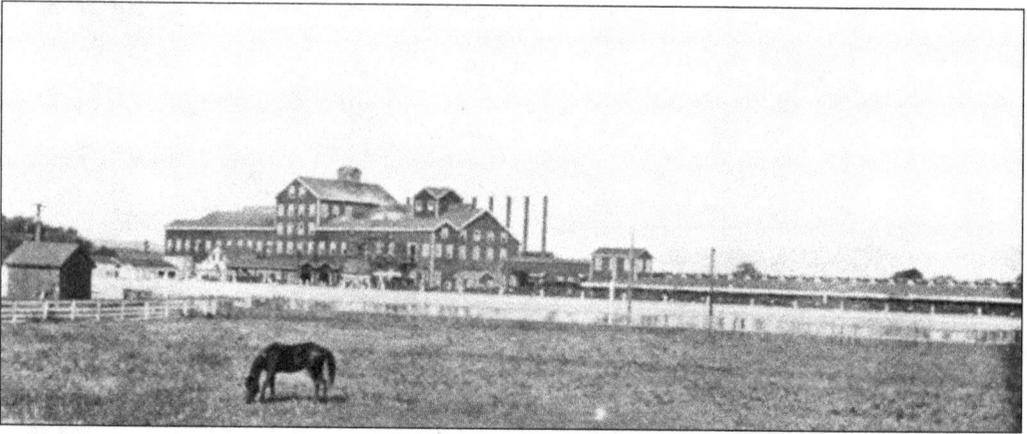

Spreckels planted sugar beets experimentally in Rio Del Mar and was pleased by their successful growth. However, after being kicked out of the Hawaiian kingdom in 1886 for being found guilty of arrogance, Spreckels realized the fertile bottomlands of the Pajaro and Salinas Valleys were well suited for sugar beet production. In 1888, he formed the Western Beet Sugar Co. and built an enormous refinery in Watsonville. It operated for 10 years until an even larger refinery near Salinas, in a town that is now called Spreckels, superseded it. On July 31, 1982, the 94-year-old Spreckels Sugar Refinery closed permanently. While there were very few sugar beets grown in Aptos, one could argue the success of the sugar beet industry in the United States was born on the experimental farms of Claus Spreckels in Rio Del Mar. (Above, courtesy of Carolyn Swift.)

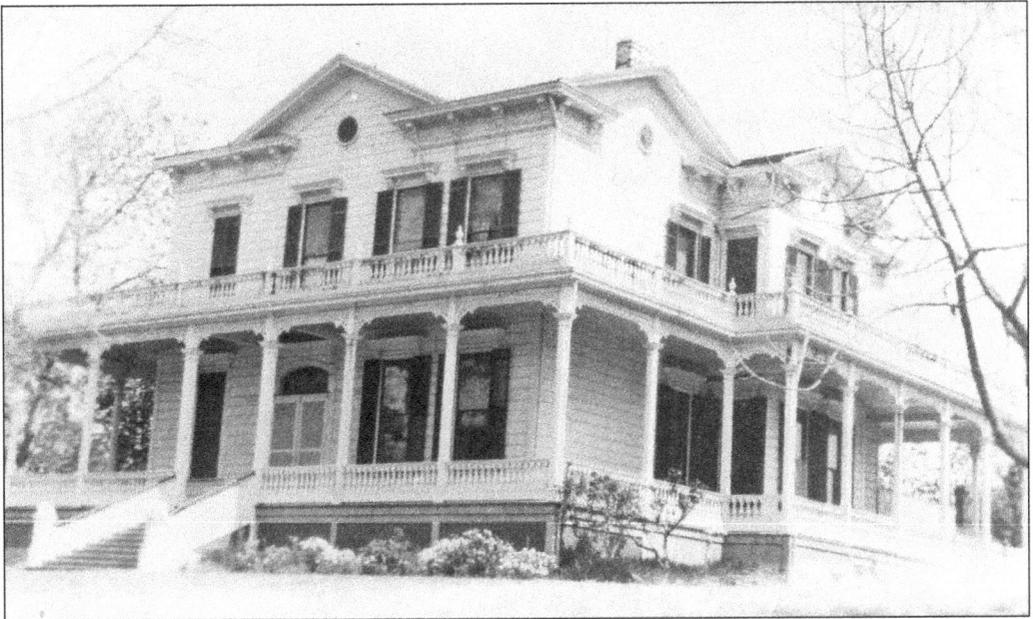

The Spreckels family home was completed in the 1870s and was an enormous two-story ranch home. It faced Coast Road (Soquel Drive) and was diagonally across today's freeway from the Arco service station in Rio Del Mar. The barns, stables, and sheds were located in the general area of today's Redwood Village. There was also a racetrack (below) on the land behind the house where today's polo fields are. The main house burned to the ground in 1929. Today, the only thing remaining of the Spreckels home is a lone magnolia tree out front. Four architecturally similar homes were built between 1873 and 1888 for various members of the Spreckels and Mangels families. The only one remaining today is the Mangels House. Although Spreckels kept his formal residence in San Francisco, he closed many business deals from his summer home in Aptos. (Below, courtesy of Capitola Historical Museum Collection.)

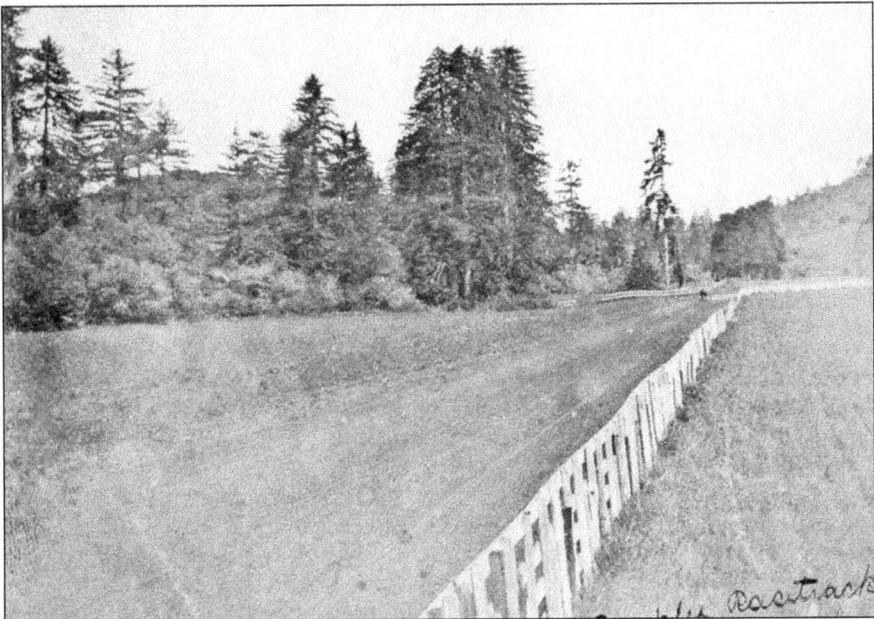

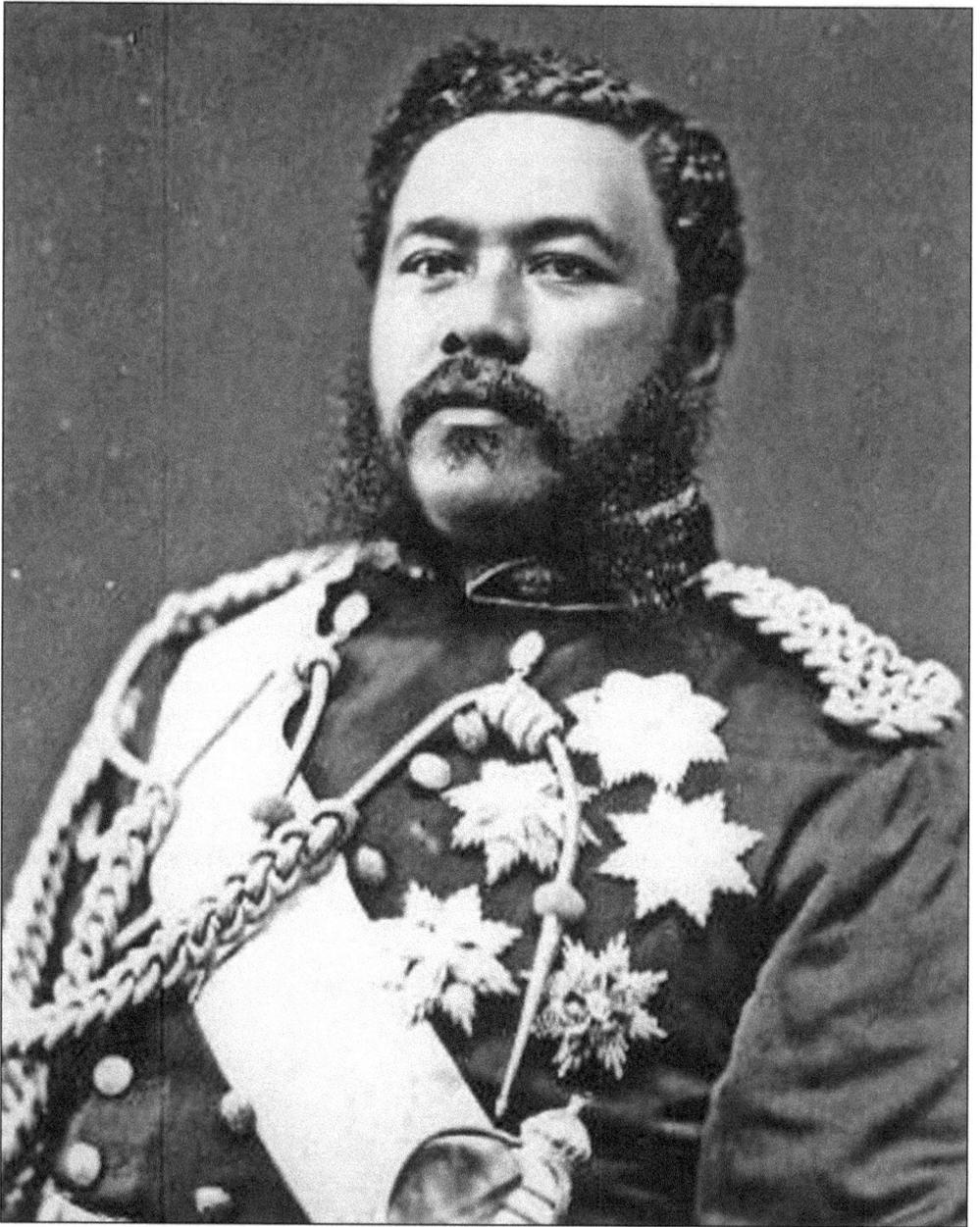

As reported in the *Santa Cruz Sentinel* on Saturday, October 22, 1881, "We have had a live King in our county." The *Sentinel* was referring to King Kalakaua of Hawaii who visited the Aptos home of Claus Spreckels. Spreckels, who was a California sugar refiner, found his business greatly threatened by the Kingdom of Hawaii's reciprocity treaty with the United States, which allowed Hawaiian sugar to come into the states duty free and cut Spreckles's profits. Rather than fight the treaty, Spreckels sailed to Hawaii and purchased half of the sugar crop of 1877 just before its value skyrocketed. Spreckels continued to purchase the sugar crops and eventually constructed a $4 million sugar mill in Wailuku, Maui. In the 1880s, Spreckels almost took control of Hawaii, and even the king was in debt to him. Eventually, King Kalakaua outwitted Spreckels and his control of Hawaii dissipated although his name stuck on his Maui town, Spreckelsville.

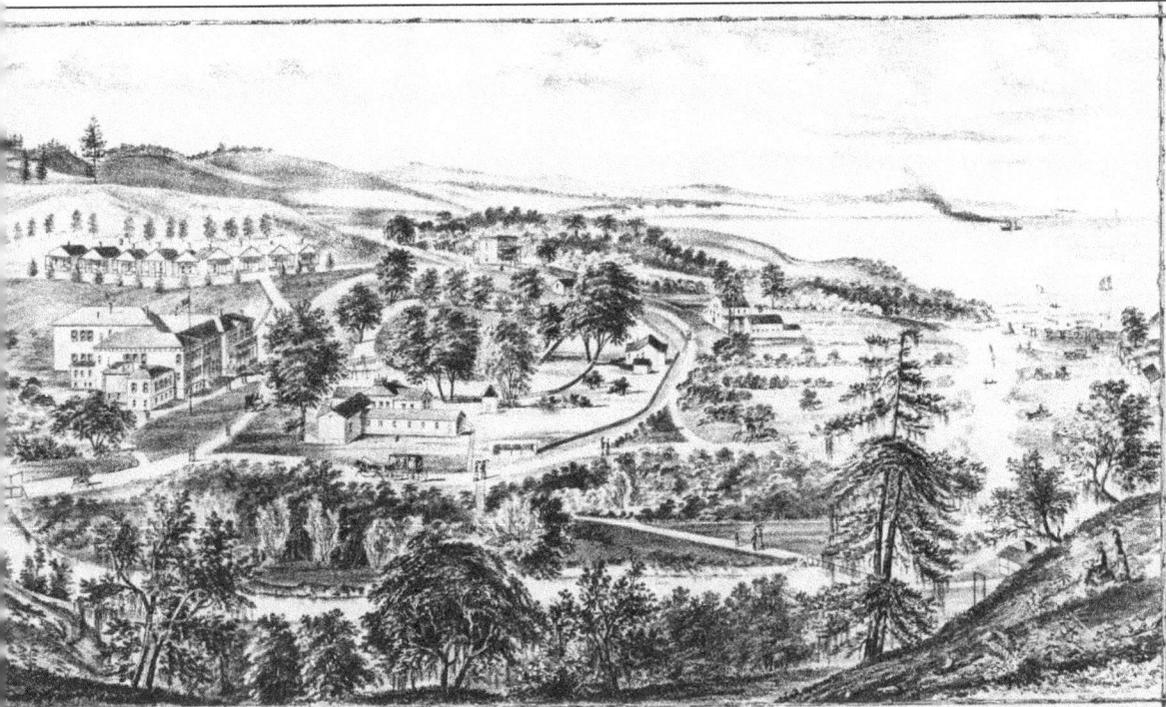

SPRECKELS. APTOS HOTEL. SANTA CRUZ CO. CALF.

Claus Spreckels, who had already proven his keen eye for business, saw a potential for economic gain with tourism in Aptos. The imminent arrival of train service would turn a two-day trip from San Francisco into a matter of hours. Spreckels built an enormous semi-private resort hotel in today's Rio Del Mar flats. The Aptos Hotel opened for business in May 1875. The main building was located on today's Claus Court. The three-story hotel was as elegant as it could be with spectacular views across Aptos Creek Lagoon to the beach and bay. Interestingly, there is a distinctive grove of rugged old cedar of Lebanon trees along today's Spreckels Drive, which were planted on the grounds of the Aptos Hotel in the 1870s. The *Santa Cruz Sentinel* of June 12, 1875, described the Aptos Hotel compound as the "Newport of the Pacific," comparing it to Newport, Rhode Island.

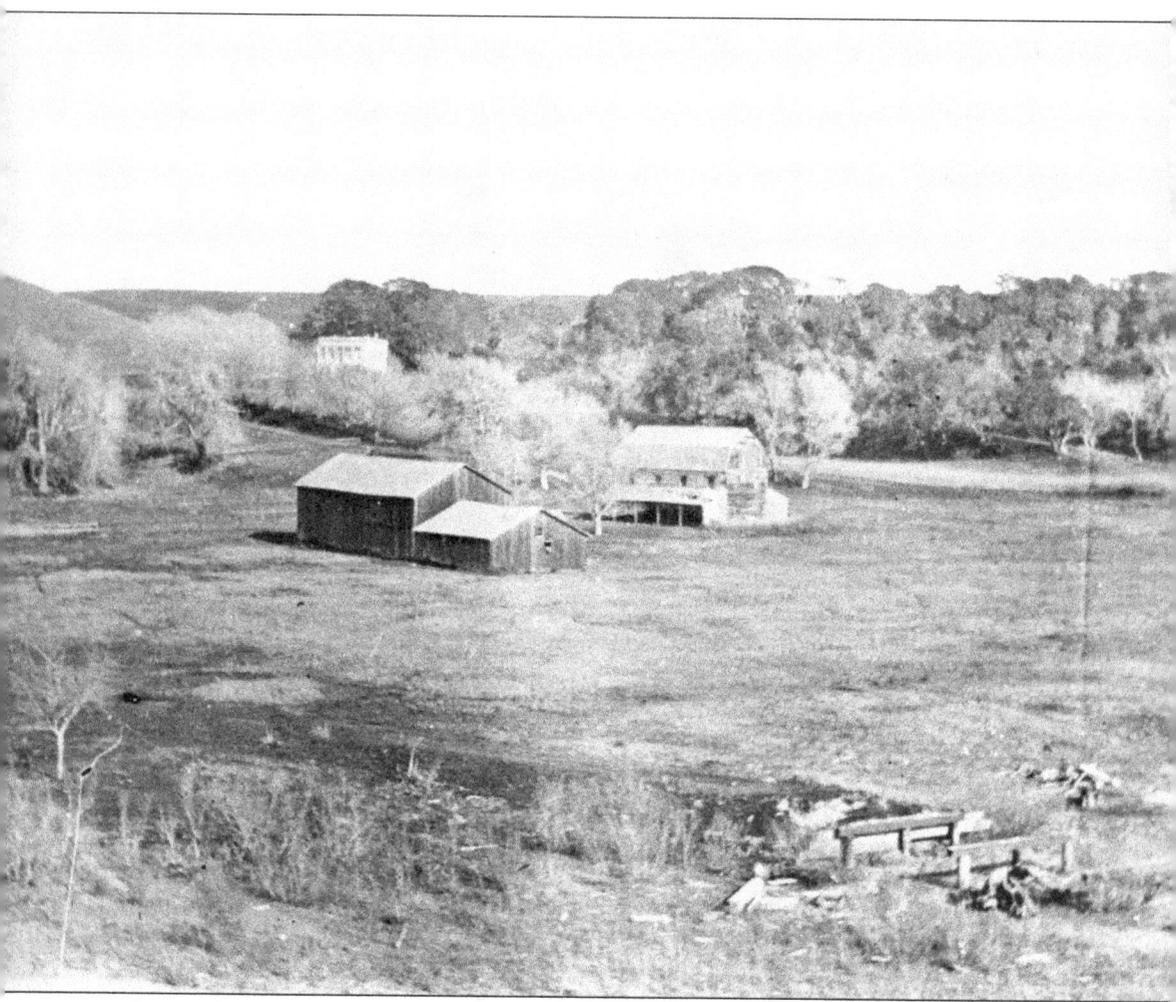

Across the street, on today's Spreckels Drive, there was a recreational club, which contained a dancehall, game room, bar, and bowling alley. Nearby was a gas-lighted pedestrian bridge, which led to an island in Aptos Creek known as Lover's Retreat. There was an outdoor dance pavilion under a natural stand of live oaks. Lover's Retreat is known today as Treasure Island, although it is no longer an island. There were nine honeymoon cottages overlooking the hotel on today's Wixon Drive. Down the road, on today's Treasure Island Drive, was a vast livery stable and equestrian center for the convenience of guests. This photograph shows the barns/stables and the caretaker's residence in the background. Although elegant and modern, the success of the hotel was short lived. As the logging industry picked up, Aptos Village became rugged and unattractive as a resort community in comparison to Monterey's Del Monte Hotel (1881) and the Capitola Hotel (1883). The Aptos Hotel was dismantled very carefully in 1896 to salvage the lumber, which was used in constructing Spreckels's sugar beet refinery.

Most people assume that the polo fields in Aptos were once used to play equestrian polo. They are correct. However, many also assume it was Claus Spreckels who built the track for polo matches. This is where they are incorrect. The first polo match was not played on the Aptos Polo Fields until March 17, 1924, a good 15 years after Spreckels's death. The confusion is understandable as the polo fields were at one point Spreckels's property. In 1872, he purchased farmland from Rafael Castro for about $75,000 and built a large home north of Soquel Drive, near the intersection of Rio Del Mar Boulevard. On this land he built stables to breed and raise horses. He also constructed a large oval track where his horses could race. This racetrack was later developed into the polo fields.

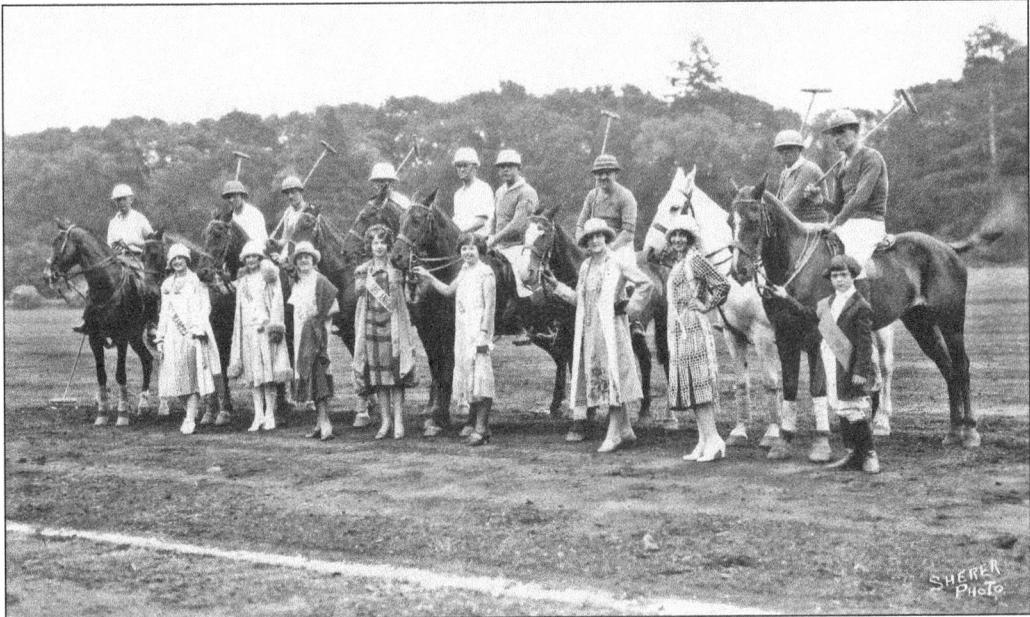

Spreckels's land was passed to a trust called the San Christina Investment Company after his passing in 1908. The trust decided to sell the property in 1922 to Fred L. Somers, a real estate investor from Pomona, California. The 2,390 acres were sold for $220,000. Somers formed the Aptos Company with the intent to subdivide and resell the property to developers. The Santa Cruz Polo Club leased 62 acres of this land, which included the stables and racing track built by Spreckels. The club declared this land as the site for its new polo grounds. Deming and Dorothy Wheeler, the area's principal retailer Sam Leask Jr., Frank Wilson of Wilson Brothers Realty, and prominent physician Dr. Golden "Goldie" Falconer were among those who originally brought polo to Santa Cruz County and were also the ones who financed the project.

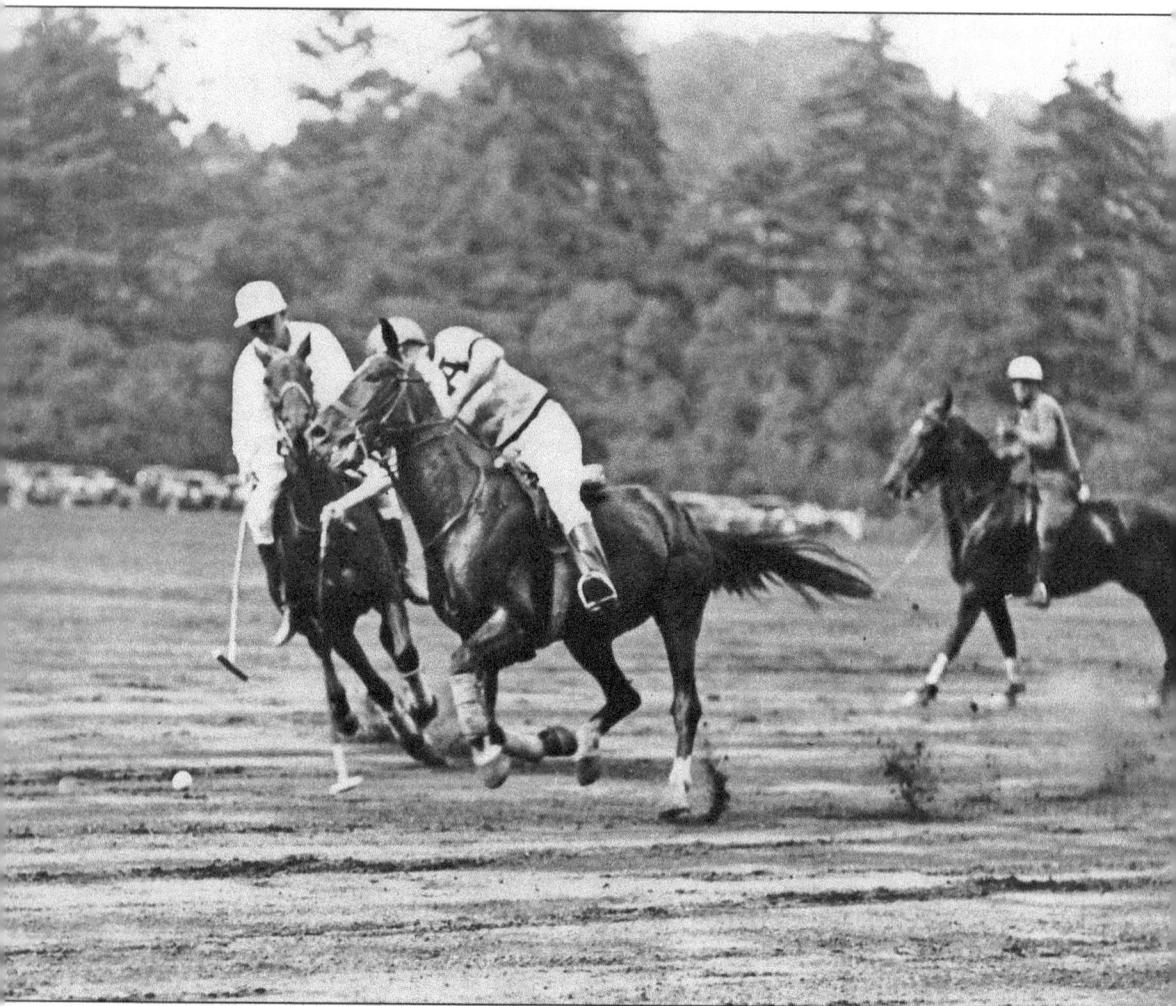

The polo fields saw its first match on March 17, 1924, as the Cavaliers beat the Tigers 9-3. The newly formed Aptos–Santa Cruz Polo Club attracted new members and spectators to its matches, which were regularly held on Sunday afternoons. In addition, teams from the outside area would come to play. However, just five years later, in an October 1929 article, the *Santa Cruz News* reported, "According to plans now proposed, the beautiful polo field of the Rio Del Mar tract will soon cease to exist and the thousands of dollars expended here for turfing and water appliances will be a total loss. The latest reports indicate that it has been leased for the culture of strawberries." And just like that, the polo fields had been converted into strawberry fields. In 1977, Santa Cruz County banned the use of pesticides, and the planting of crops was discontinued. In 1985, the county designated the space as a regional park known today as the polo fields.

Claus Mangels, pictured in 1919 with the Bay View Hotel in the background, was Claus Spreckels's brother-in-law and business partner. He was responsible for getting the local farmers to plant sugar beets. He invented the Mangels Plow for use with beets. Mangels was born in 1832 in the independent kingdom of Hanover, before Germany became a country. His farm was neighbored with the Spreckels farm. In 1846, Mangels and Peter Spreckels (Claus Spreckels's brother) came to America and worked in the grocery business. Claus Spreckels soon followed and eventually ended up owning the business. Claus Spreckels married Claus Mangels's sister, Anna, in 1852. Claus Mangels and Peter Spreckels met and married twin sisters Agnes and Anna Grosse. Claus and Agnes had five children together: Philip (who died as an infant), John Henry, Agnes, Anna, and Emma. In 1863, the three couples started the Bay Sugar Refining Company in San Francisco and were very successful. Agnes Mangels died in 1875; in 1876, Claus was remarried to Emma Zweig. Claus Mangels died on April 22, 1891. (Courtesy of Hanchett family collection.)

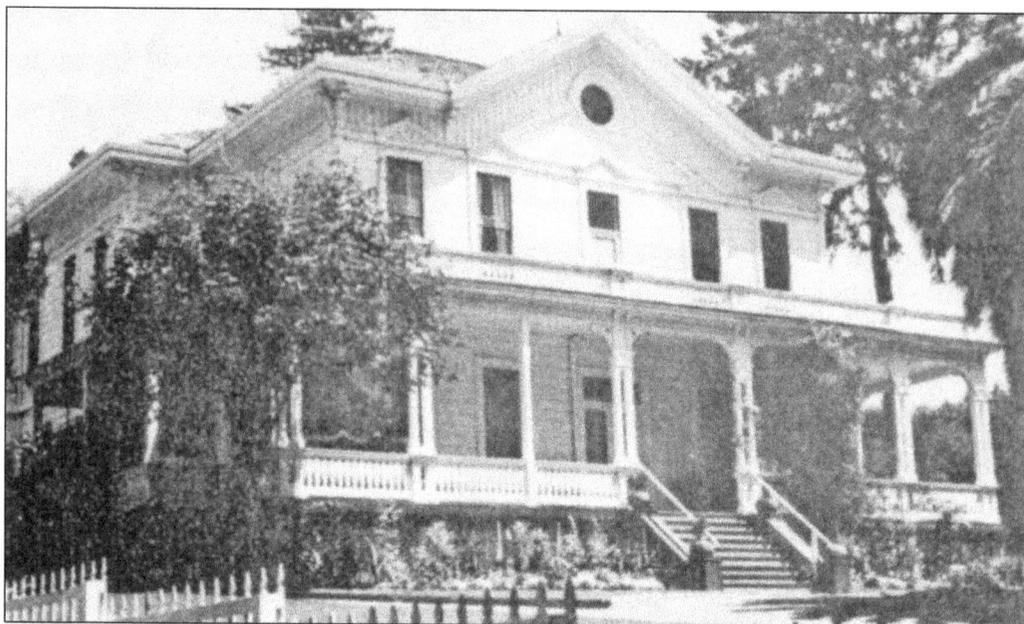

In 1888, after acquiring about 550 acres of land from his brother-in-law Claus Spreckels and Vicente Castro, Claus Mangels built his summer ranch house near the entrance of the Forest of Nisene Marks. The house was built with clear heart redwood from the Loma Prieta Mill. It contains 15 rooms including 10 bedrooms, a kitchen and butler's pantry, two parlors, a dining room, a card room, a full basement, 3,000 square feet of living space on each of its two floors, 14-foot ceilings on the main floor, and a full attic topped by a widow's walk.

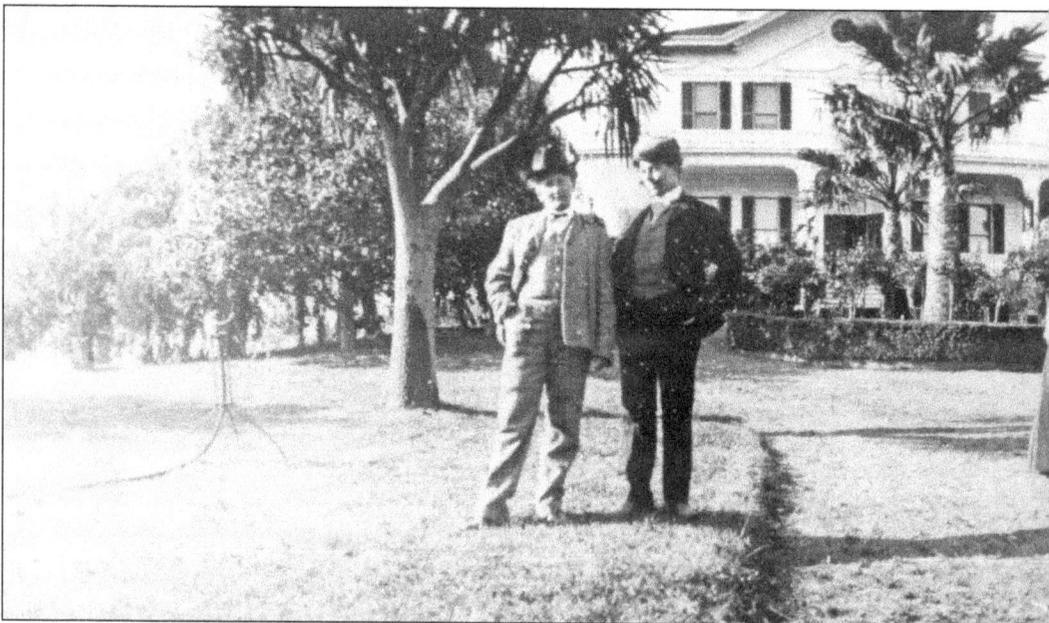

The Mangels House was built for Claus and Emma and was the last of four homes built by the Spreckels-Mangels clan. All of the houses were built to look similar. Claus Spreckels, who built his home where Huntington Drive, Monroe Avenue, and Soquel Drive intersect today, erected the first of the four. Later, a similar home was built for John Mangels (a nephew) and his wife, Emeline,

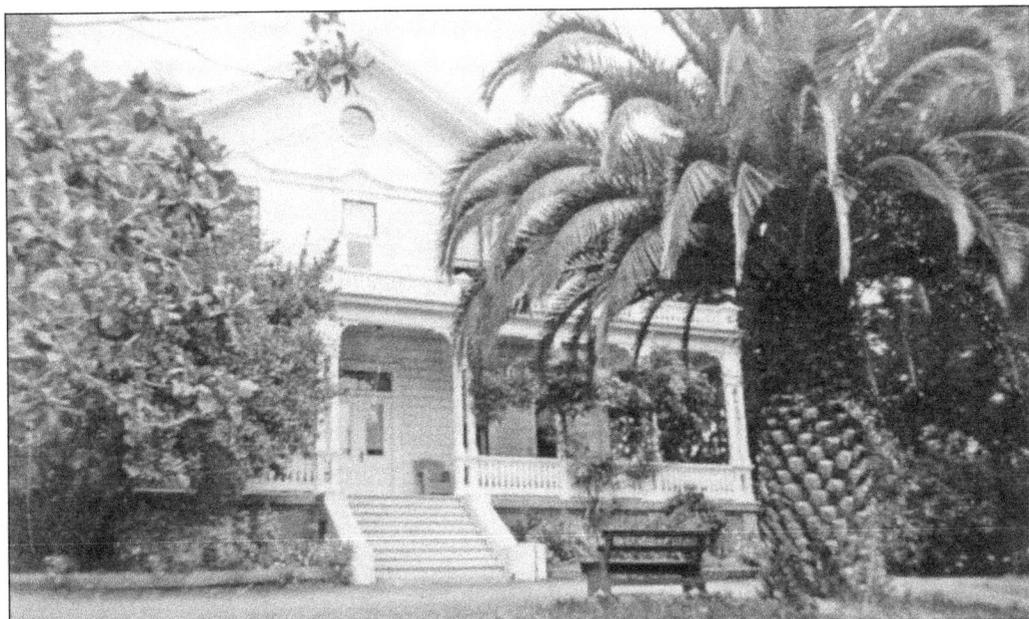

The style is called Carpenter's Gothic. The house was built to be used for six weeks in the summer and could sleep 23 people. The estate stayed in the family through four generations until 1979, when it was sold to Dr. Ron and Jackie Fisher. The Fishers operated a beautiful bed-and-breakfast with Jackie as the charming hostess who prepared wonderful breakfasts that always exceeded one's expectations. After Jackie's passing in 2004, the bed-and-breakfast ceased operations. The house is now the private residence of Dr. Fisher.

on Bayview Court off Aptos Beach Drive. John managed Spreckels's Aptos Hotel. A third home was prefabricated and shipped to Honolulu, Hawaii, for Spreckels to use while overseeing his sugar business in the Sandwich Islands. The only one remaining today is the Mangels House.

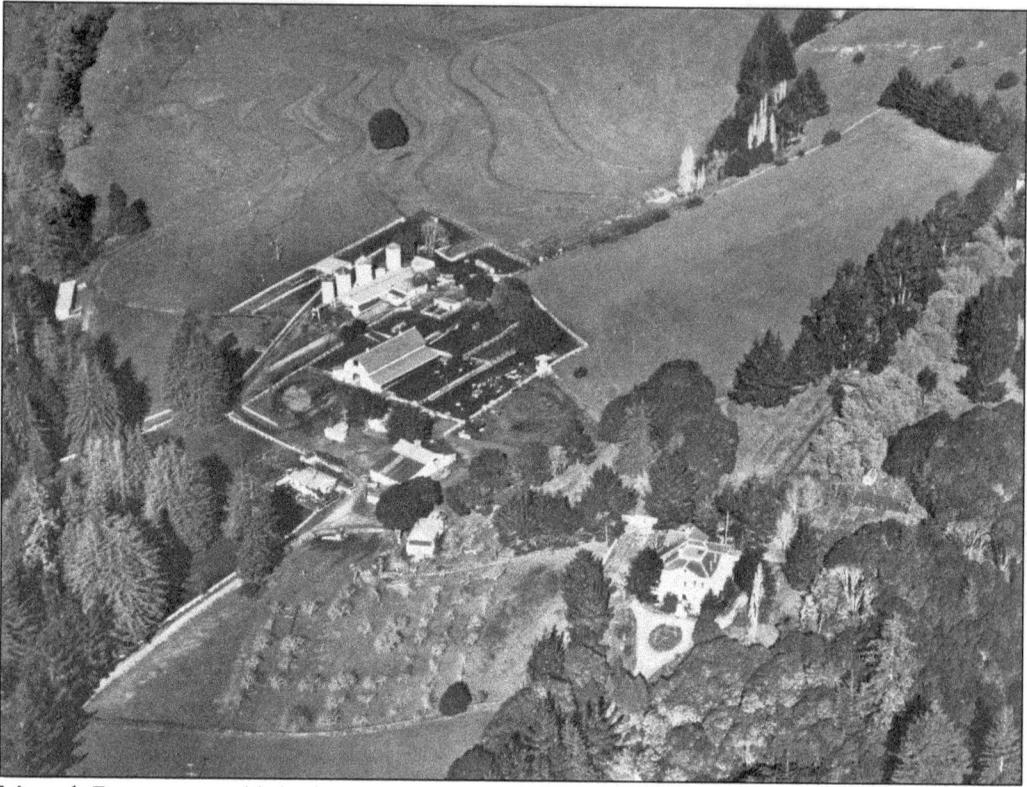

Mangels Dairy was established at Mangels Ranch in the 1920s. Milk was trucked to Golden State Dairies in Watsonville, where it was sold for 8¢ per gallon. Workers would bring back silage for the cows from the lettuce packing plants. Karl Mertz, Claus Mangels's great-grandson, fondly remembers eating the baby heads of lettuce that were too small for market. The dairy failed during World War II when all the Swiss and Bavarian milkers went to work for Salz Tannery in Santa Cruz. The tannery was expanding because of the war, and the pay was better. Karl Mertz still lives on the Mangels Ranch property and is very active with the Aptos History Museum.

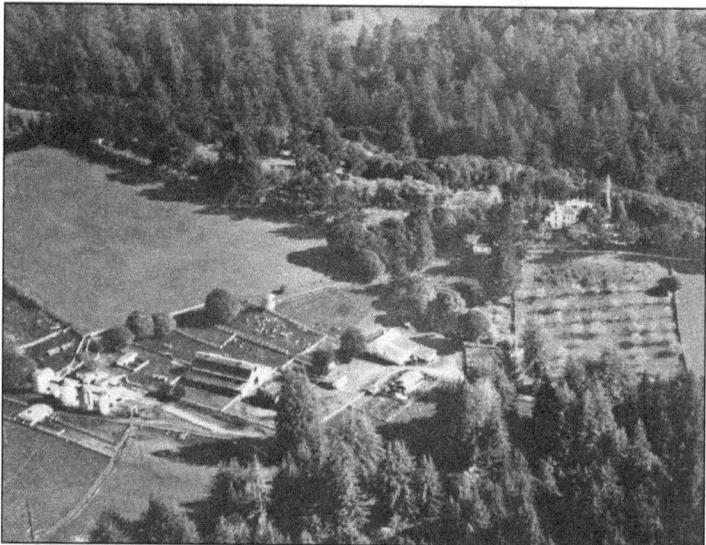

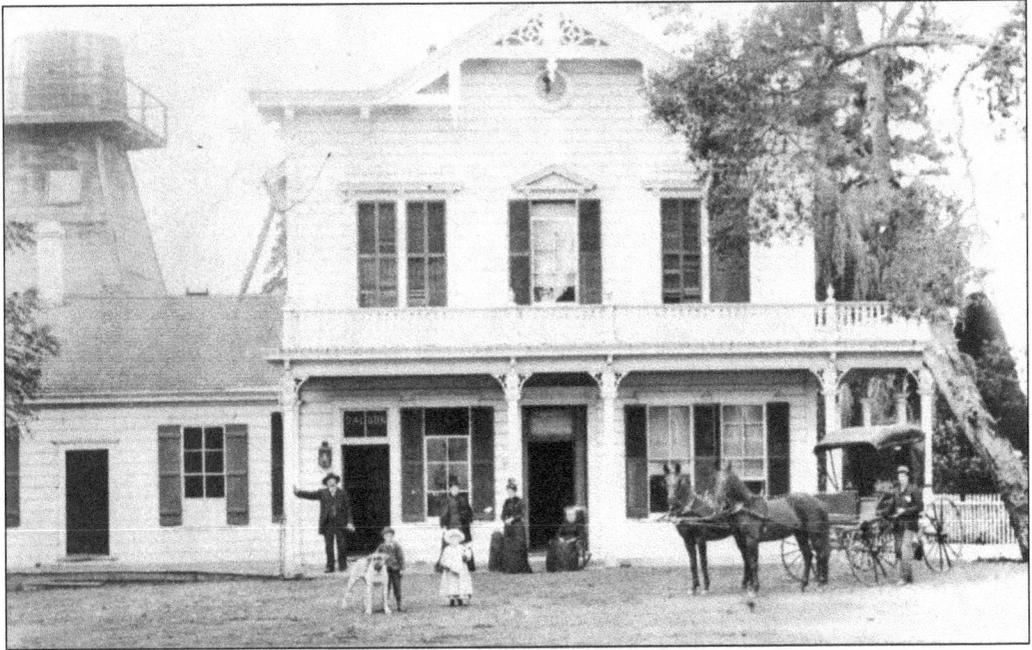

In 1869, Patrick Walsh erected a hotel and named it the Live Oak House. The front of the building faced Coast Road, now Soquel Drive, and stood where Bay Federal Credit Union is now located. It was the first full-service hotel in Aptos. The Live Oak House included a lobby, dining room, and kitchen facilities on the first floor, and 12 sleeping rooms on the second floor. The bar and card room became famous as the Aptos Club.

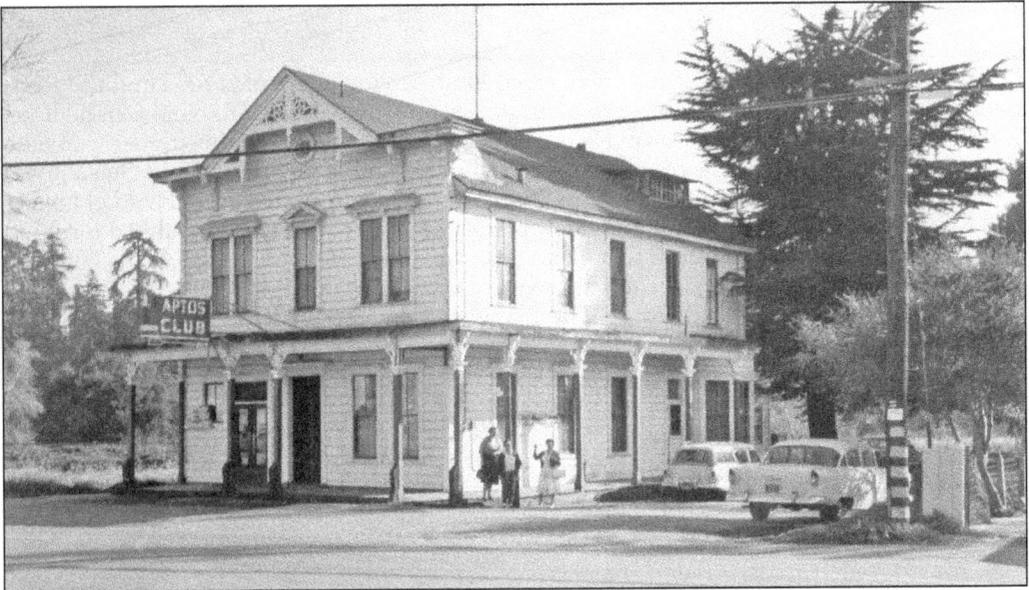

The Live Oak House operated as a hotel until one year after Catherine Walsh died in 1909. Patrick kept the saloon open, however, and even when the town went dry in November 1912, he refused to close the doors. He would be warned, fined, and arrested on many occasions, only to return to the bar each time. He died in his sleep on February 28, 1927. The Aptos Club was there until the building went down in 1966.

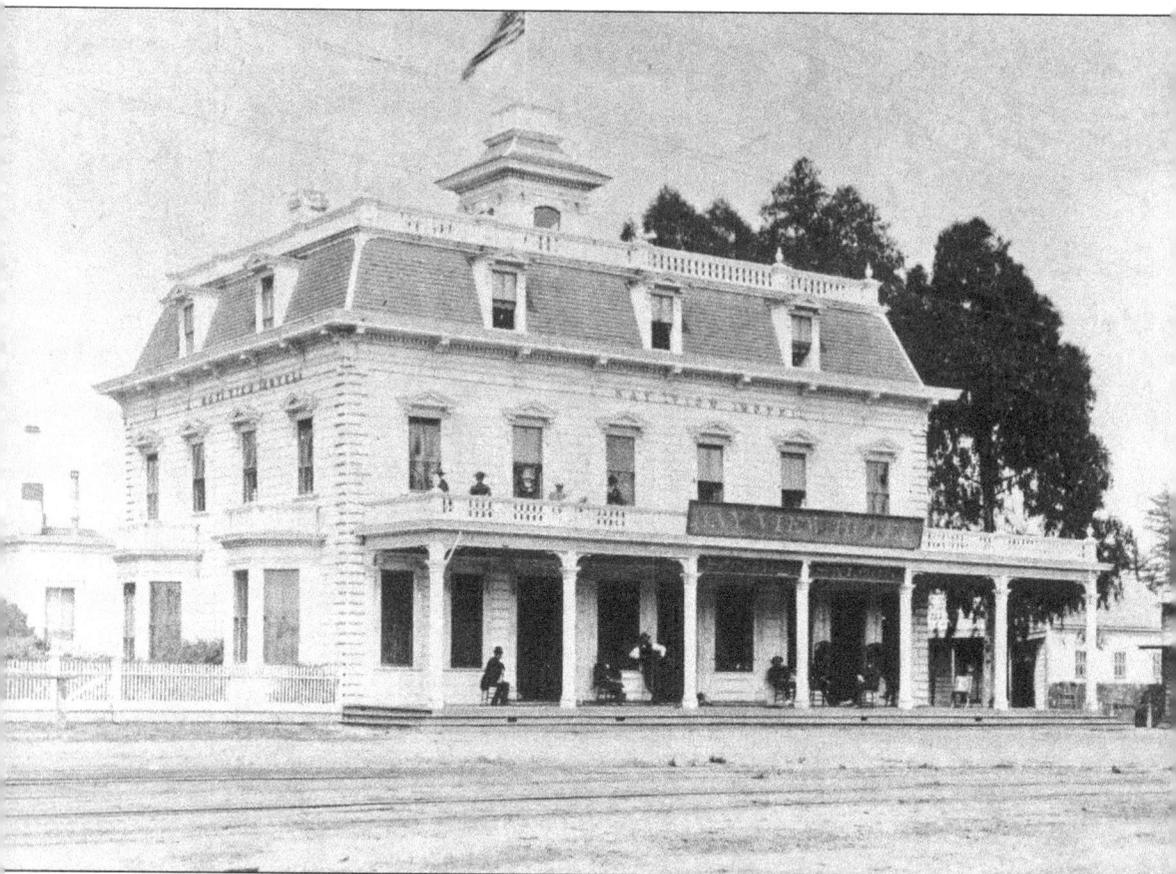

The railroad built in the mid-1870s encouraged lumbering in the Aptos hills and the town expanded across the creek to support the industry. Joseph Arano decided to build a grand hotel in the center of the new part of town. He used the profits he had made at his store to purchase the property at the corner of the county road (Soquel Drive) and Trout Street (Trout Gulch Road) from his sister-in-law Maria Antonia Castro. Arano personally inspected every board of lumber used to build the hotel. He ordered the finest marble fireplaces from France and had furniture hand crafted in Spain. It is rumored that Claus Spreckels may have even helped Arano build the hotel so that he would have a place to send some of his rowdier Aptos Hotel guests, located on today's Spreckels Drive at Claus Court. The Bay View Hotel, originally known as the Anchor House, was completed and opened in 1878. (Courtesy of Vincent T. Leonard.)

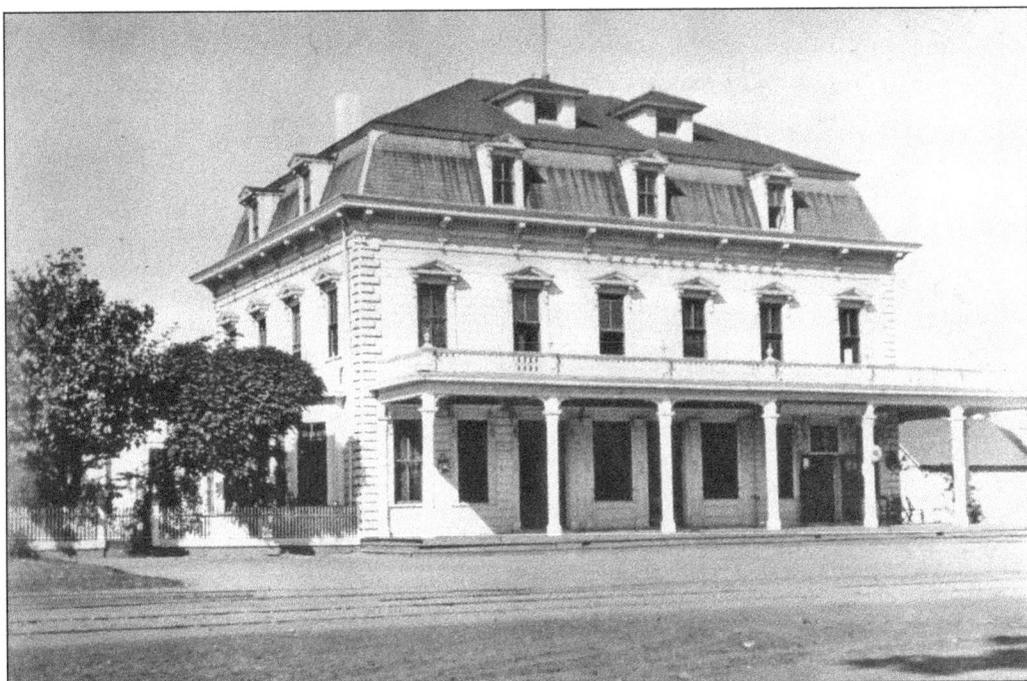

The Bay View Hotel had 28 large and sunny rooms, and a formal garden adjacent to the hotel on the west side was used a buffer for the lumber activity. It is believed that architect Thomas Beck designed the hotel. The original building had a Parisian-style, flat mansard roof with a cupola on top. The cupola was removed sometime between 1890 and 1918 and replaced with the peaked roof of today, which included a fourth-story attic. In the mid-1940s, owners Fred and Babe Toney jacked up the hotel, put it on rollers, and moved it approximately 120 feet to the west into the old formal garden, which is why the old magnolia tree is now in front of the hotel. The hotel has survived two fires, one in 1928 and the other in 1975. The business has changed hands several times since the Aranos first built it. It was named a California State Historic Monument in 1974 and was listed in the National Register of Historic Places in 1993. (Courtesy of Vincent T. Leonard.)

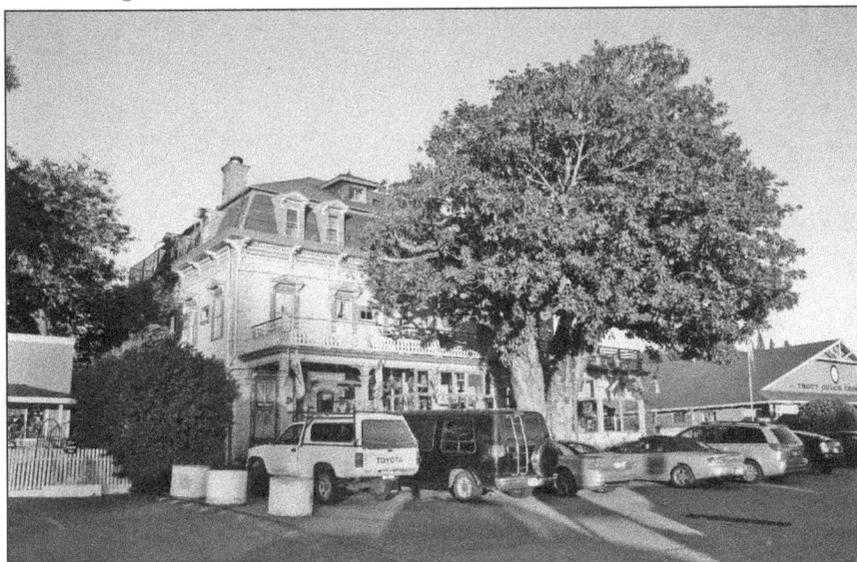

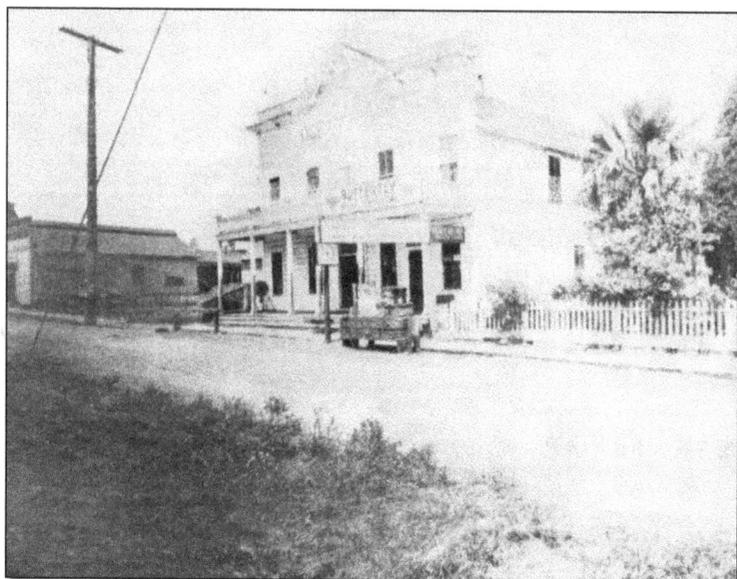

The Ocean House was a hotel built between 1884 and 1888 and operated by Louis Thurwachter. The lot on which the hotel was built may have been the site of the home of Rafael Castro's daughter Maria Antonia and her husband, Guadalupe Bernal. The Bernals sold 10 acres of land to F.A. Hihn, who subdivided them. The Ocean House was built on Lot 9. Guadalupe and Maria Bernal both died in 1891. (Courtesy of Vincent T. Leonard.)

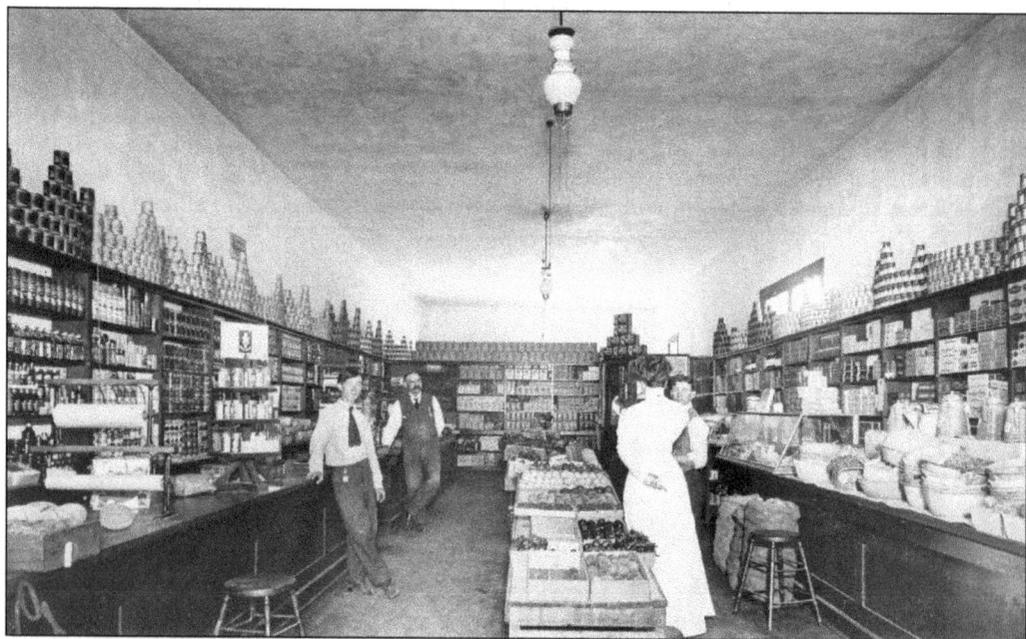

Sometime between 1921 and 1940, the property became Robert and Kate Menefee's grocery store. By 1952, the building was owned by Joe and Nola Gales, who later sold the property to the Aptos Fire Protection District. The building was razed to construct the new three-stall firehouse, which served the community until 1971. It has since been used as retail space and is the current home of a barbecue restaurant.

Benjamin Franklin Porter came to California from New England in the winter of 1850–1851. He and his cousin George did not come west for gold but for business and land opportunities. In 1854, Benjamin purchased a tannery that was built alongside the watershed, which is today known as Porter Gulch. In the 1860s, Ben returned to New England and married his boyhood sweetheart, Catherine "Kate" Hubbard. (Courtesy of the Porter Sesnon family.)

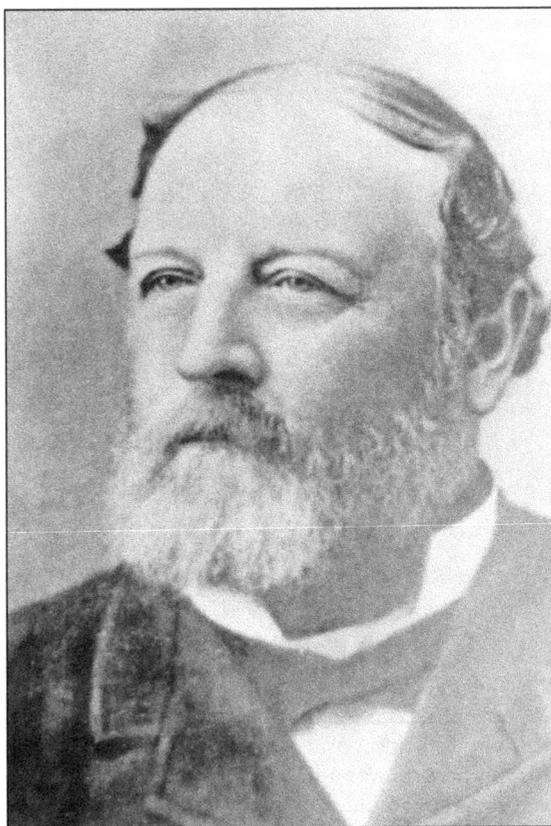

Benjamin and Kate built their home (pictured) in 1872, just south and across the road from the tannery. After Benjamin died in 1905, his daughter Mary and son-in-law, William Sesnon, began plans for a summer home, in his honor, on the rise beside Benjamin's original home. They began building in 1909 and finally completed the project, which they named Piño Alto, in 1911. (Courtesy of the Porter Sesnon family.)

William T. Sesnon and Mary Porter Sesnon were married in 1896 and built the Sesnon house in 1911. Sesnon was a well-to-do owner of the Sesnon Oil Company and his wife, Mary, was the only surviving child of Benjamin Franklin Porter. Around town, the house was often referred to as the "Sesnon Mansion," but the name given by the Sesnon family was Piño Alto, meaning tall pine; a reference to the giant trees on their property. The house itself was built with the finest woods. The floors were a fine polished oak, and a massive oak banister led to the second floor. The tile roof weighed 97,000 pounds, and the rain gutters were made of copper. The editor of a Santa Cruz newspaper commented that the house "would endure forever, as far as living men may know." The total cost to build the mansion is estimated between $60,000 and $70,000. (Both, courtesy of the Porter Sesnon family.)

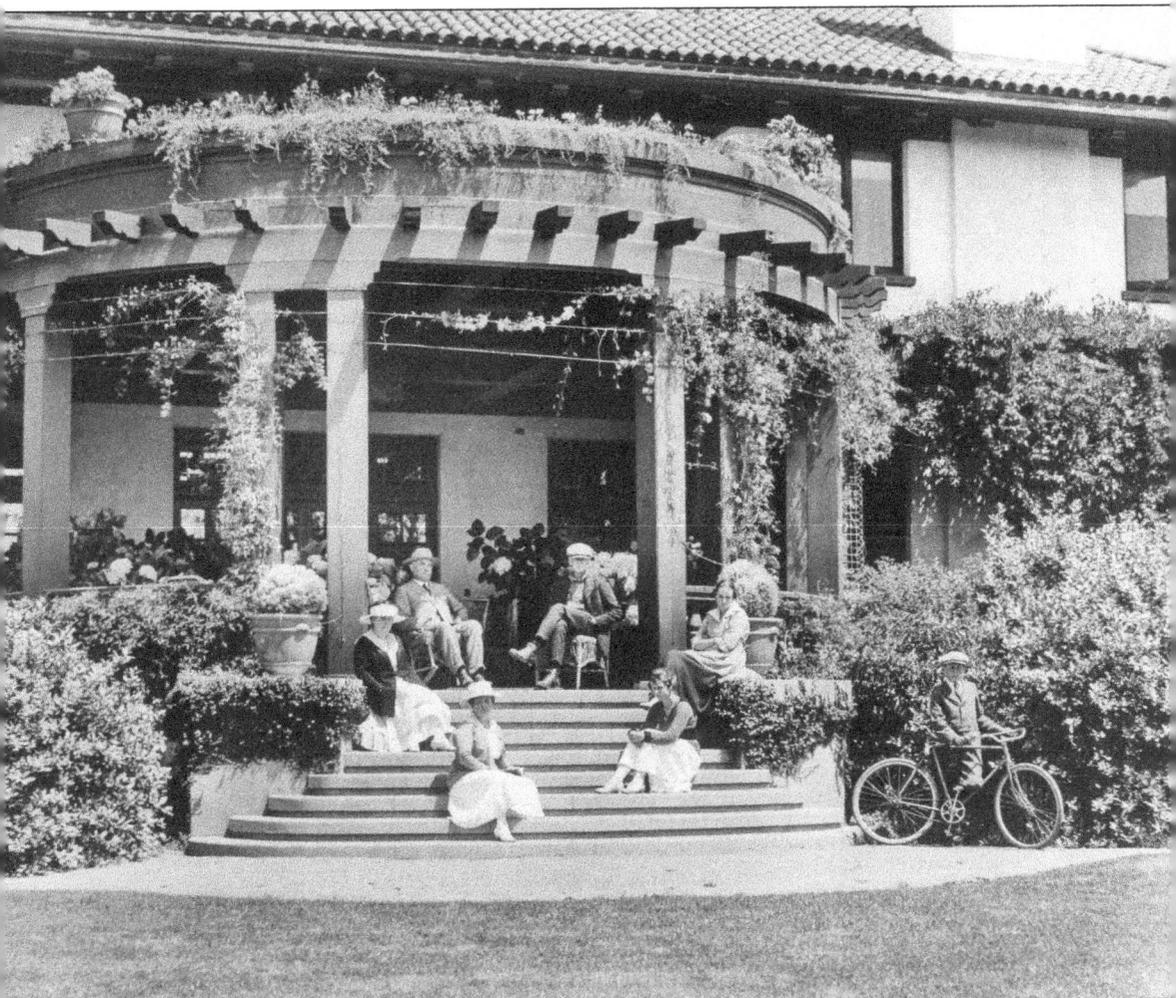

The grounds adjacent to the house were landscaped extensively, and the stream in Porter Gulch was diverted to create a chain of two lakes connected by a waterfall and used as reflecting pools. The downstairs had an Oriental theme, while the upstairs was more of an English country style. William died in June 1929, and Mary died just six months later in January 1930. The Sesnon family spent less and less time at Piño Alto and, eventually, decided to sell the mansion. For the next 30 years, the Salesian brothers and then the Salesian sisters occupied the grounds. The sisters ran a girls' school there until 1974, when Cabrillo College acquired the home and adjoining land. Interestingly, the house is located on the west side of Borregas Gulch, which means it is technically in the town of Soquel, but when Cabrillo College purchased the property it became part of the Aptos zip code. (Courtesy of the Porter Sesnon family.)

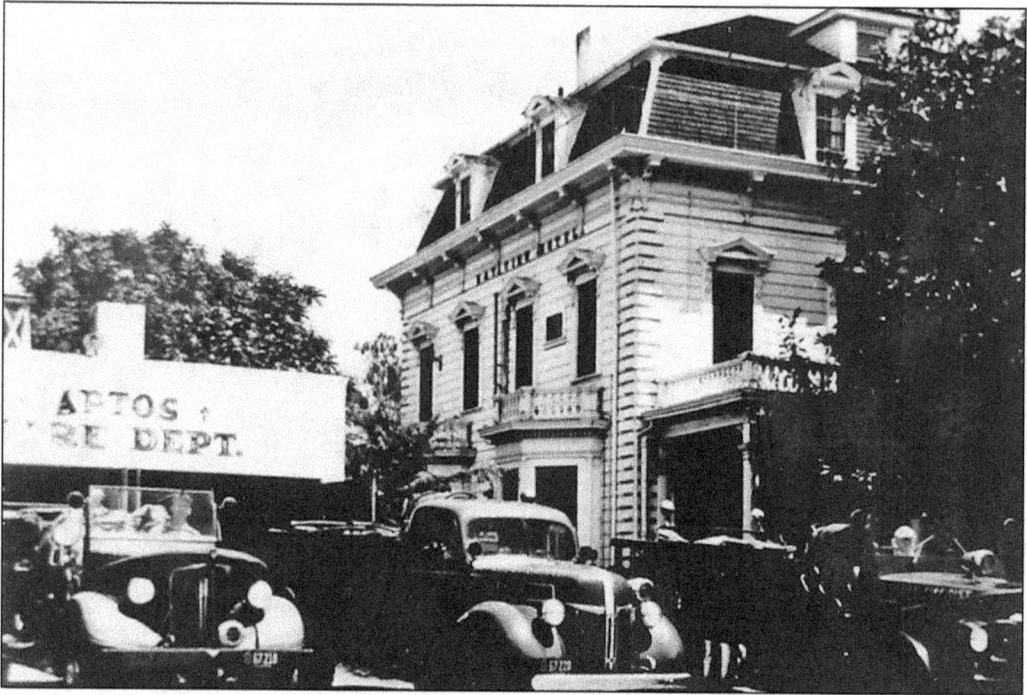

The fire equipment storage building for the Aptos Volunteer Fire Department was offered by Joseph Arano, owner of the Bay View Hotel next door, who leased the building's land from Southern Pacific Railroad. It was originally constructed as an office for the Loma Prieta Lumber Company in 1888. The Aptos Volunteer Fire Department became the Aptos Fire Protection District in 1930, and continued to use the building until 1952, when the station moved to Aptos Street. (Courtesy of Ralph Mattison.)

The Aptos Fire Station, located at 8059 Aptos Street, was constructed in 1952 on the former site of the Ocean House Hotel and Menefee's grocery store. The new three-stall firehouse served the community until 1971, when it was deemed too small. Since that time it has been remodeled to serve a variety of retail uses. Most recently, it has been the home of Aptos Street BBQ (formerly Coles BBQ). (Courtesy of Ralph Mattison.)

Before there was an official fire department in Aptos, there was a big fire bell in the middle of the village that would call volunteers to a fire. The equipment available was minimal. There were just a few lengths of one-and-a-half-inch hose kept coiled up in front of Van Kaathoven's Red & White store, and three hydrants in town. After a few bad fires in 1921, the first fire truck was acquired, a Locomobile chassis from Cunnison brothers in Soquel, to which a body and two big chemical tanks were added. There was no way to carry or pump water, so firefighting was successful only if the fire was reached within the first few minutes after it started. If a fire were successfully extinguished, the volunteers would ask for a donation, which helped pay off the first fire truck within one year.

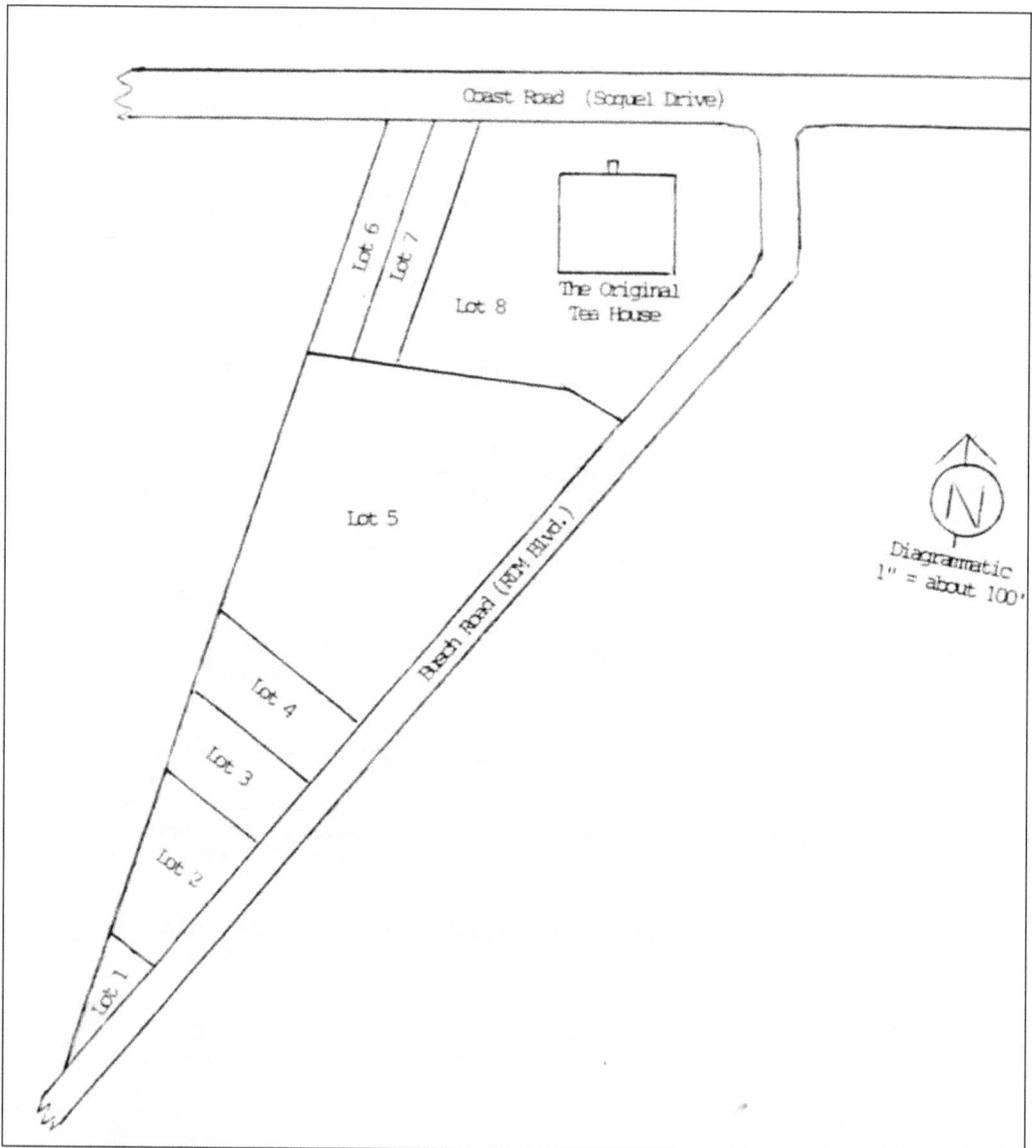

Coast Road (Soquel Drive)

Lot 6
Lot 7
Lot 8
The Original Tea House

Lot 5

Beach Road (RDM Blvd.)

Lot 4

Lot 3

Lot 2

Lot 1

N

Diagrammatic
1" = about 100'

In 1872, Claus Spreckels purchased a large portion of Rancho Aptos from Rafael Castro and built a home for his ranch manager Peter Larsen. This home became known as the Company House. After Spreckels's passing in 1908, Larsen moved out and the Company House switched hands a few times until 1924, when it was sold to George Humes. Humes's sister Harriet "Hattie" Sweet remodeled the house and established the Deer Park Teahouse. While the teahouse may have initially served tea and dainty food, it became popular for its bar, heavy food, gambling, and ladies of the evening. Since this all took place during Prohibition (1920–1933), the title "teahouse" was a clever tactic for hiding its true business activities. In 1926, the teahouse was sold to residential developers Monroe, Lyon & Miller, who were developing Rio Del Mar. They changed the name to Deer Park Cavern. The word "cavern" was chosen because, during Prohibition, names such as "tavern," "bar," or "saloon" was forbidden.

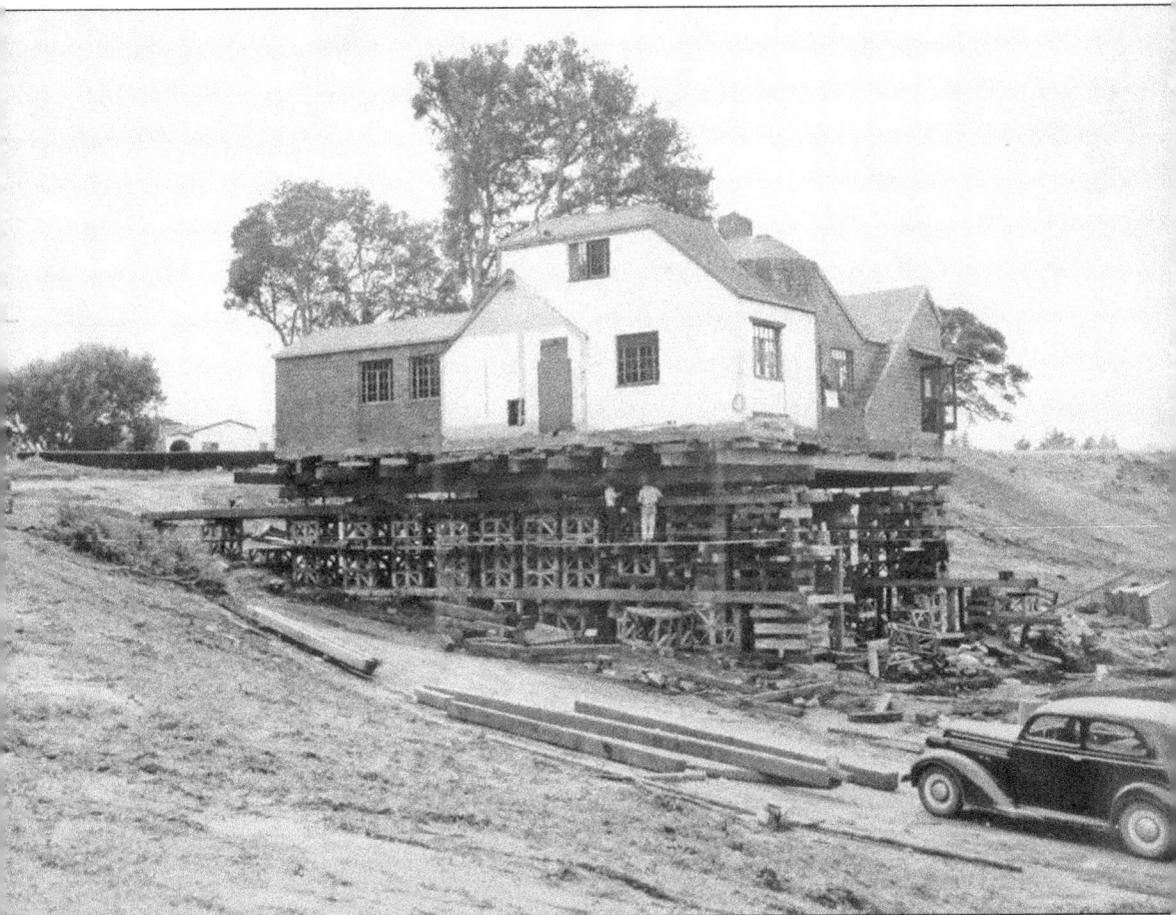

Prohibition was repealed, and again the business changed hands a number of times before Nicholas "Shorty" Butriza became full owner in 1945. By then, the name had changed to Deer Park Tavern, and the original Company House had either been torn or burned down in 1934, being replaced with a more appropriate one-story, concrete-block building on the site. In 1947, the state was set to build a new highway right through the tavern's property. Rather than tear down the building, Shorty decided to move it to a new site atop the ridge to the south after purchasing 4.5 acres of land from Amelia Arano. In 1948, the tavern was jacked up another 10 feet and moved horizontally over and over again until it reached the top of the hill. The tavern was back in business for the summer of 1948. In 1954, after Amelia Arano passed away, Shorty inherited the half-acre site and historic barn where Amelia Arano had once lived.

In 1968, armed robbers broke into Shorty's small home next to the tavern, beat him, taped his mouth, bound his hands and feet, and ransacked both his home and the tavern. By the time he was found, circulation problems had set in, and these injuries plagued him for the rest of his life. Shorty's lifelong friend and hunting companion Peter Copriviza volunteered to oversee the tavern's business operations. In 1972, there was talk of a new, major shopping center to be built nearby, and the construction worried Shorty, adding to his failing health. Shorty Butriza died on March 20, 1975, at 80 years old. He never married. About 90 percent of his estate, including the tavern, was left to Peter Copriviza. That same year, the county permitted the Deer Park Shopping Center to begin construction. Anticipating years of heavy construction and knowing Shorty's wishes, Copriviza decided to stage one last New Year's Eve extravaganza (Shorty was famous for his New Year's Eve parties) and close the doors.

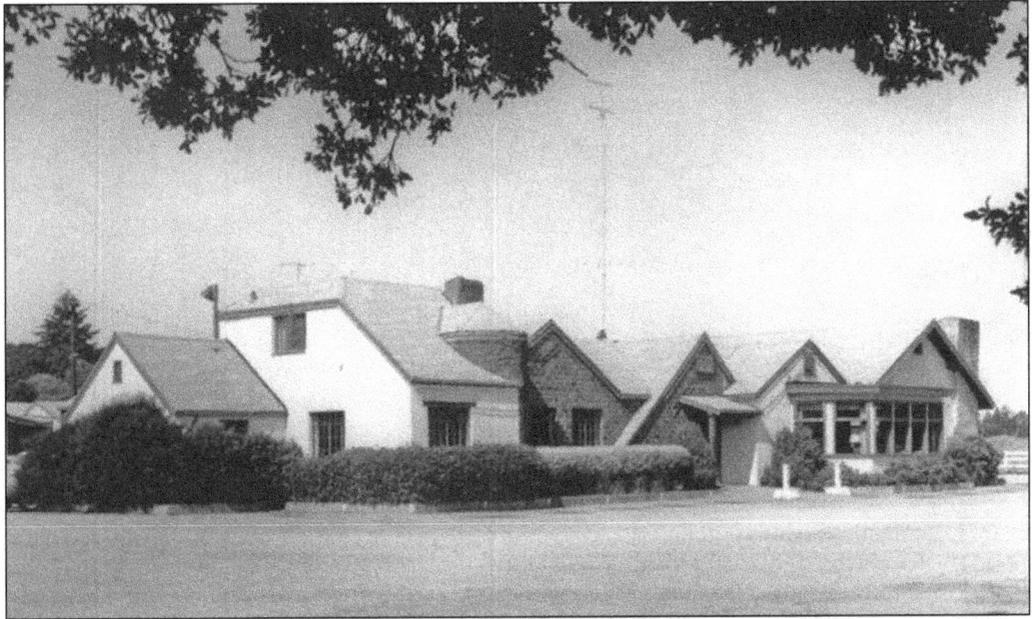

In 1976, Peter Copriviza sold all of his Deer Park properties to the Carl N. Swenson Company, the developer of the new shopping center. In 1978, the Deer Park Shopping Center was completed, and the Swenson Company deeded the Deer Park Tavern to Alfred and Robert Castagnola. The tavern was in need of renovation, so the brothers refurbished it by expanding and modernizing the kitchen, sandblasting and painting the walls, renewing the plumbing and electrical systems, and adding new carpeting. They leased the property to Greg Dunn and Frank Capriotti, who staged an invitational cocktail party for about 1,000 old-time tavern customers on November 3, 1979. Dunn and Capriotti operated the tavern until 1987. Since then, the owner has changed many times, but the place still operates as a restaurant and bar.

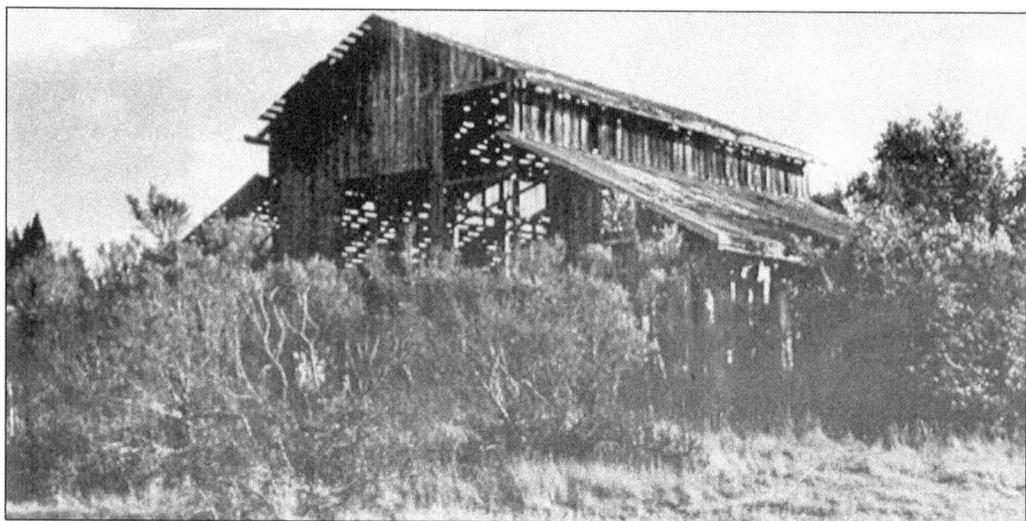

In 1871, Benjamin Nichols purchased 120 acres of farmland from Rafael Castro. He built a barn along the Coast Road (Soquel Drive), which is still visible from today's Highway 1. William H. Dawson acquired the farm from Nichols in 1897. Dawson was a single man who became terminally ill with cancer. He passed away in 1904 and bequeathed his land to the two women who cared for him while he was ill, Clara Walsh, who worked at her uncle's Live Oak House, and Amelia Arano, who ran the Bay View Hotel, which was built by her parents. The farmland was divided in half, and Amelia ended up with the barn along with 54.4 acres of land. She converted the west bay of her barn into her living quarters. She moved out in 1950 to take care of her brother after a highway accident left him critically injured. Amelia died on June 29, 1954, in her brother's house, at the age of 91. She never married or had any children. Today, as pictured below, a replication of the barn's frame can be seen as part of the upper Deer Park shopping center.

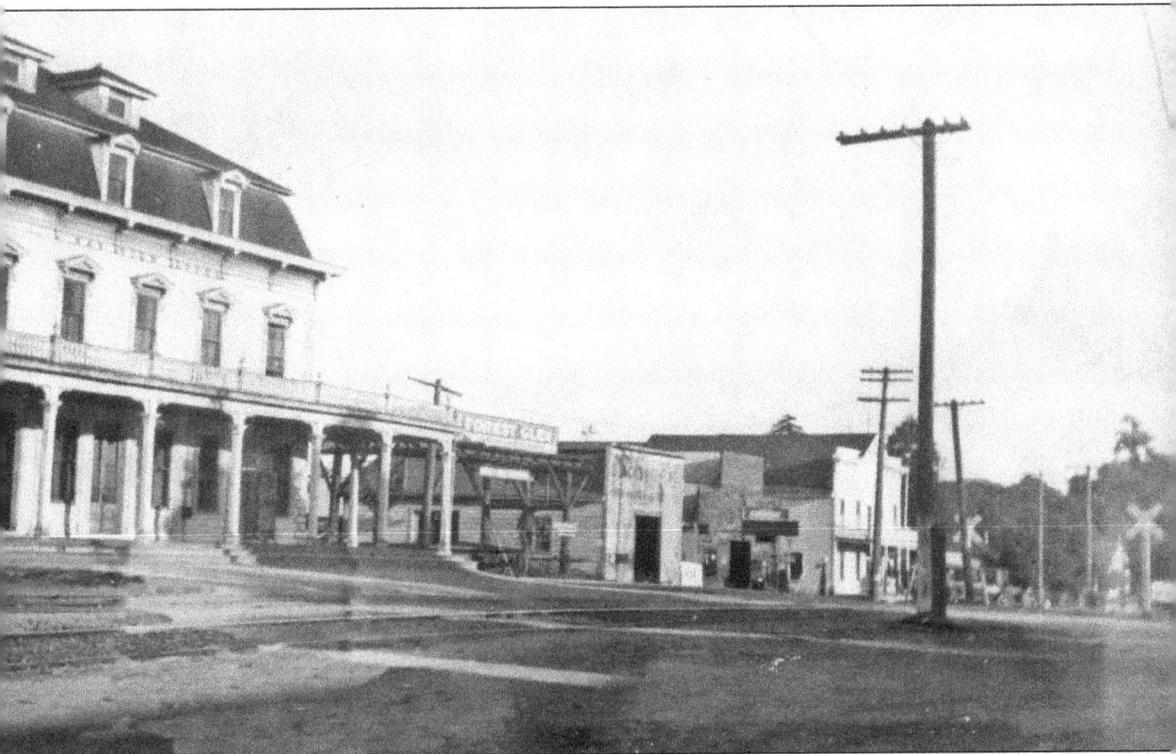

Forest Glen was a real estate development project that began in 1924. The entrance to Forest Glen was off Trout Gulch, as seen here with the Bay View Hotel on the left and the blacksmith shop and Ocean House on the right. Trout Gulch and Valencia Roads bordered the timbered bungalow and cabin sites on either side, with a mountain stream running through the property mostly parallel to the roadways. When Claus Spreckels died in 1908 followed by his wife in 1910, their family trust known as the San Christina Investment Company managed their land. Because the land was owned for leisurely purposes by Spreckels and not as a business venture, the trust decided to sell his entire land holdings in Aptos in 1922, thus ending the Spreckels era. The purchaser, Fred Somers, who had already been successful in real estate ventures, formed the Aptos Company to become directly involved in development projects. Before the sale of Spreckels's land was even official, Somers had negotiated the sale of 411 acres, some of which would become Forest Glen.

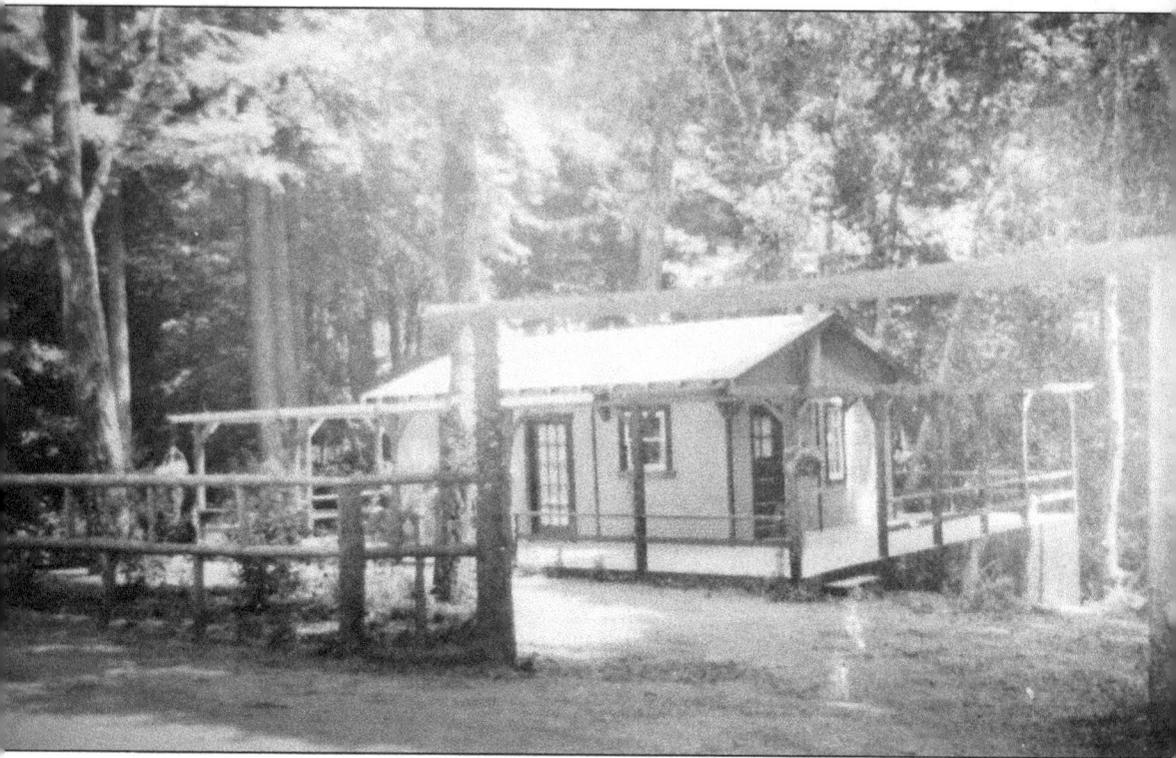

The *Santa Cruz News* reported on May 29, 1924, that Mr. Gingg of San Jose had purchased the land on Trout Gulch Road to build a summer home on part of the property. The remainder of the land would be subdivided for cottages. The development, initially known as Forest Park, changed its name to Forest Glen with no explanation as to why the change was made. On June 15, 1924, the first day that the 112 lots on the tract were made available for purchase, nine lots were reported sold. One writer boasted that never again could Aptos be called a "sleepy village," which is what a San Francisco reporter had written some years before. Another article said Aptos was now "on the map" and intended to remain there. Today, most of the cabins have been modified and modernized. The bridge over Valencia Creek is long gone and so is the entrance sign over Trout Gulch Road. While Forest Glen was a major player in the development of Aptos, it remains today as only a memory.

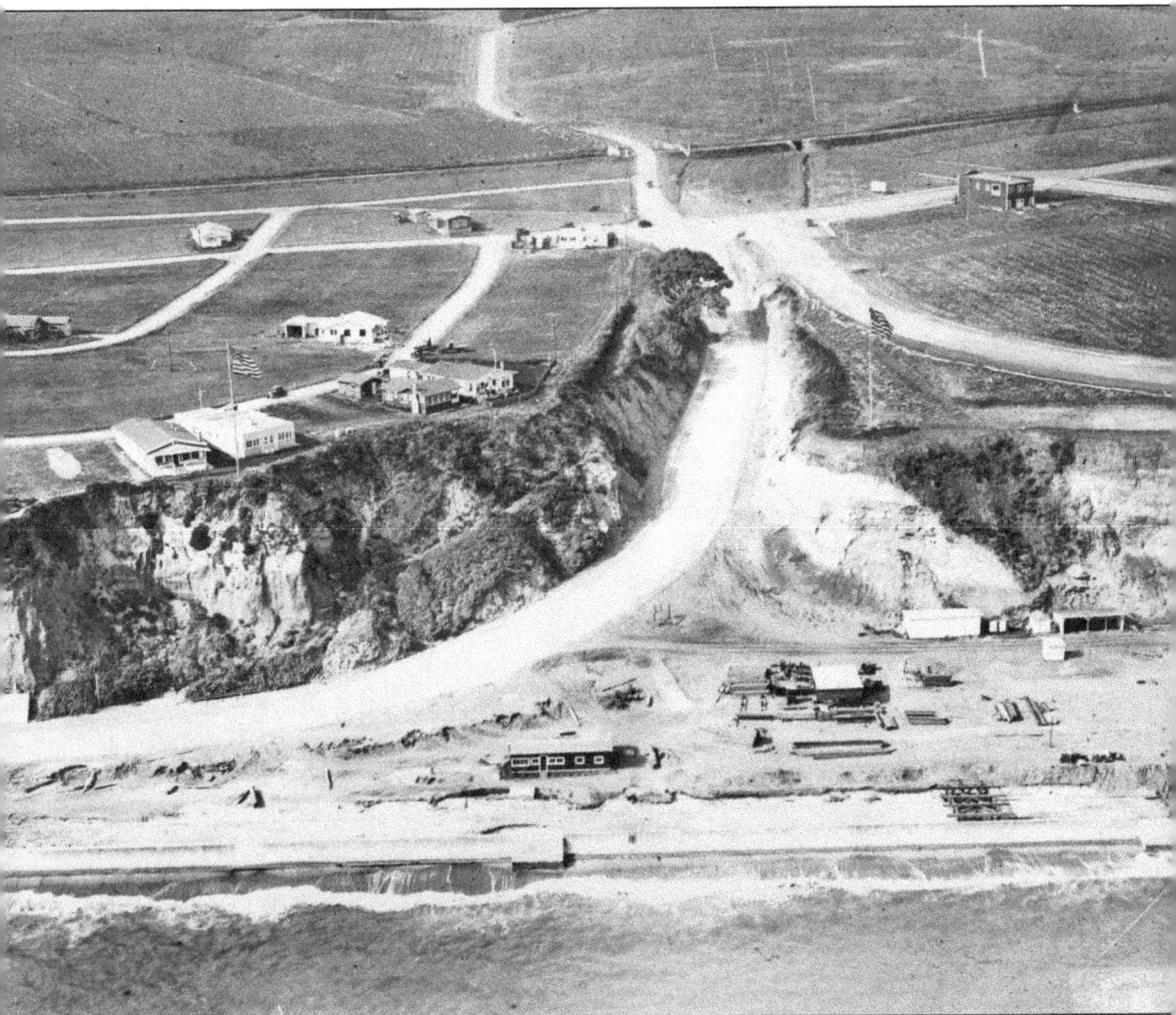

The land encompassing Seacliff State Beach was originally granted to Rafael Castro in 1833. At the mouth of Aptos Creek, Castro constructed the town's first wharf, which served as an important early Monterey Bay shipping point. Claus Spreckels, founder of the Spreckels Sugar Company, was attracted to the area for its agricultural potential and pleasant atmosphere. In 1872, Spreckels purchased 2,390 acres from Castro, including today's Seacliff Beach area. It was during this period that the fields in back of the present-day Seacliff Beach were devoted to sugar beet crops. Winter storms repeatedly destroyed any structure built on the beach, including most of the buildings pictured here.

Spreckels passed away in 1908, and the remainder of his Aptos property, including the present-day Seacliff Beach, was sold in 1922. The land holdings in this area remained mostly intact and undisturbed until 1925, when they became part of a commercial subdivision called Seacliff Park. A road that ran down to the beach just north of Aptos Creek was constructed, and development begun. In 1929, the Cal-Neva Stock Company purchased 500 feet of beachfront from George Hume, who had purchased property in the new Seacliff Park subdivision. It was this investment group that purchased the SS *Palo Alto* (the cement ship) in 1930 and had it towed to Seacliff. Cal-Neva constructed a pier out to the ship, which was gutted and renovated as an amusement center featuring the Rainbow Ballroom, a swimming pool, dining room, and restaurant known as the Ship's Café and Fish Restaurant.

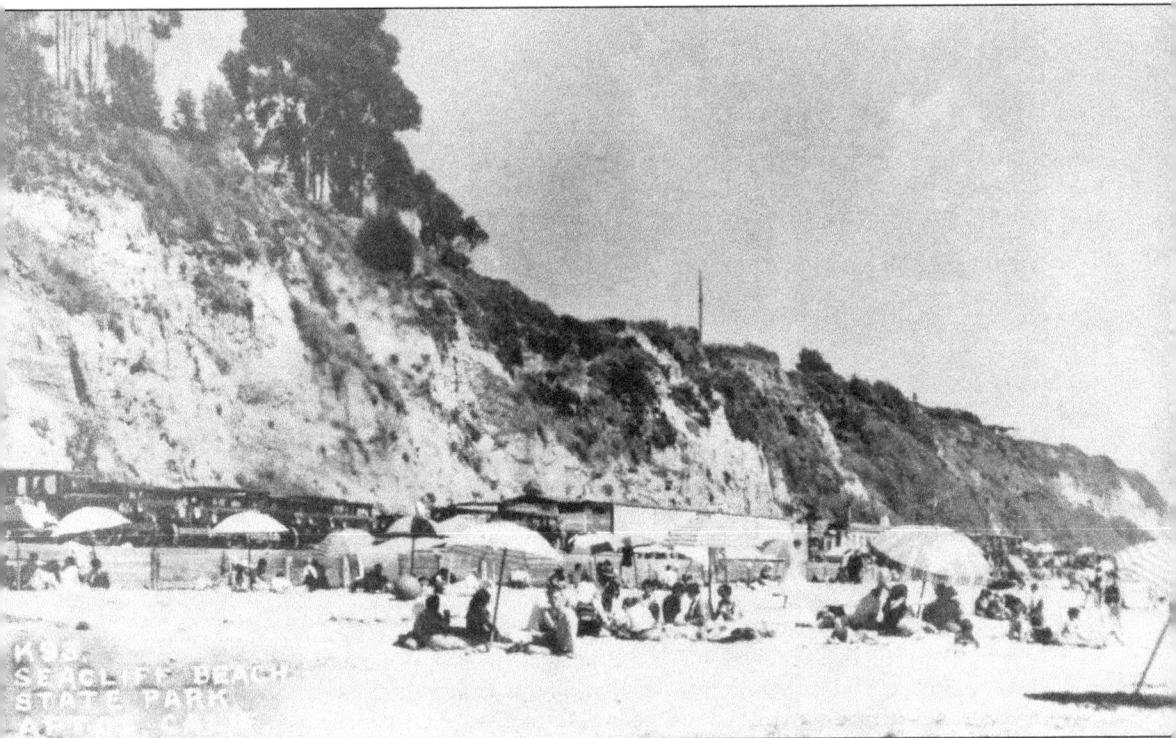

In 1931, a 26.97-acre parcel of land was sold to the state of California, which included beachfront property north of the pier and Seacliff Park subdivision lots east of the beach, thus establishing one of the earliest state beach units in California. In 1932, Cal-Neva went bankrupt, ending the *Palo Alto*'s stint as an amusement center; shortly after, a winter storm cracked the vessel. California State Parks negotiated a deal to purchase the ship from the bankrupt company for $1 in 1936. During the 1930s, the Civilian Conservation Corps helped develop Seacliff State Beach. The original ranger's office, the current visitor's center, was constructed in the 1940s and remodeled and expanded in 1987 to include a larger exhibit space. Today, Seacliff Beach remains the property of the California State Parks and is a popular place for both locals and visitors. The *Palo Alto* is no longer accessible but is still a well-known landmark that leaves many curious gazers wondering about its history. The pier, however, is still accessible and is a resource for fishermen of all skill levels.

67

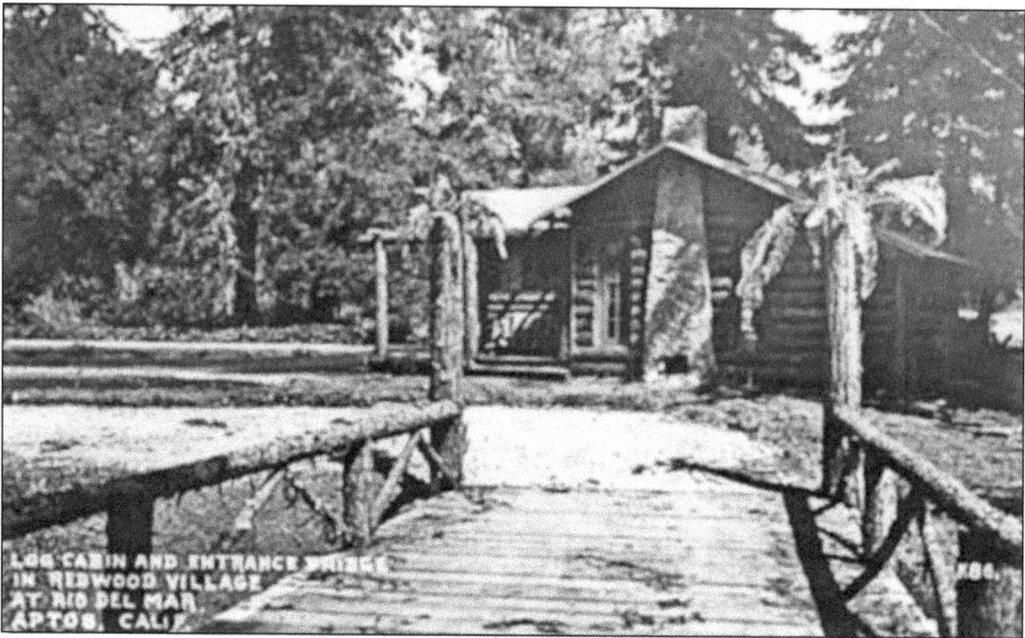

Raymond Parker built Redwood Village, originally called the Redwood Village Lodge, in 1928. Its location within a grove of coastal redwood trees is the former site of Claus Spreckels's stables. The redwood grove was thinned, and the timber was milled to construct the cottages. Parker designed his motel using a unique vernacular design with each cabin hand crafted and designed to fit into the redwood grove. A center gazebo was used for dancing. The motel was a popular place until after World War II when it began experiencing a decline in users. Parker died in 1939, and his widow, Mabel, sold the property in 1940.

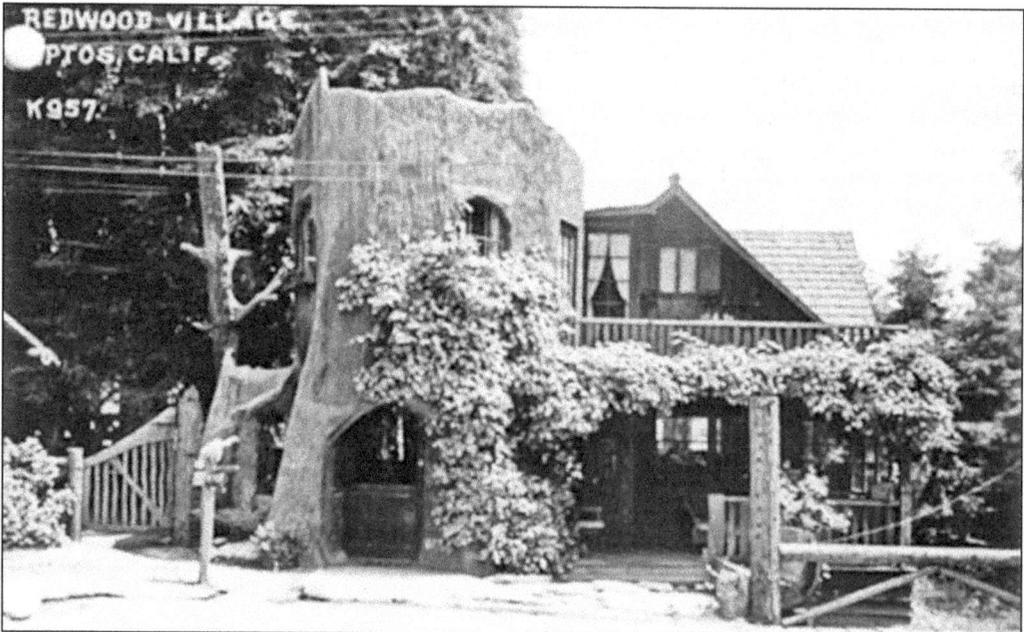

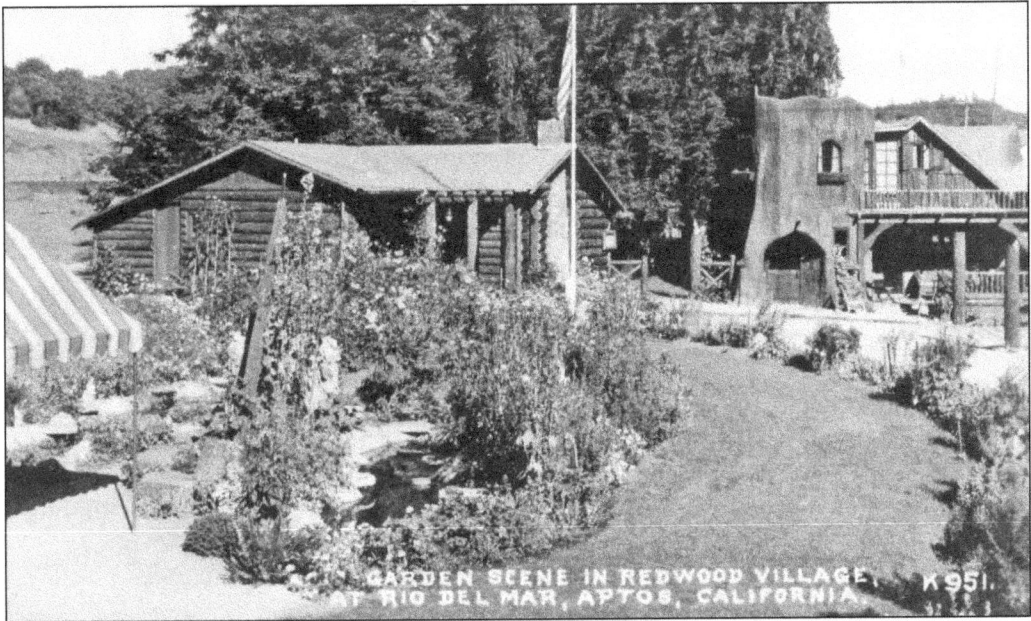

GARDEN SCENE IN REDWOOD VILLAGE, AT RIO DEL MAR, APTOS, CALIFORNIA. K951.

In 1974, the motel was abandoned in favor of a retail use that put 15 independent businesses into the cottages. In addition to creating the only such vernacular shopping center in the county, 1974 was also the year the bridge over Aptos Creek was capped. The covered bridge, which is just short of 90 feet long, connects one end of Redwood Village to Soquel Drive. It was originally used as an entrance to the village. Throughout the years, the bridge has been used for antique shows and special events. Today, the bridge is no longer open to vehicle traffic, but one can still walk across it.

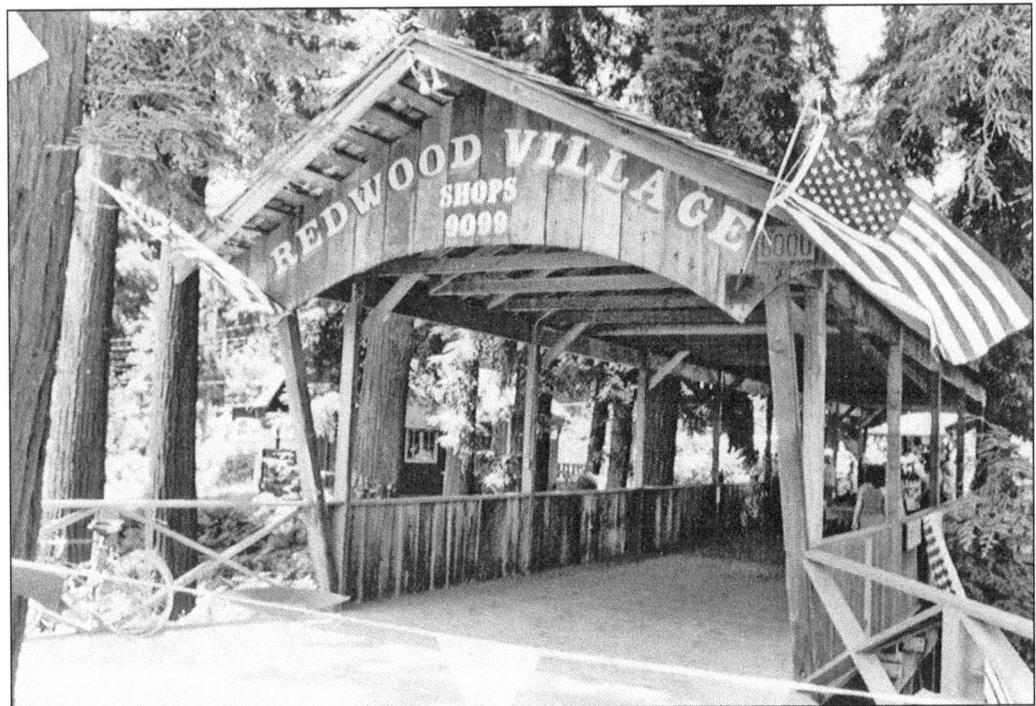

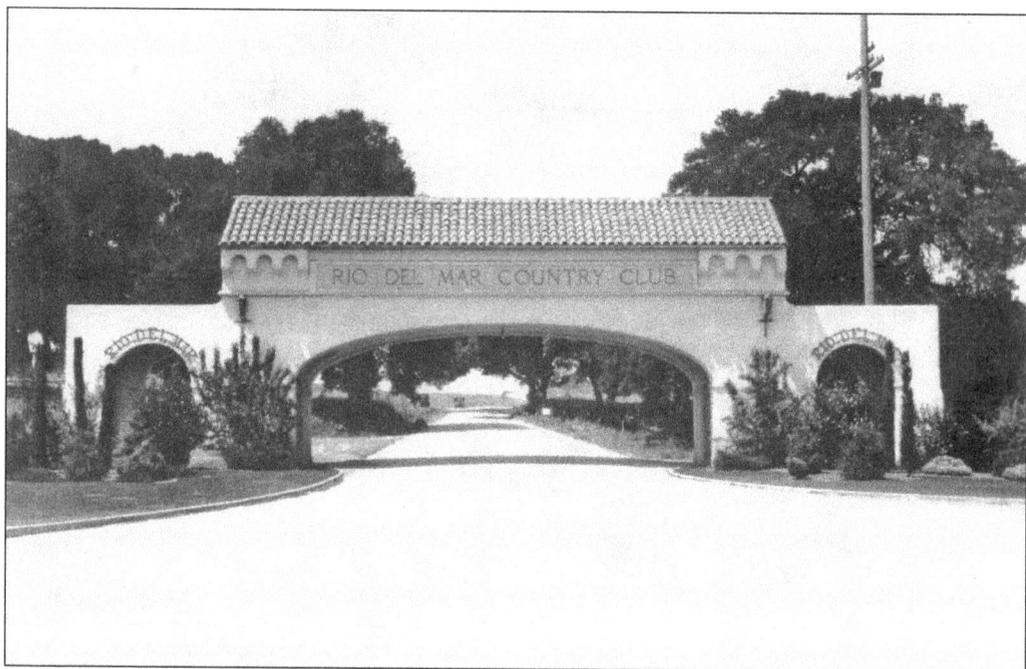

This gateway was located over Rio Del Mar Boulevard at Soquel Drive, right about where the highway overpass is today. It was the main entrance to the Rio Del Mar Country Club. It was built in the late 1920s and torn down around 1947 to accommodate the construction of Highway 1. At the bottom of the hill, just before approaching the gateway, was the office of the Peninsula Properties Company, run by Monroe, Lyon & Miller. The Peninsula Properties Company, pictured on the right below, agreed to purchase 820 acres from the Aptos Company in 1924 and is responsible for the development and naming of Rio Del Mar.

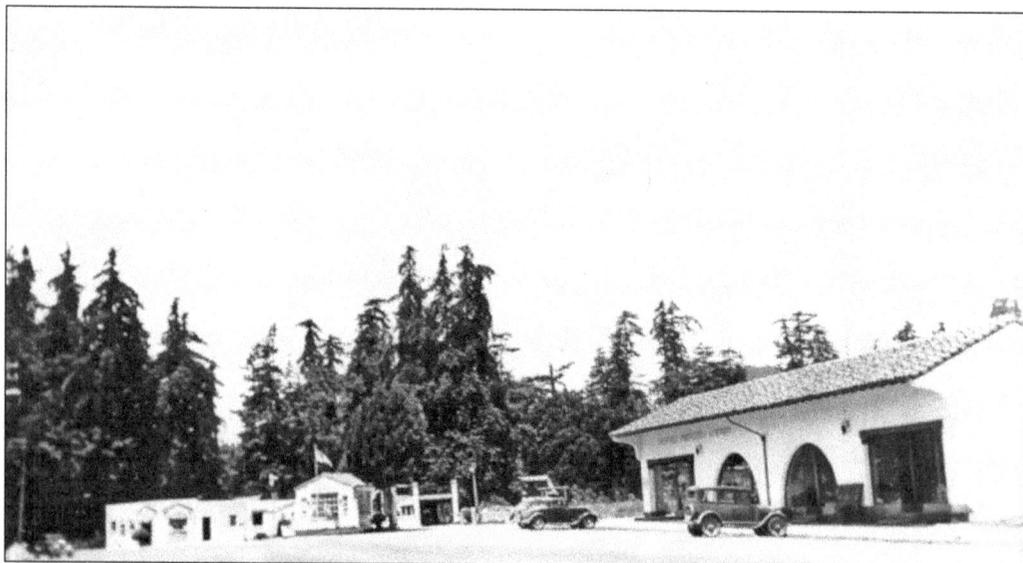

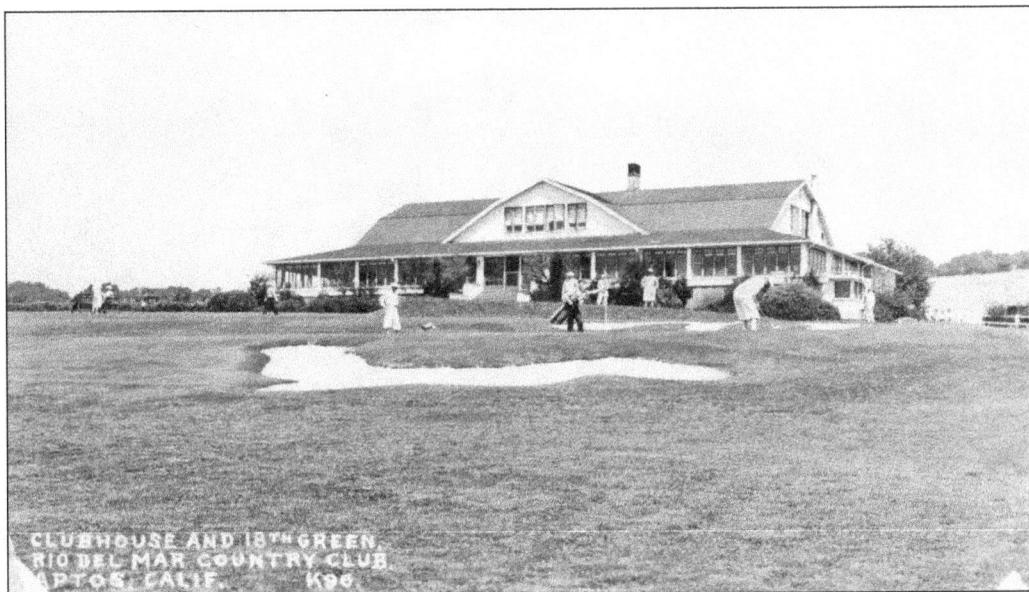

CLUBHOUSE AND 18TH GREEN,
RIO DEL MAR COUNTRY CLUB,
APTOS, CALIF.        K96.

The Aptos Beach Country Club's golf course was laid out in 1925. Its designer, Willie Lock, was a professional golfer who played in the 1921 National Open Championship and supposedly invented the nine-iron. The holes on the front nine were very much as they are today, but all of them, except one, played much longer. Today, the holes on the back nine are quite different than they were back then.

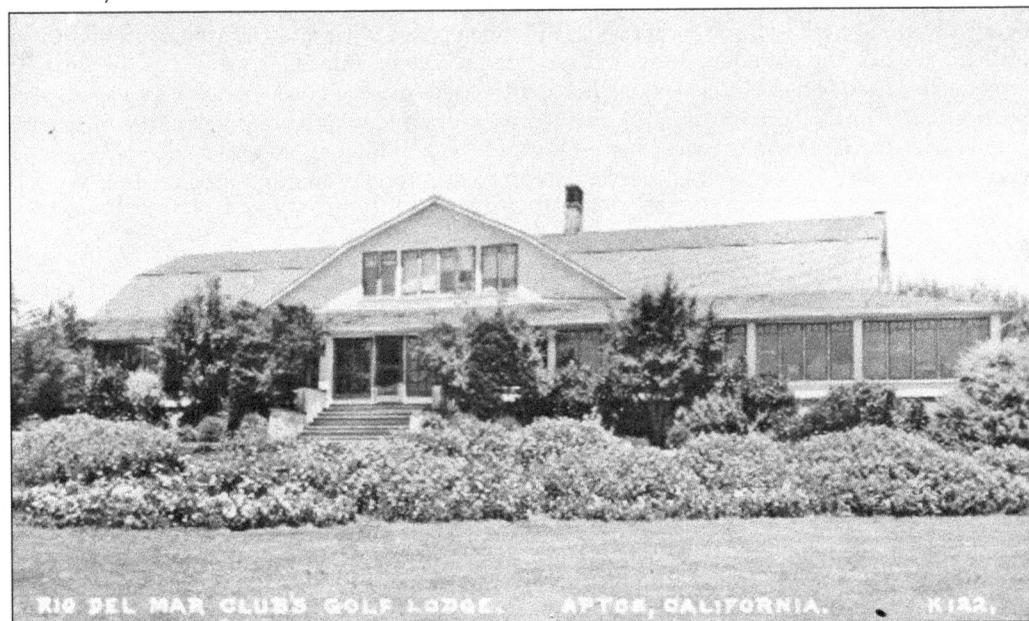

RIO DEL MAR CLUB'S GOLF LODGE.        APTOS, CALIFORNIA.        K182.

The Golf Lodge was originally used for potential property owners to stay in while in town. In 1935, the lodge was refurbished and featured new cast-iron and wrought-iron fixtures and lamps by famous Santa Cruz artist "Otar the Lampmaker." Beginning in the fall of 1942 and ending in the summer of 1957, the golf course was decommissioned. During the World War II years, it became a vegetable garden, planted mostly in corn. The lodge became a housing unit for the Army officers who were stationed at Ford Ord and Camp McQuaide.

71

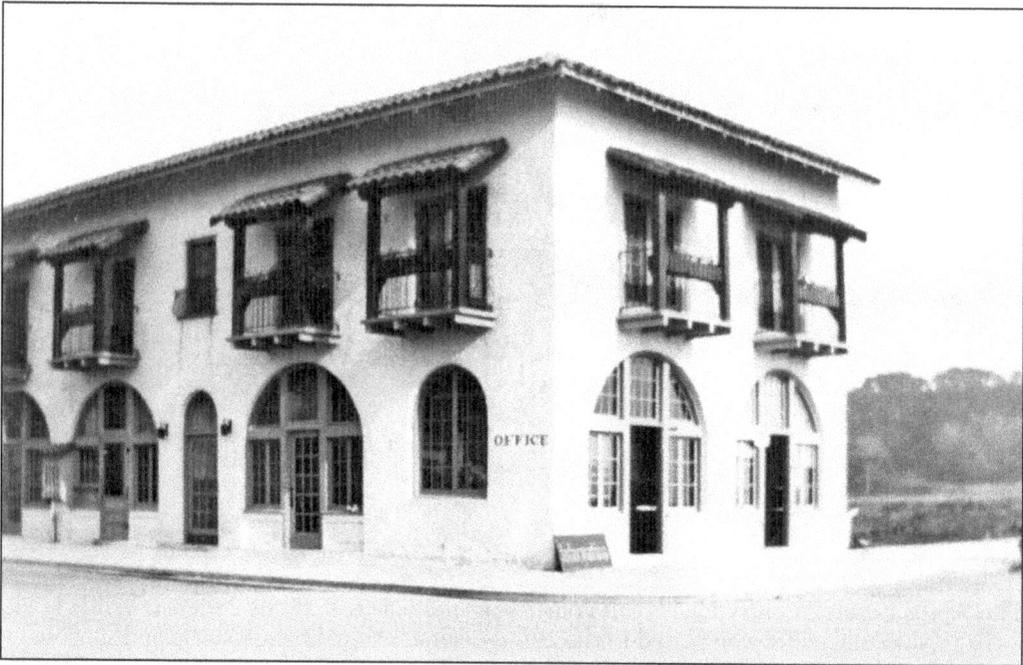

A.A. Liederbach erected the Sea Breeze Building in 1926. It was the first to be built in the Rio Del Mar flats. It was the first sales office for the Rio Del Mar Company and has a long history as an apartment house, bathhouse, restaurant, and tavern. One of its most interesting owners, Georgia Derber, purchased the property in 1973. She opened a bar and ran a successful business until 1988, when she closed its doors and retreated to the upstairs apartment. For the next 16 years she lived as a recluse, rarely leaving her apartment as the rest of the building sat vacant and deteriorating. She died on June 8, 2004. She was an only child with no children of her own. The County of Santa Cruz administered her estate, and the building was sold to its current owners, who, in September 2007, reopened the Sea Breeze as a bar and restaurant, pictured below.

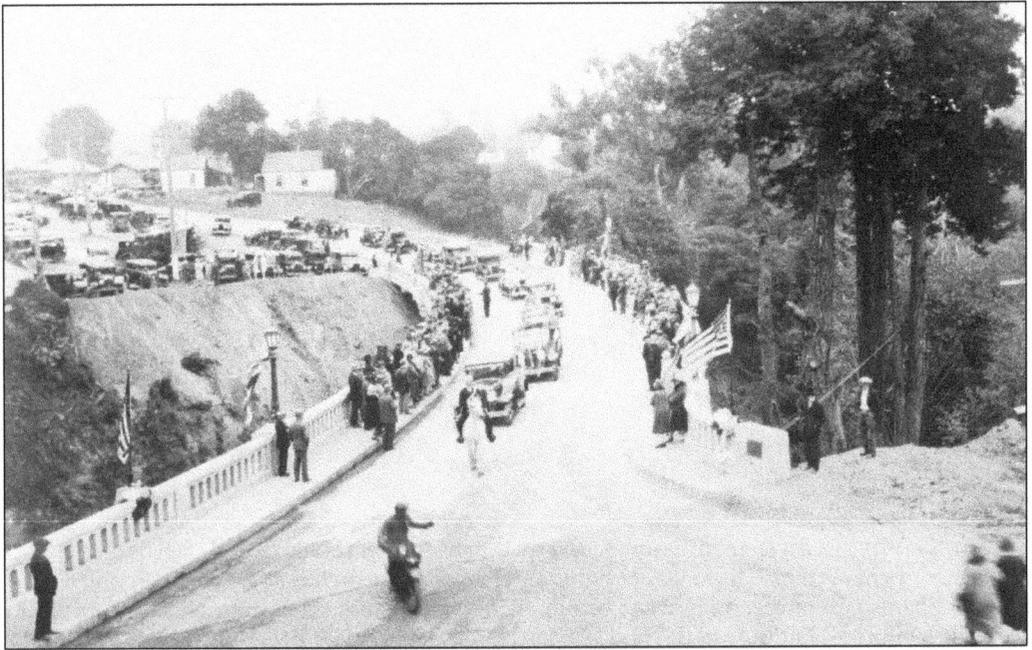

The first bridge over Aptos Creek was built in 1860 and was washed out in the flood of 1862. It was eventually replaced by a bridge that no longer stands today, but whose abutments can still be seen in Aptos Creek. In the 1920s, as automobiles began replacing the horse-drawn wagons, there were so many accidents on the first turn of the bridge that it was known as "death curve." On May 17, 1929, a new concrete bridge was officially dedicated. Two men representing opposite ends of Santa Cruz County met in the middle and shook hands. A bottle of nonalcoholic sparkling apple cider was used in the ceremony, as Prohibition was still in effect. (Above, courtesy of Paul Johnston; below, courtesy of Vincent T. Leonard.)

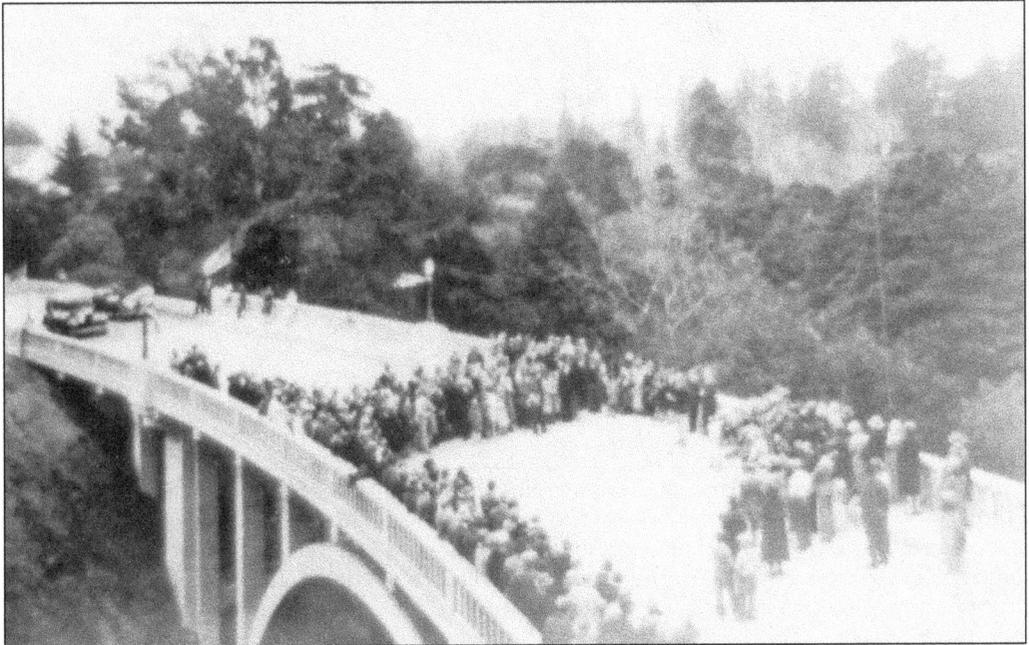

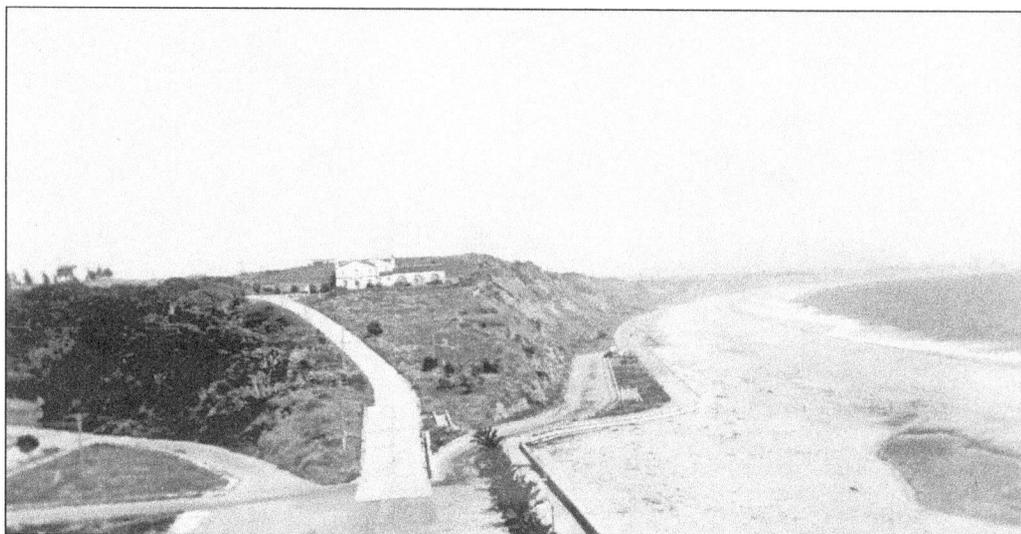

On May 1, 1929, just seven months after construction began, the Hotel Don Rafael de Castro was completed. Benjamin D. McDougal of San Francisco was the architect for the 22-room, stucco hotel of Spanish architecture. It would be renamed four different times during its existence: Rio Del Mar Country Club Inn, 1931; Rio Del Mar Hotel, 1946; Aptos Beach Inn, 1955; and Aptos Beach Inn and Racquet Club, 1962. (Courtesy of Paul Johnston.)

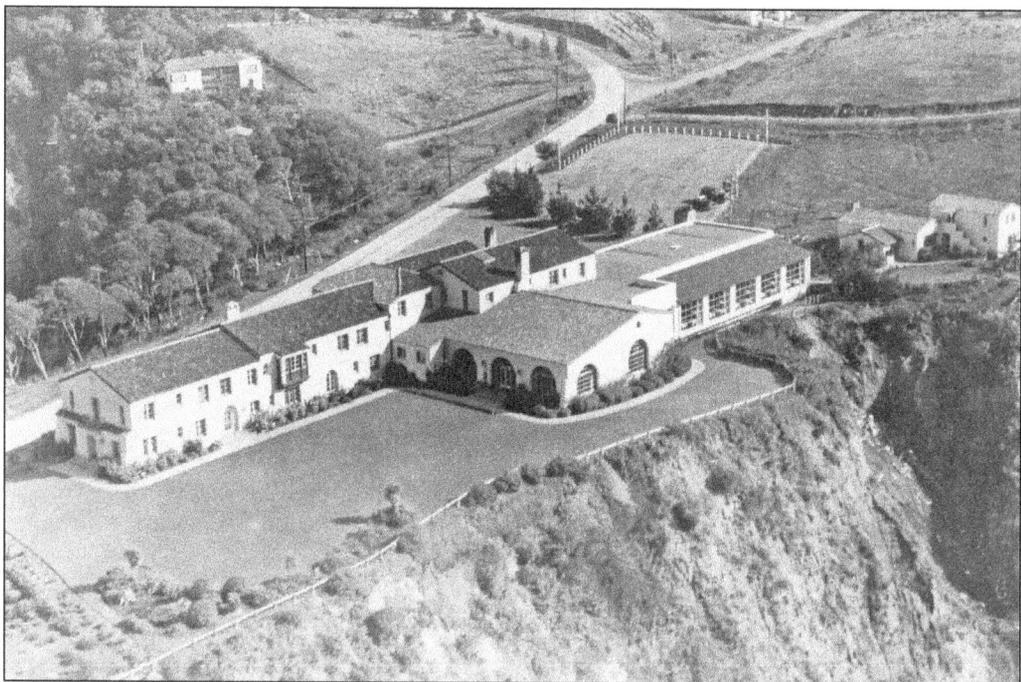

The hotel was a very popular spot. Lodging plus three meals cost $4.75 (increased to $5.50 in February 1937). For others, breakfast went to 75¢, lunch to $1, and dinner to $1.50. Well drinks and eastern beer were 35¢, and martinis and local beer cost 25¢. There was no cover charge for dancing. There were only 40 overnight accommodations at the hotel. Most of the units were privately owned second homes. The small house on the right was used as a gambling casino and still stands today as a private residence.

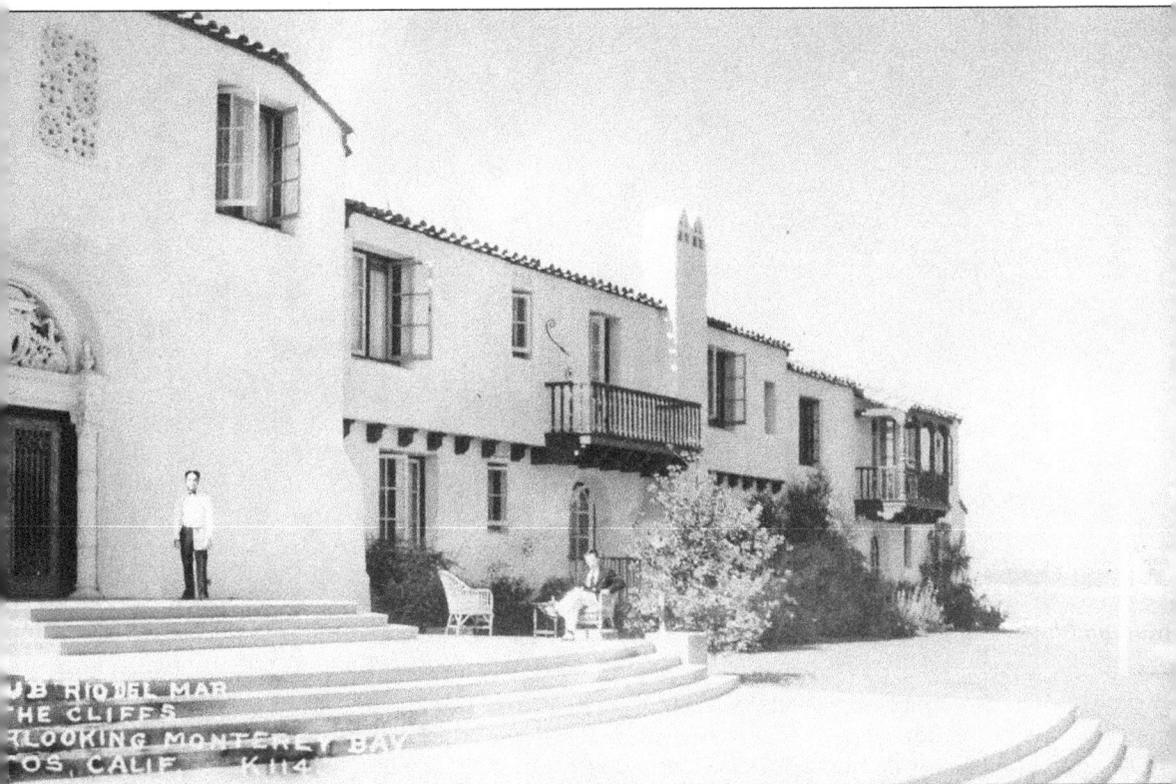

UB RIO DEL MAR
HE CLIFFS
LOOKING MONTEREY BAY
OS, CALIF.    K 114

When Japan launched its surprise attack against Pearl Harbor on December 7, 1941, World War II suddenly arrived on the west coast. The war effort intensified in Aptos. There were civilian defense organizations formed, "blackouts," and even air raid drills. The military organized a coastal patrol in the area and requested the Rio Del Mar Beach Club as a barracks for these men. During this time, access to automobiles, tires, and gasoline, along with other items such as food, clothes, appliances, and cigarettes for nonessential civilian use were reduced due to rationing. This had a severely negative effect on Rio Del Mar. The club unsuccessfully tried organizing ride groups and/or chartered bus excursions from urban areas around San Francisco Bay and other selected valley towns. The club also offered free limousine service from the Greyhound bus terminal in Santa Cruz. In its last bulletin mailed to members in May 1942, the club tried convincing people it was their patriotic duty to travel to their pleasure club and properties in Rio Del Mar in order to boost health and morale. This also did not work. In autumn 1942, it ceased to function as a club.

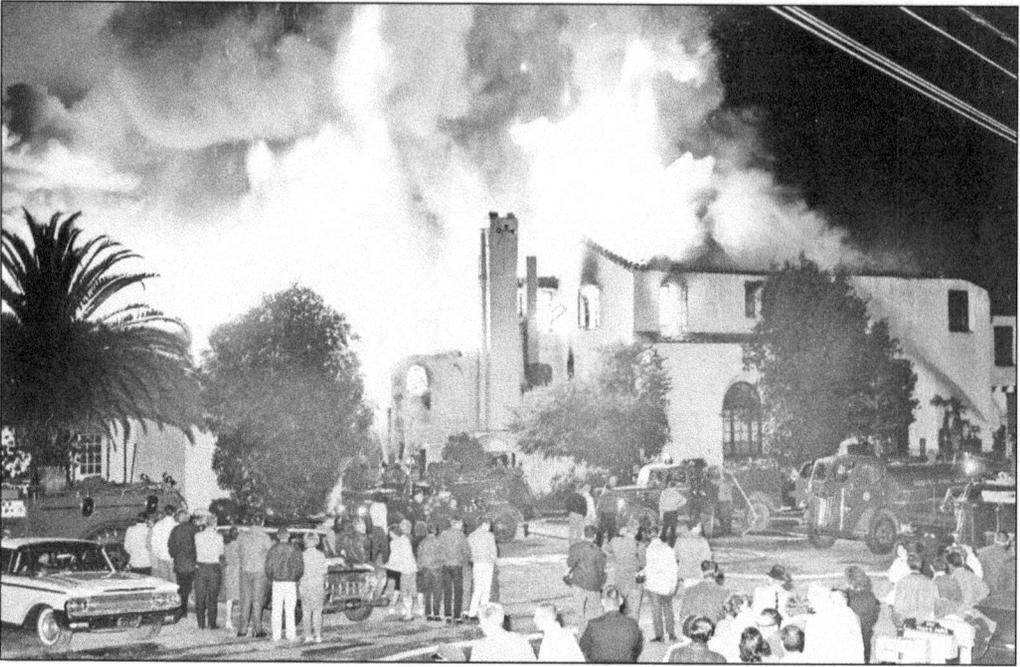

The club would reopen and close many more times until October 1962, when Pete Denevi negotiated a five-year lease agreement for the inn. He refurbished the hotel and planned to install shops, an "arcade," a swimming pool, and tennis courts on-site. It would operate as a private club named the Aptos Beach Inn Racquet Club. The reopening, which would prove to be the last, occurred in late November 1962, despite the arcade, swimming pool, and tennis courts never having been built. On the evening of March 17, 1963, during a dinner party for Coast Counties Gas employees, a grease fire broke out in the kitchen and the building burned to the ground. In October 1963, the site was cleared. The Aptos Beach Development Company sold the old hotel property in increments to the Shore Del Mar Developers Inc. of Half Moon Bay. It was this company that built the three tiers of condominiums overlooking the bay today (below). (Above, courtesy of Sam Vestal/*Register-Pajaronian*.)

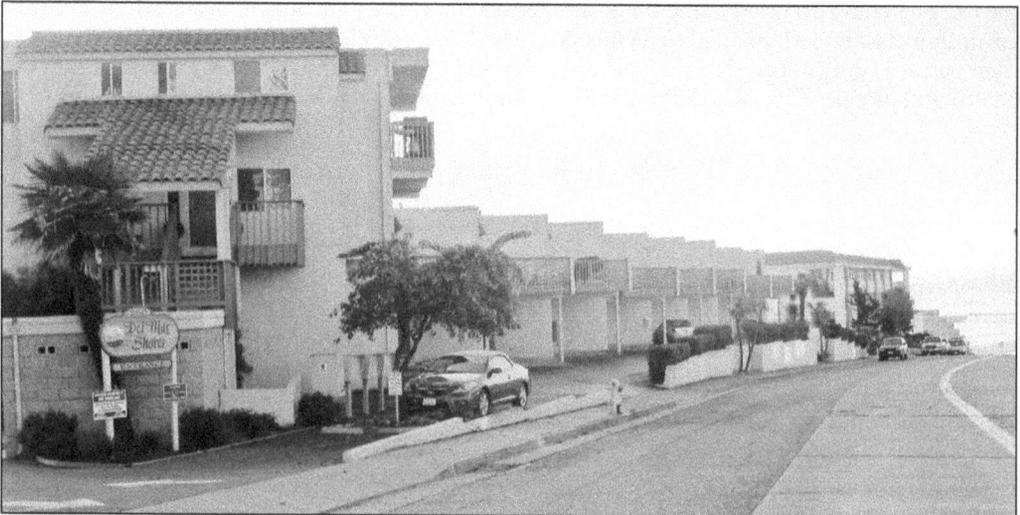

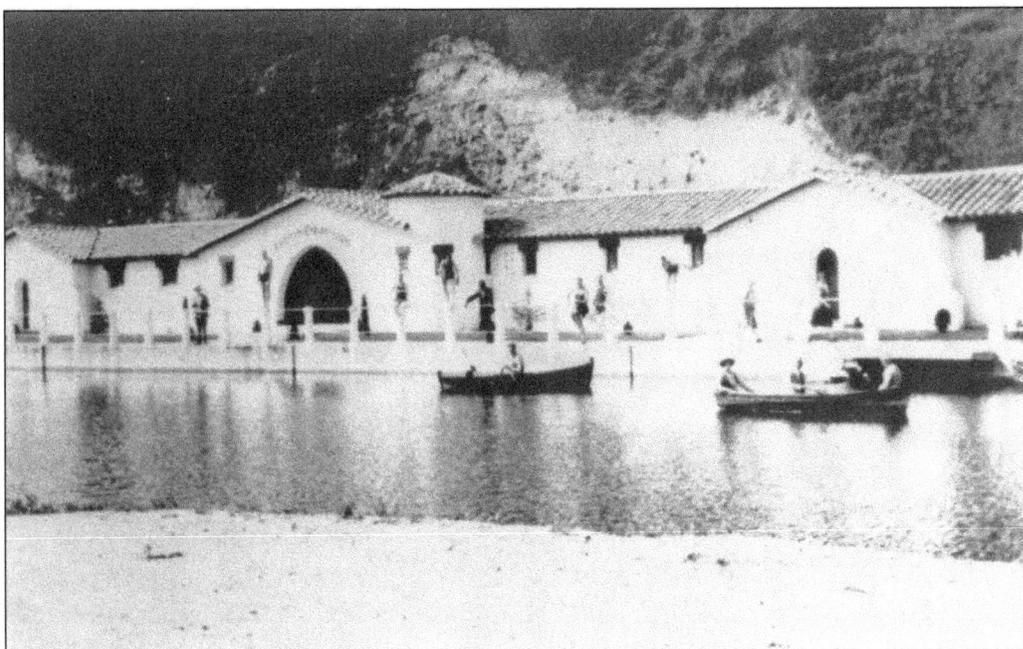

In March 1928, just upstream from the present-day pedestrian bridge at Rio Del Mar Beach, construction of a concrete dam and bathing pavilion began. The dam was built across the mouth of Aptos Creek, resulting in what was advertised as the "world's largest freshwater swimming pool." Alongside the creek the single-story, white stucco bathing pavilion was built. Some of the activities available at the pool were a floating diving platform sitting midstream, canoe rentals, and along the east wall (the wall closest to the Esplanade and today's Sea Breeze Tavern), a full-length set of steps and a handrail for those looking to rest or just hang out and watch the excitement. Pictured below is the site today. (Above, courtesy of Vincent T. Leonard.)

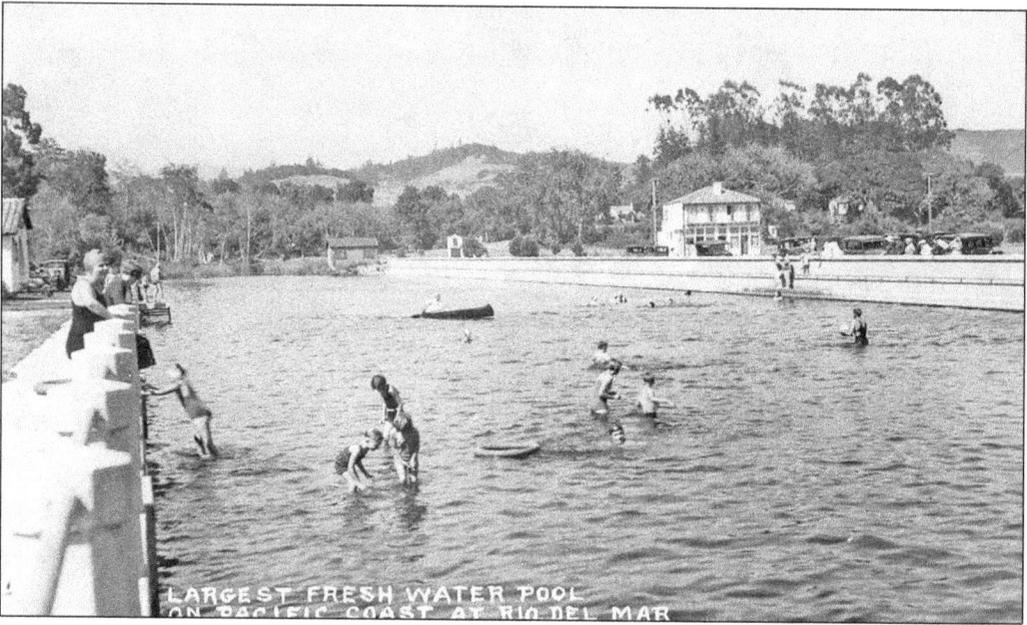

LARGEST FRESH WATER POOL
ON PACIFIC COAST AT RIO DEL MAR

The 1,000-person bathing pavilion, designed by Benjamin J. McDougall, was equipped with men's and women's locker rooms for showering and changing and a wind-protected patio for sun-bathing. During the winter of 1930–1931, a sea storm took out the dam, which was never replaced. The bathing pavilion, another victim of stormy weather and lack of tourism due to the Great Depression, was torn down in 1935. Today, the only remains of the once popular bathing facility are the broken footings of the old dam on the Seacliff side of the creek, two cantilevered diving platforms on the west retaining wall, and the steps and handrail built into the east retaining wall.

The SS *Palo Alto* was launched on Thursday, May 29, 1919, at the San Francisco Shipbuilding Company's yard on Government Island. The oil tanker was built with a 2,800-horsepower steam engine, bronze fittings, an 11-ton bronze propeller (15 feet in diameter), a 15-ton rudder, decks of white Norwegian ash, and a tile-floored galley. It had 14 watertight oil compartments with a total carrying capacity of three million gallons.

The SS *Palo Alto* is better known as the cement ship. There is just one little problem—it is not a cement ship—it is a concrete ship! The term cement is often confused with concrete, but cement actually refers to the material used to bind the aggregate materials of concrete. While "cement ship" rolls off the tongue a lot nicer than "concrete ship," it is technically an incorrect nickname. (Courtesy of California State Parks.)

San Francisco Shipbuilding Company

Superintendent for
United States Shipping Board
Emergency Fleet Corporation
Concrete Ship Section

Cordially invite you to witness

the launching of the

7500 ton Reinforced Concrete Ship

"Palo Alto"

Government Island, Oakland California

Thursday, May twenty-ninth

Nineteen hundred and nineteen

at 2:30 p. m.

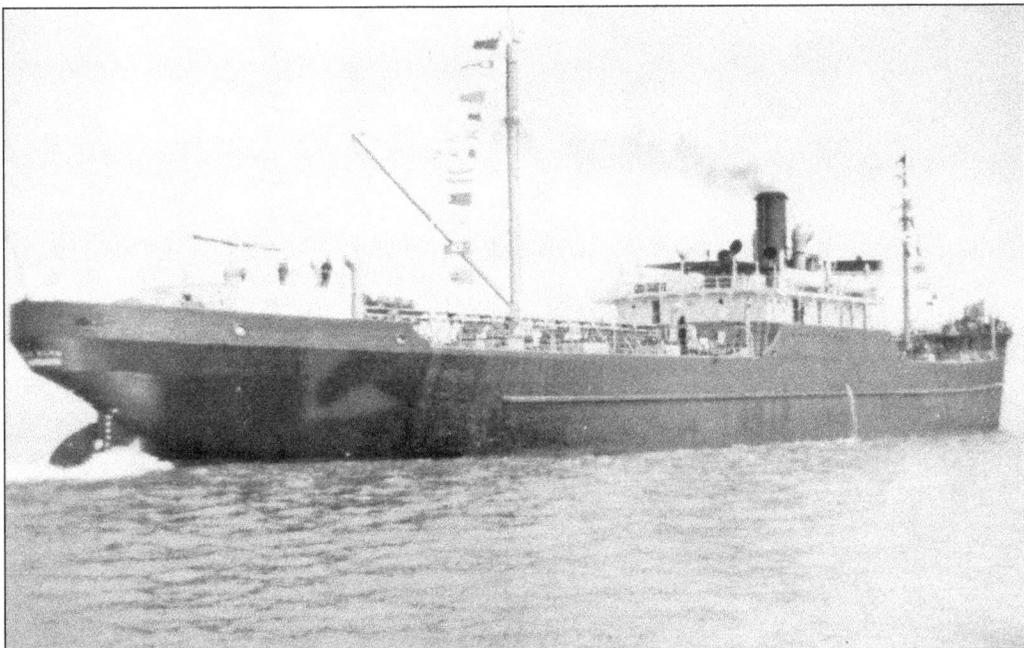

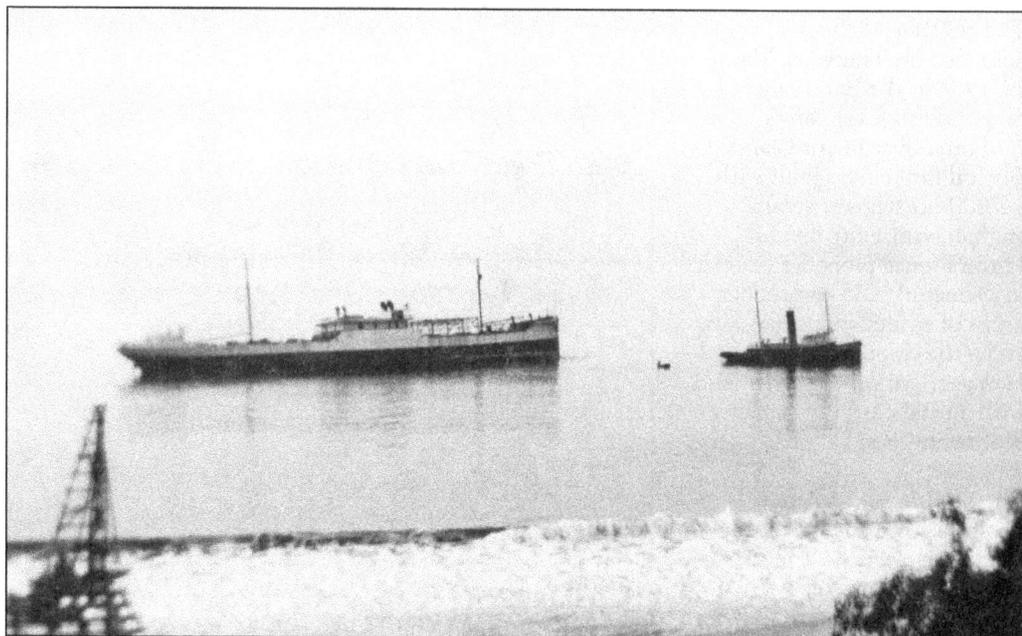

The Seacliff Amusement Corporation formed in 1929 and planned on building a resort on Seacliff Beach. The 430-foot ship was purchased to provide dining, dancing, swimming, fishing, and whatever other forms of entertainment the pubic required and the law would allow. On Tuesday, January 21, 1930, the *Palo Alto* began her final voyage, leaving the Moore Shipbuilding Yard in Oakland and arriving at Seacliff Beach on Wednesday, January 22, 1930. The *Palo Alto* was towed by a Red Stack tug, and under orders, the speed was kept below five knots. (Both, courtesy of Ralph Mattison.)

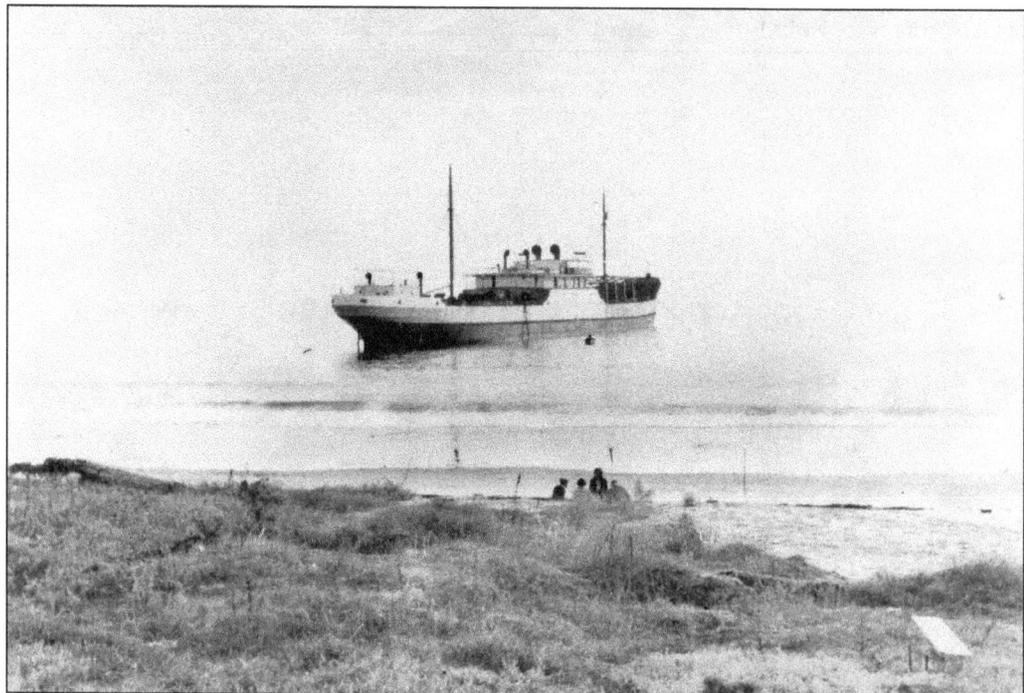

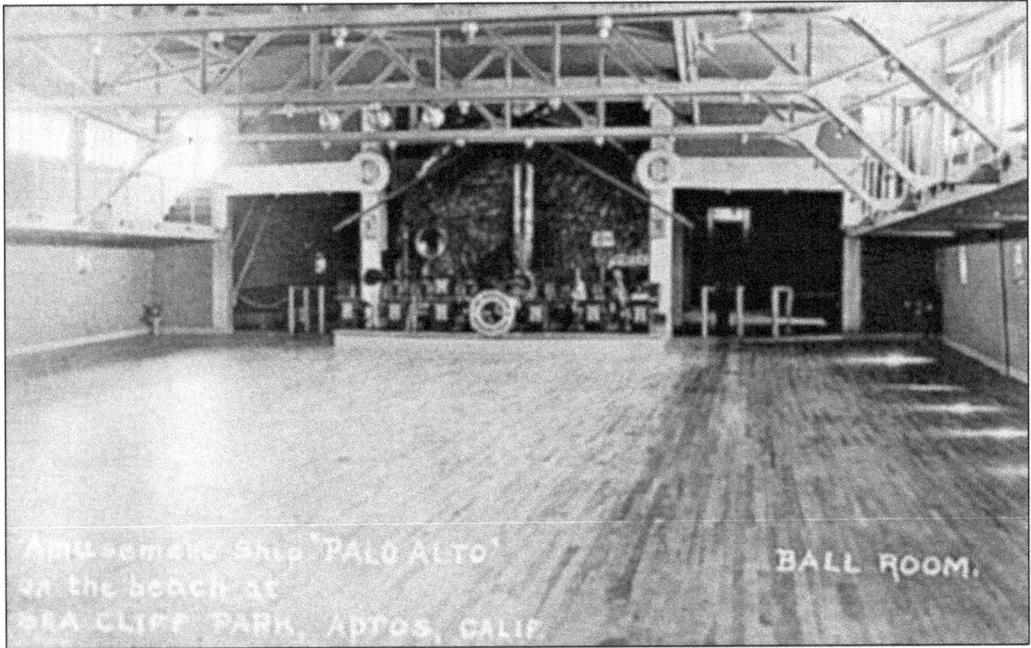

The Rainbow Ballroom was the dance hall on the ship. It occupied most of the main deck and was 54 feet wide. The ballroom opened on Saturday, June 21, 1930, for a special preview. Ed Rookledge's 10-piece orchestra provided the music for the several hundred people who showed up that inaugural evening. The official opening was the following Saturday night, June 28, 1930. Despite a promising commencement, the ship's use for entertainment would not survive the effects of the Great Depression. As business fell off during the winter of 1930–1931, the ship was closed more often than not.

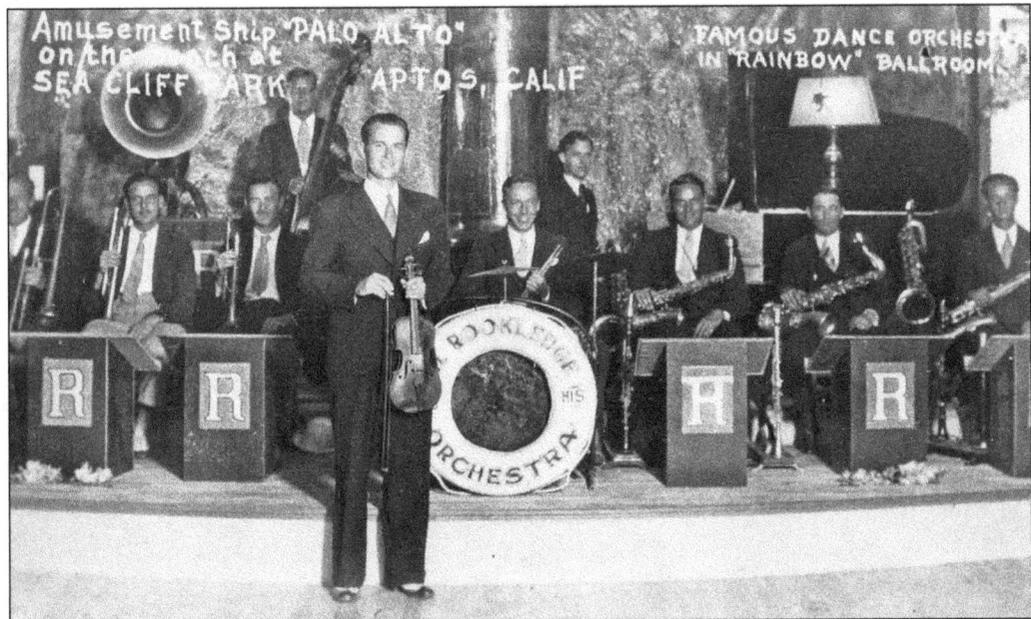

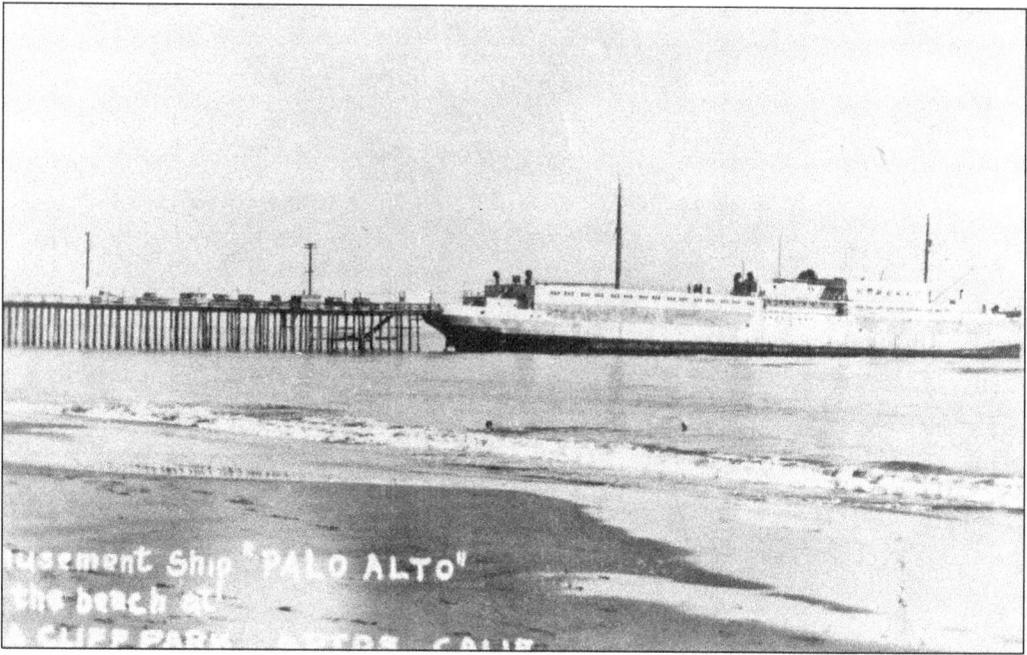

Amusement Ship "PALO ALTO"
the beach at
CLIFF PARK

The Rainbow Ballroom had its grand reopening on Memorial Day 1931. On August 8, 1931, the state of California acquired the first parcel of Seacliff Beach from the Santa Cruz Land Title Company. The stormy winter of 1932 produced strong enough surf to create a crack in the hull just in front of the swimming pool. The ship was boarded up, and the end of the Seacliff Amusement Corporation was rapidly approaching. After defaulting on its loan, the company lost its land and the ship to the Calavada Investment Company. In 1934, Calavada sold the right to dismantle and sell everything salvageable on the ship. The ship itself was also sold. On February 12, 1936, the ship that cost $1.5 million to build just 17 years earlier was sold to the California Division of Parks for $1.

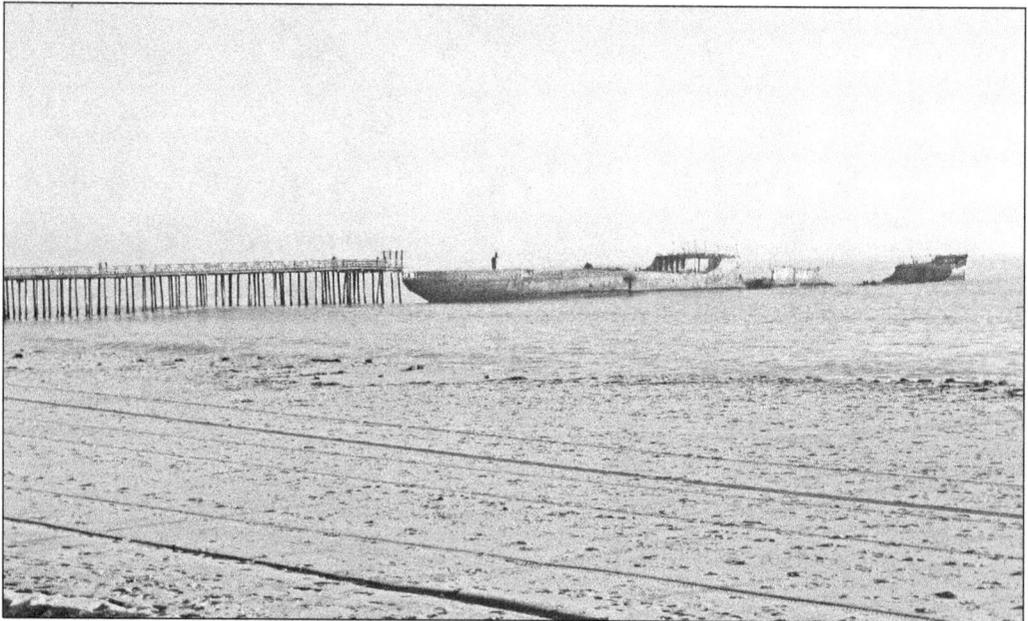

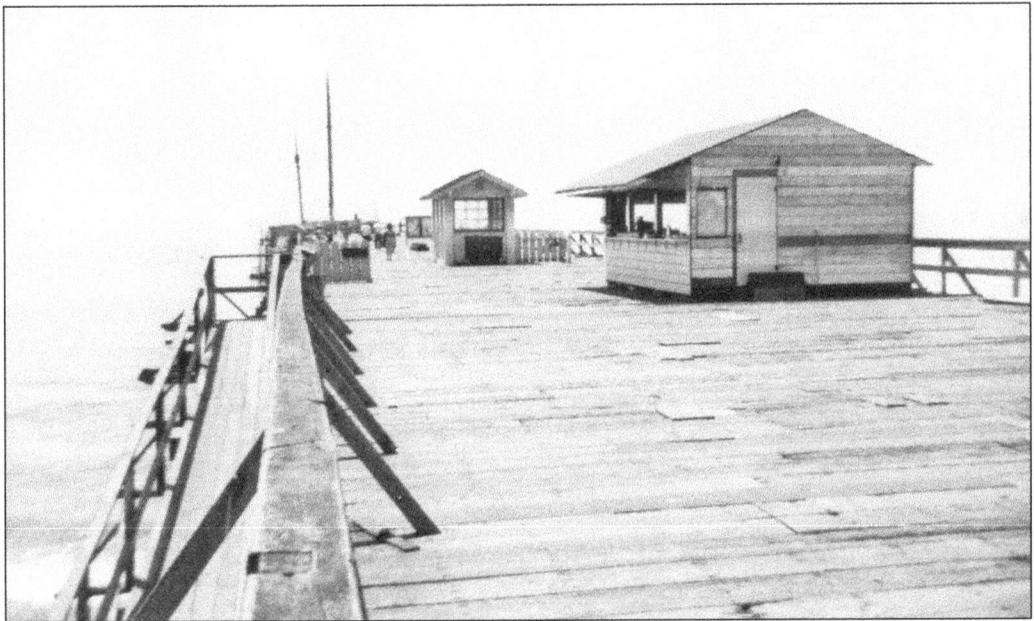

Around 1945, Ralph Creffield opened a hamburger stand in a trailer at the entrance to the pier. The trailer was replaced by a larger, wooden stand in the early 1960s. In 1983, the wooden hamburger stand was removed from the pier, in one piece, and placed across the road where it survives today as a snack shack during the summer beach season. Ralph Creffield also had a bait and tackle shop, which occupied the stern cabin during the 1950s. In addition to burgers and bait, Creffield also operated a rowboat rental service on the ship. The rowboats were equipped with outboard motors and were kept on deck. With the use of a small crane, they were lowered over the port side where passengers would be waiting to board from a launching dock at the bottom of a 30-foot stairwell.

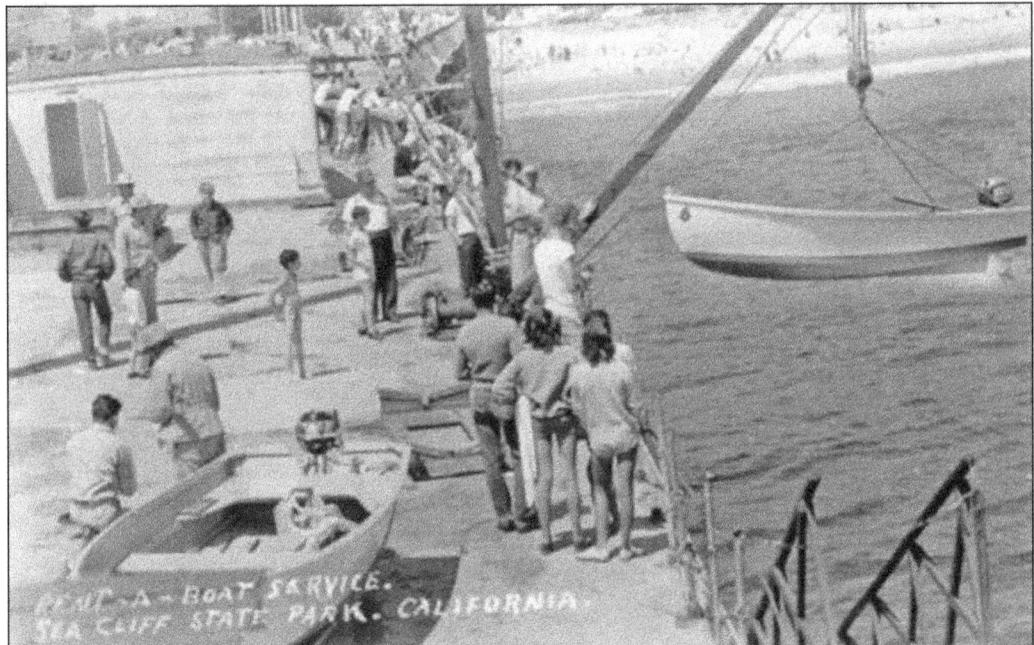

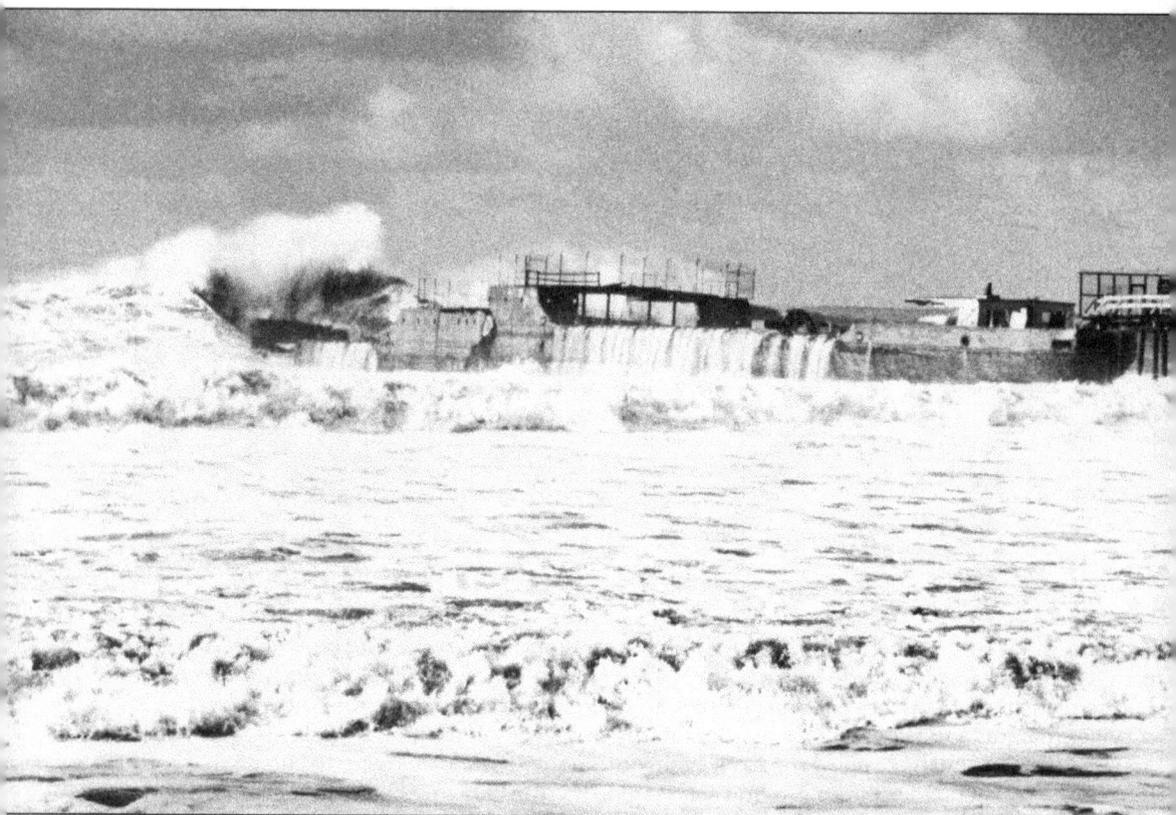

The hull of the ship, which was cracked in 1932, finally broke during the winter storms in early 1963. The bow settled several feet into the sand, and with more heavy storms in January 1978, the break in the hull increased, causing all but the stern to settle to starboard. The pier was also damaged in 1978. Heavy seas tore pilings loose from the pier. The ones that remained were battered and weakened. Enough of the pier's planks were gone that it was closed for safety reasons and would remain that way for the next five years. There was not enough money in the park administration's budget to restore the damaged boat and pier, and hopes of reopening fell even further after the particularly fierce storms of 1980 and the continuing damage caused by the force of heavy seas.

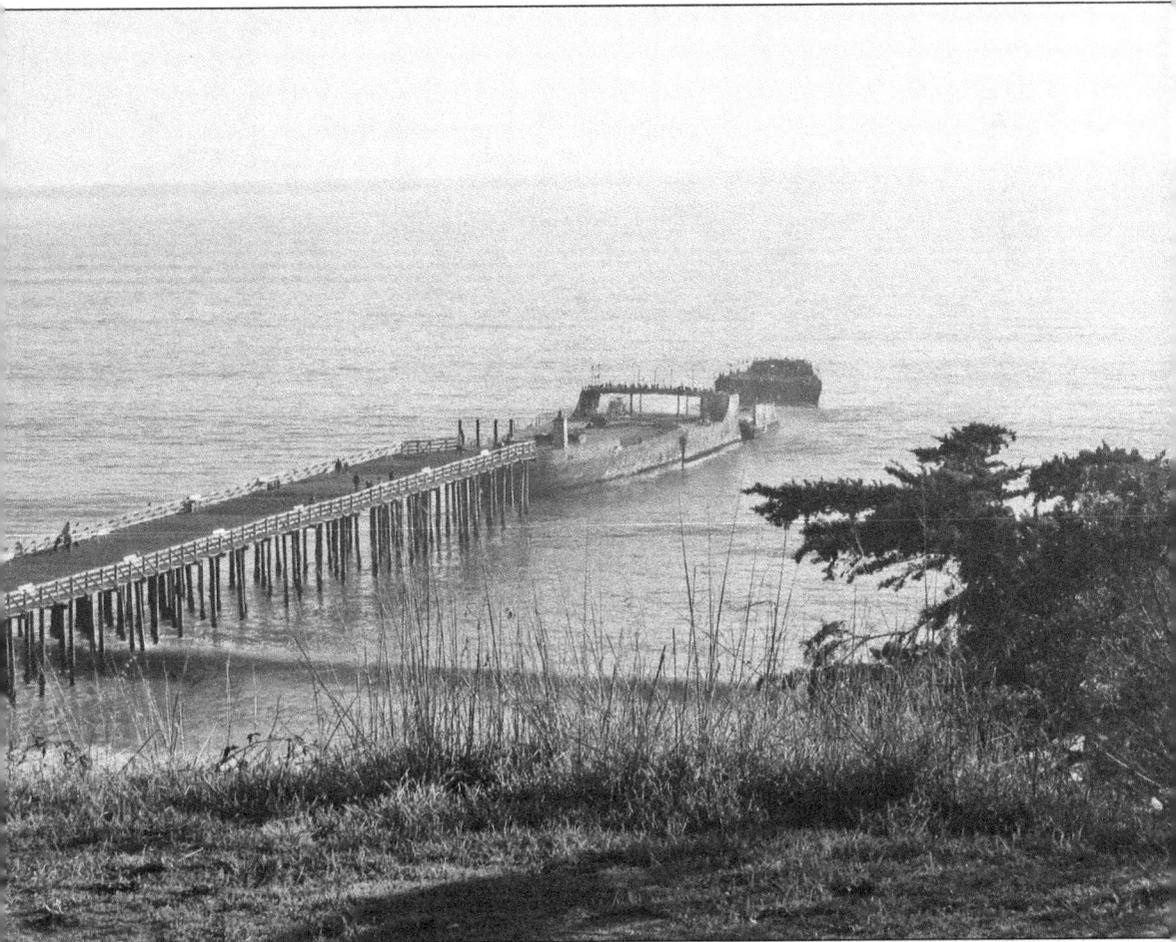

Not accepting the fact that the ship would never reopen, several locals donated time, money, and labor (an estimated 8,000 hours of work, which saved the state at least $50,000), to help the pier and ship to reopen on July 23, 1983. As the years passed, more storms and heavy seas caused the ship to close for good on October 27, 2001. Today, the ship remains closed, but the pier is still open for fishing. Restoration of the ship appears to be nearly impossible, and it is now up to Mother Nature and the mood of the Pacific Ocean to determine how much life is left for the concrete ship. For now, it remains to be loved and admired by children and adults of all ages.

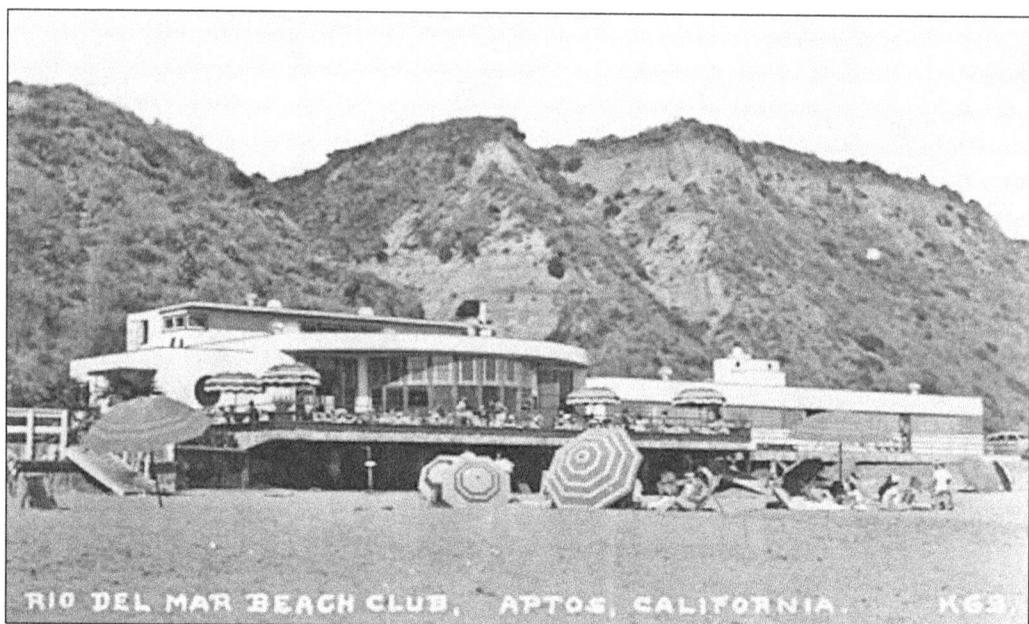

RIO DEL MAR BEACH CLUB, APTOS, CALIFORNIA. K63

The Beach Club located at the east end of Beach Drive was commissioned in the fall of 1936 and was considered to be high fashion, unique, and lovely. The club was equipped with an inside-outside dining room over the sand, locker rooms for showering and dressing, and a large landscaped patio known as the Palm Court. The main lounge was a glassed-in, semicircular room looking out over the sand and into the Pacific Ocean. After the attack on Pearl Harbor in 1941, the military coast guard requested to use the Beach Club as a barracks for the men patrolling the coast. The Beach Club was boarded up after the beach patrols ended in 1942. It deteriorated rapidly in the moist salt air and was prone to vandalism due to the remote location. It did reopen in June 1946, as an adjunct to the new Rio Del Mar Hotel, but without much fanfare. It lasted only that summer and then was closed permanently and eventually torn down.

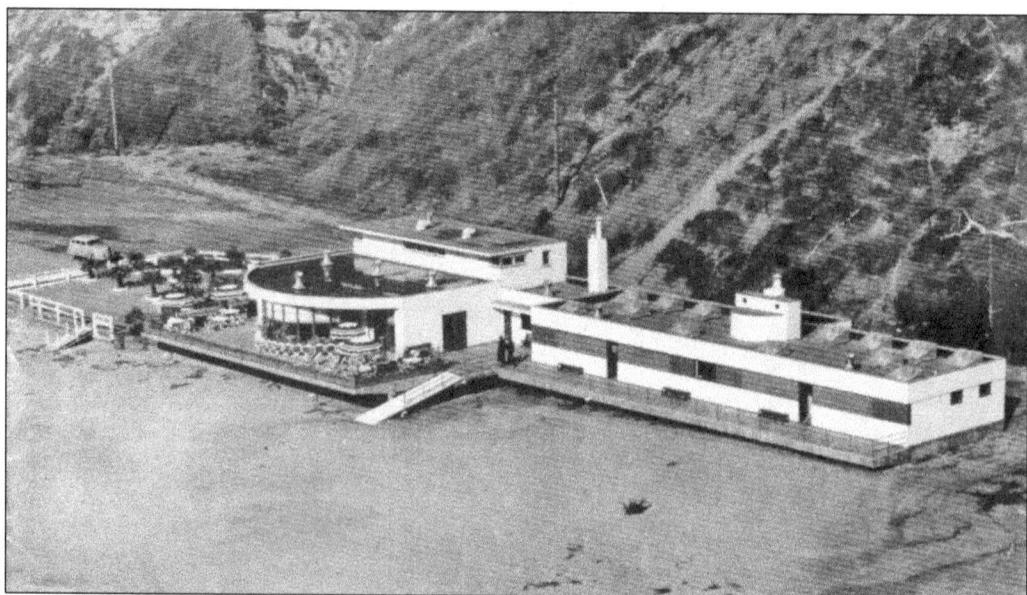

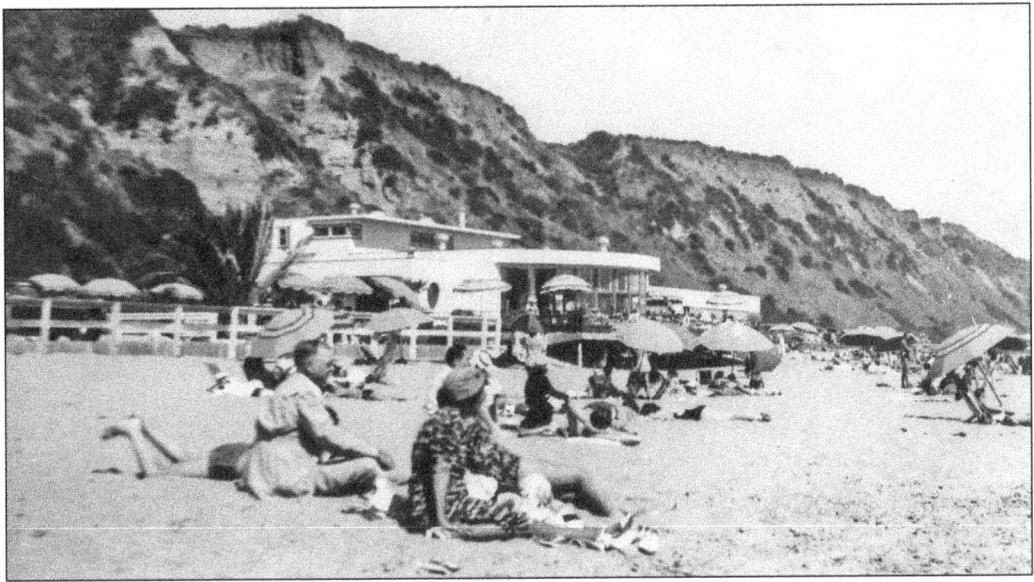

A portion of the Rio Del Mar Beach and the old Beach Club structures were sold to the state in 1955 as the last addition to Seacliff State Beach. The main building was match-marked, dismantled, and given to a local convalescent home for rebuilding very soon thereafter. The locker rooms and restrooms, which were the last standing remnants of the complex, were torn down in July 1966. The current facility was completed in December 1980 and sits on the original Beach Club floor slab. Today, the only evidence of the Beach Club that exists is the original concrete support pilings, foundations, and floor slabs.

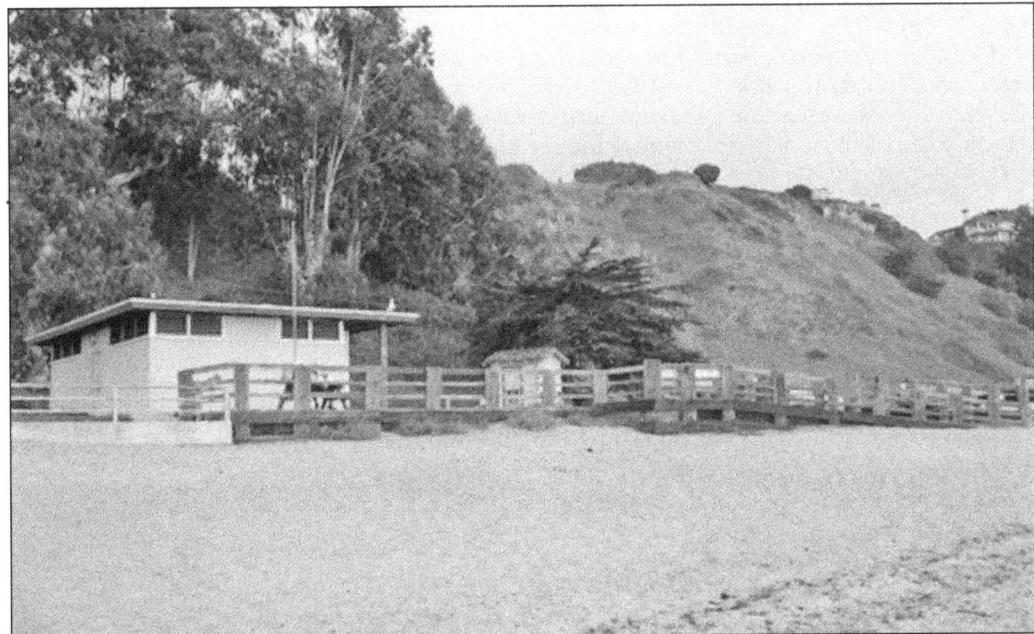

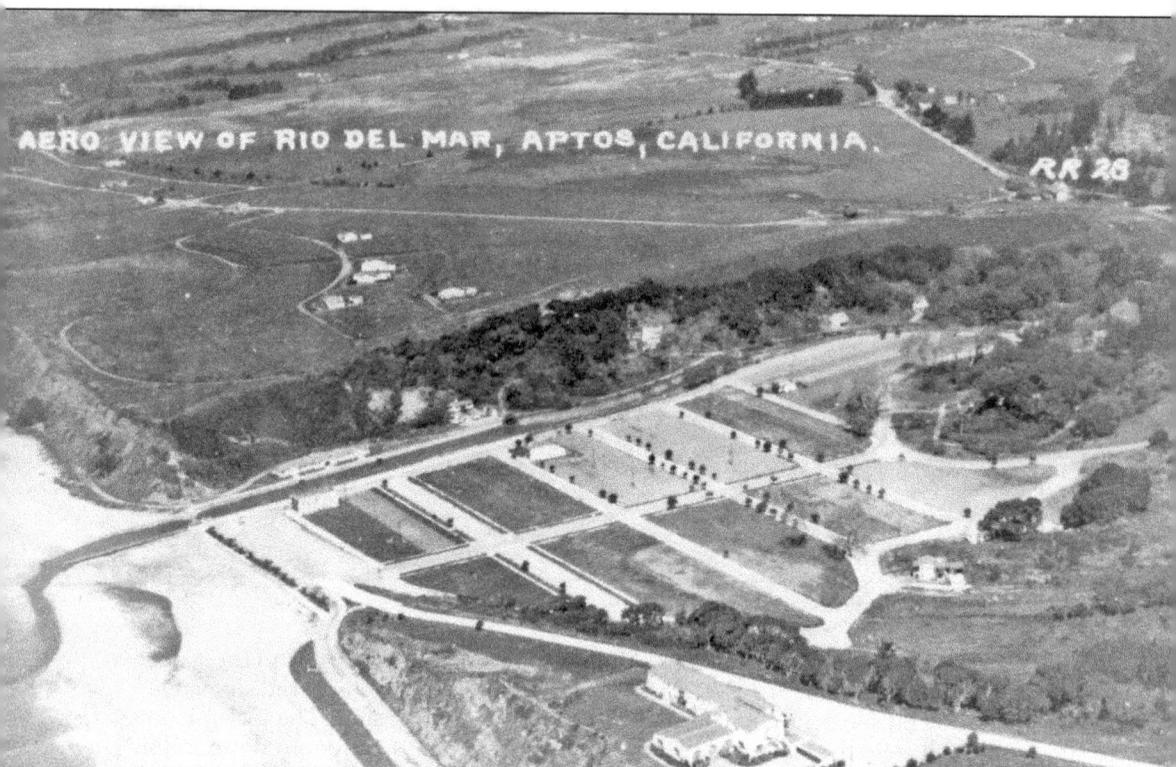

This aerial image of the Seacliff and Rio Del Mar area was taken sometime between 1928 and 1935. At the bottom of the cliff alongside Aptos Creek, one can see the Rio Del Mar Bathing Pavilion and dam, which claimed to be the "world's largest freshwater swimming pool." Just across from the bathing pavilion is the first building to be constructed in Rio Del Mar and the home of today's Sea Breeze Tavern. Continuing up today's Aptos Beach Drive, at bottom center is the Aptos Beach Inn that burned to the ground on March 17, 1963. At upper right is the Aptos Creek Bridge. What most people notice first about this photograph is the amount of open space; it is also important to notice the lack of trees along the coastline. It is not because they were cut down for timber. It is because the Indians would burn down the trees as a method of wildfire prevention. All the trees visible today were planted and are not part of the natural landscape.

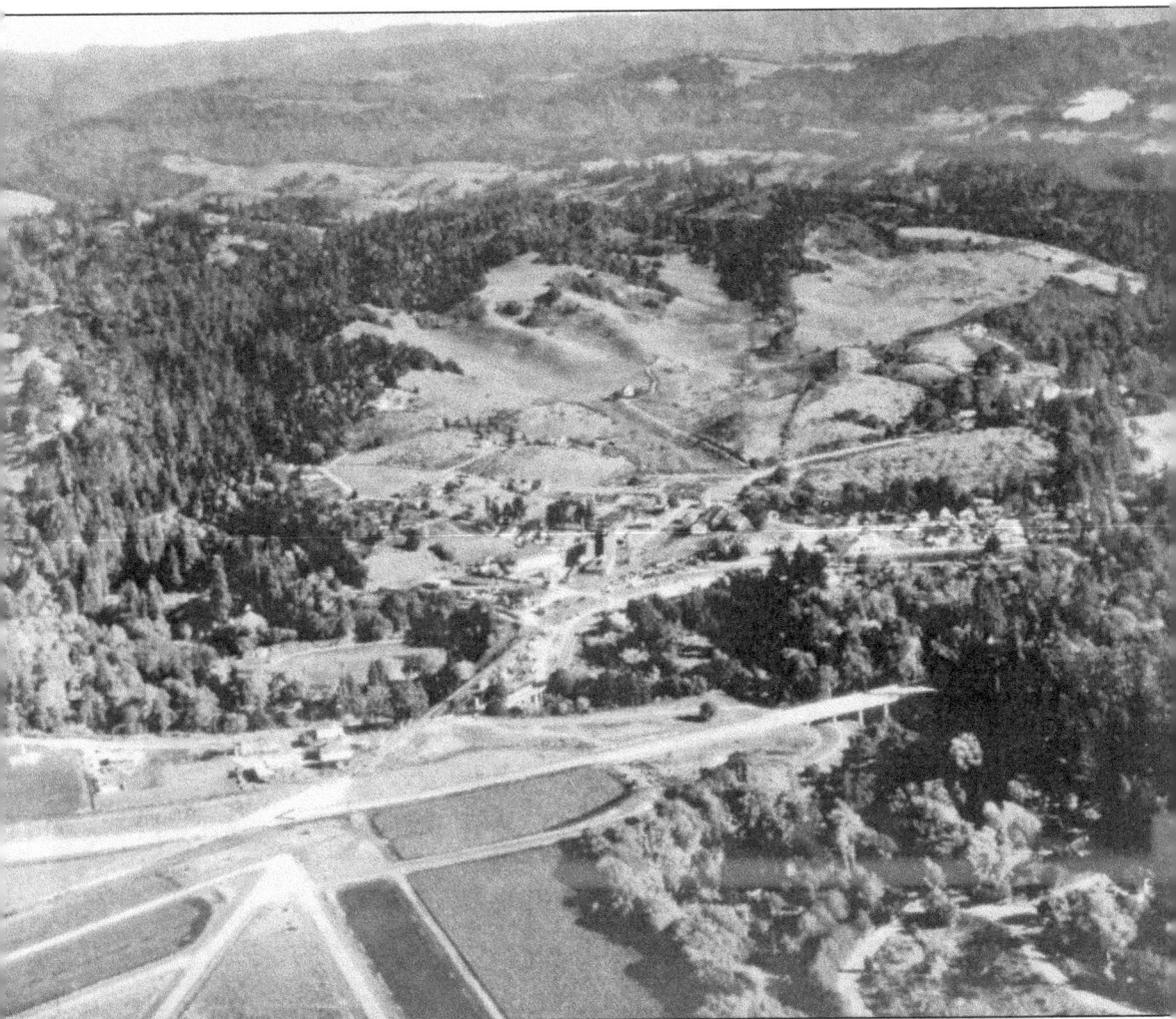

This areal shot taken in 1948 is a beautiful photograph of Aptos Village and shows the newly constructed Highway 1, which was not yet open for traffic. The overpass on the right is the Spreckels Drive overpass. One can also just make out the Aptos Creek Bridge toward the center. Just to the left are two white houses; the first house, not the one closest to the bottom of the photograph, is the old Arano store and the oldest house in Aptos. This was the original Aptos Village. Aptos Wharf Road used to run directly from Soquel Drive to the original Aptos pier built by Rafael Castro. Aptos Wharf Road was cut short with the construction of Highway 1. Today, the existing portion of the road, running from Soquel Drive to the old Arano store, is the shortest road in Aptos.

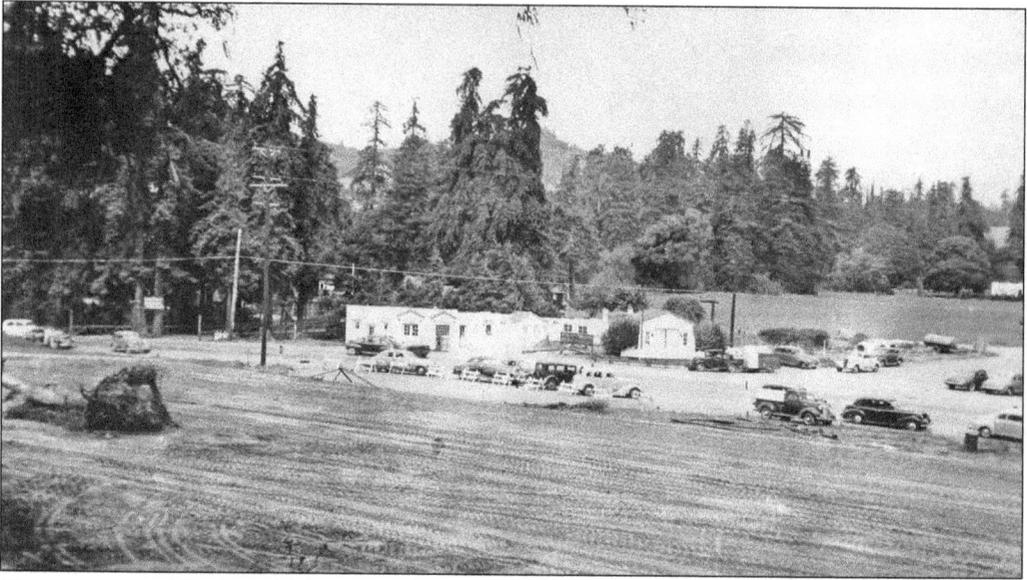

Construction of Highway 1 began in late 1947 and was not finished until November 4, 1949. This photograph, taken from the hill near the present-day Deer Park shopping center, shows the highway under construction. On the left is the bridge entrance to Redwood Village. The open field on the right is the polo grounds. The overpass was built in 1963, and the intersection was once again reconfigured. (Courtesy of Carolyn Swift.)

The Highway 1 dedication ceremonies on November 5, 1949, started at Deer Park Tavern in Aptos. Originally named Rob Roy Highway, it would later be known as the Cabrillo Highway. The first weekend it was open, 23,314 Sunday drivers, a number considered amazingly high 50 years ago, hit the road. The old route between Santa Cruz and Watsonville, which wound through Soquel and Aptos, was forever changed by this straight 7.7-mile stretch of highway. (Courtesy of Frank Daubenbiss.)

# *Four*

# PEOPLE

## THE UNIQUE CHARACTERS OF APTOS

There is very little known about the Ohlone tribe that lived for thousands of years in the Aptos area. There is even less known about the individuals who made up the tribe. It is known that, since Rafael Castro was granted Rancho Aptos by the Mexican government 180 years ago, Aptos has had its fair share of characters. These characters are the people who have shaped Aptos into what it is today. They helped to build the town. They have helped maintain peace and ease of living. They are political, social, religious, and spiritual leaders. However, every good story has a villain, and Aptos is not an exception. Thankfully, there haven't been many bad characters in this story, but it is still important to recognize all significant players, good and bad.

Howard Thurman, author, poet, scholar, and civil rights leader, once wrote, "Community cannot for long feed on itself; it can only flourish with the coming of others from beyond, their unknown and undiscovered brothers." Once the "others from beyond" settled into this town, things changed quickly. Houses, hotels, pubs, retail, and entertainment all seemed to appear within a relatively short time. It was the people of Aptos who built the town of today.

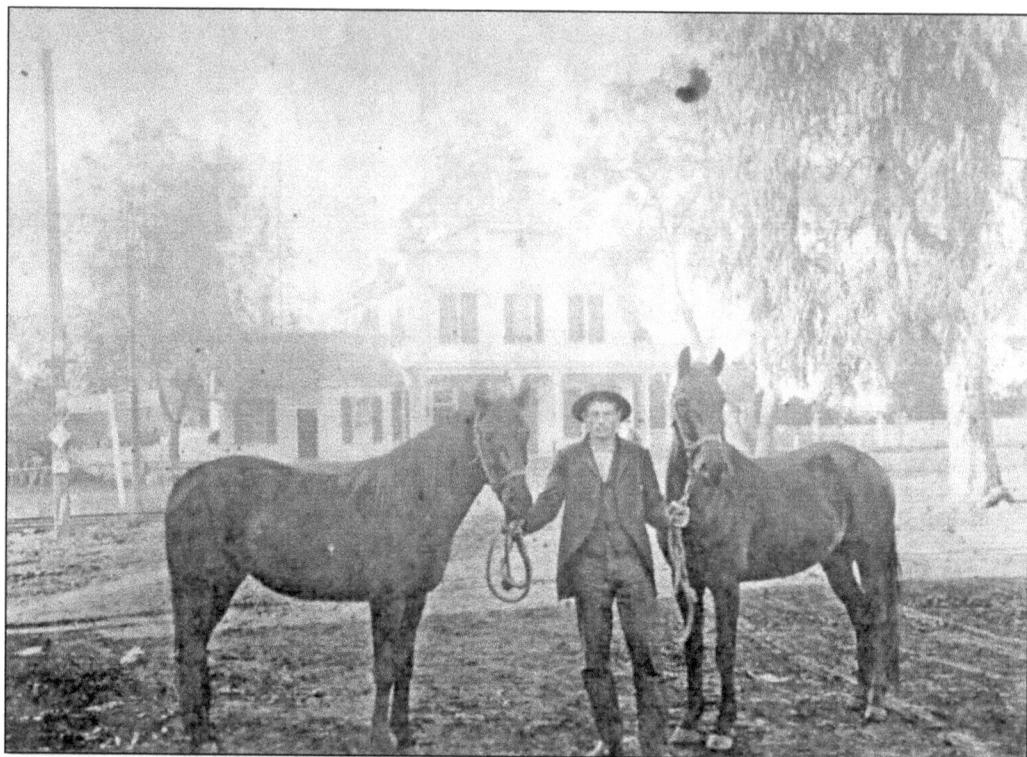

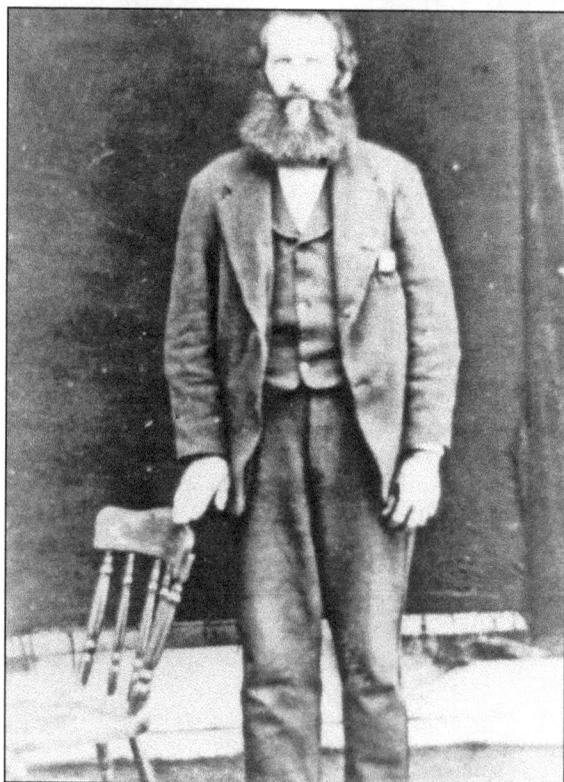

After being punished for stealing a salmon at the age of 13, Patrick Walsh ran away from his homeland of New Zealand to Liverpool. He gave his age as 17 and began work on locomotives. At 21, he was recruited by an American railroad. By the mid-1850s, he was an engineer on a train out of St. Joseph, Missouri. He married a young Canadian named Catherine. He was a slave owner and a veteran of the Confederate army. Around 1865, he joined his relatives in Aptos who had made the trip west by wagon train. Patrick and Catherine built their home on the bluff overlooking Valencia Creek in about 1869, which still stands today as a private residence. They also built and operated the Live Oak House, which was the town's first hotel. (Left, courtesy of Vincent T. Leonard.)

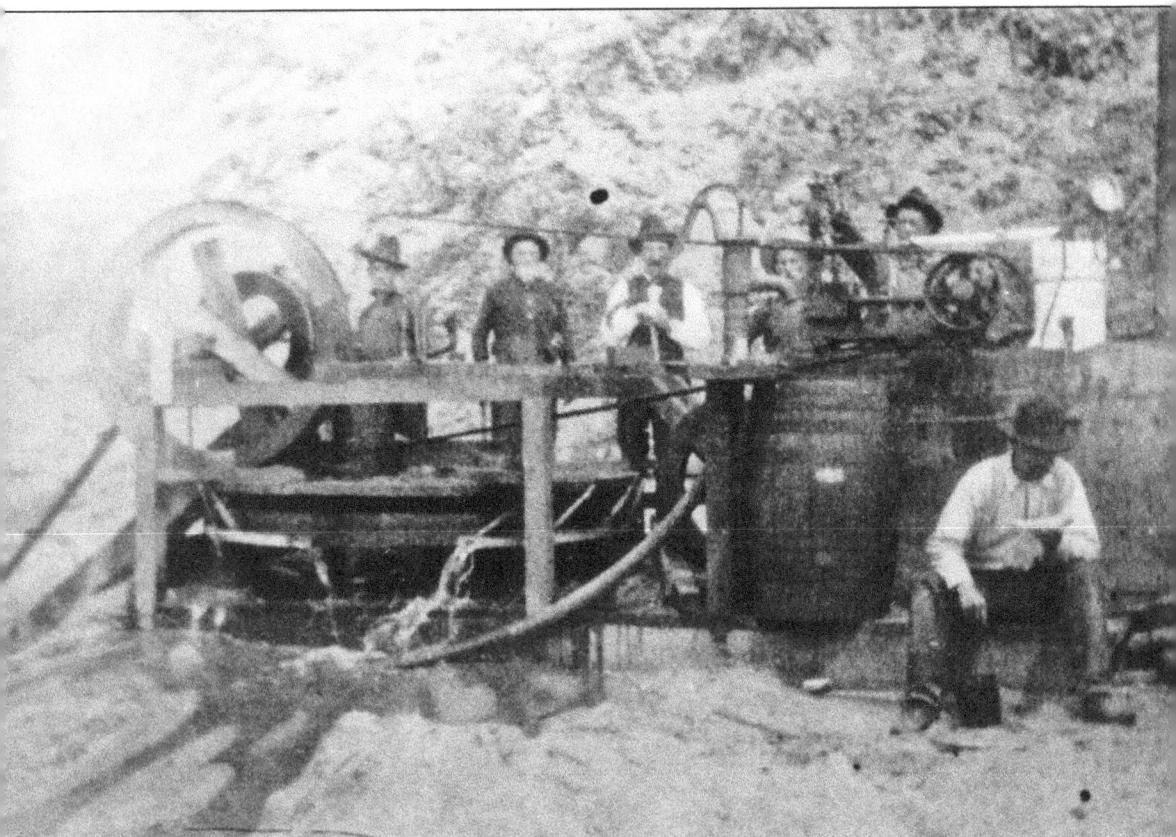

John Montgomery was an aeronautical innovator who, in 1905, used a hot-air balloon to lift his newly designed flying machine, which he called an "aeroplane" (a word he coined), into the sky and cut it loose over Aptos at heights of 800 to 3,000 feet. His is recorded as the first public flight in a fixed-wing aircraft. He also invented the machine he called a gold concentrator, seen above. It was used on the Leonard family property at today's Manresa Beach. The Leonard family would shovel sand onto a slough lined with carpeting. The gold remained when the sand was washed away. The Leonard family was among the first to settle in Aptos Village. They established a grocery store near the corner of Trout Gulch Road that was soon destroyed by a fire. Leonard family members made enough money from their black sand mining operation to rebuild their grocery store, which still stands today as Café Sparrow. (Courtesy of Vincent T. Leonard.)

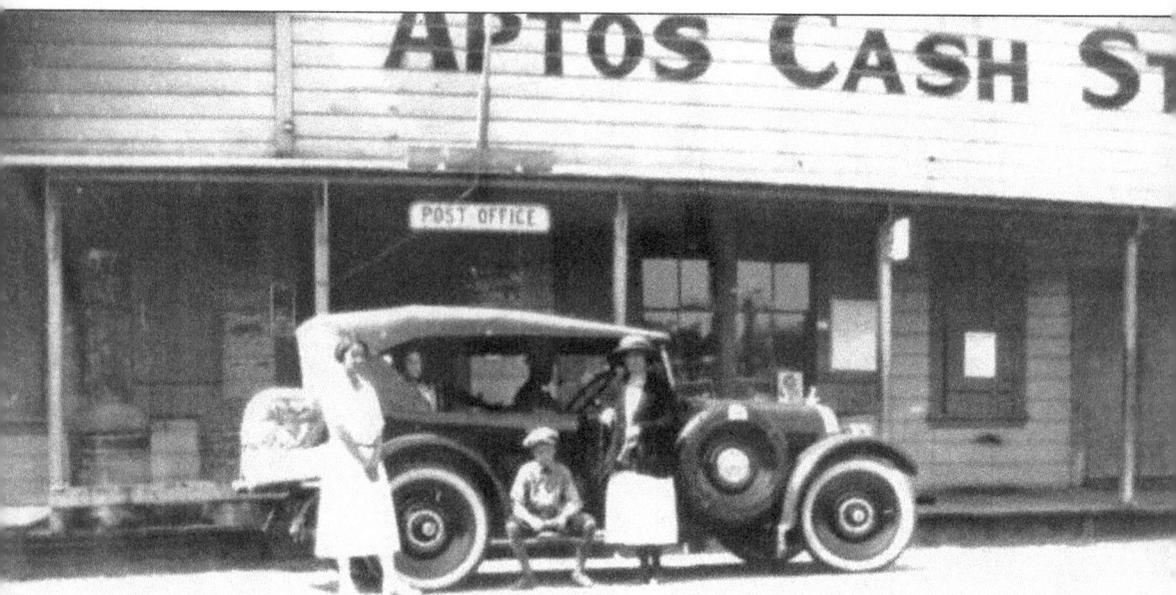

Kess (Case) van Kaathoven came to America in 1889 with his mother, brother, and sister Elizabeth. Kess, along with his wife, Agnes, owned the Red & White store in Aptos Village. They purchased it in 1922. They lowered the building to street level and removed the old covered porch. Their son Harry worked in the meat department. They changed the name from Aptos Cash Store to Van's Store, as most folks referred to them as Mr. and Mrs. Van. Apparently, the long Dutch name van Kaathoven was too awkward for people. Mr. Van continued to operate his store efficiently until his 90th birthday, when he sold out to Fred Toney. He lived seven more years with deeply engaged affection and respect of the Aptos community. Today, this building is the home of Café Sparrow and several other retail businesses.

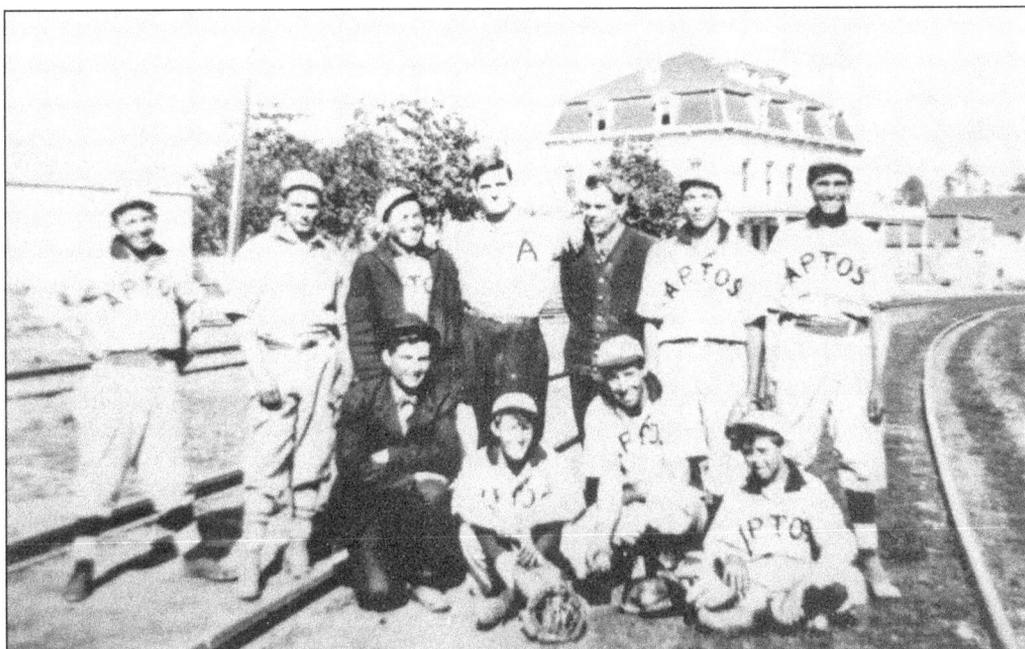

In the early 1900s, baseball teams were forming all across the nation. Santa Cruz County had its fair share of semiprofessional teams that would often play each other on Sundays. Above, this photograph of the 1903 Aptos squad was taken on the railroad tracks in front of Aptos Station with the Bay View Hotel in the background. (Pictured below is the same site today.) Team members are, from left to right, (first row) George Traites, unidentified, Bud Parks, and Willie Baughauser; (second row) Castro, unidentified, Lloyd Haines, D.L. Maguire, Castro, and unidentified. Paul Johnston may also be pictured. Although Harry Hooper never played for the Aptos team, he did play for the Soquel Giants. Hooper was inducted to the hall of fame in 1971 after playing for the Boston Red Sox and Chicago White Sox. He was part of four World Series champion teams while with the Red Sox. He is now buried in the cemetery next to Resurrection Catholic Church. (Above, courtesy of Vincent T. Leonard.)

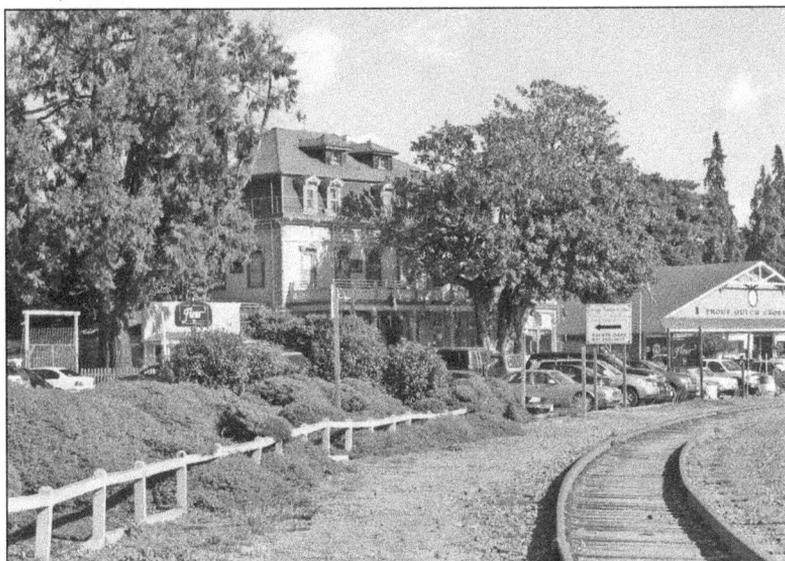

Martin Jongeneel came to San Jose to prepare himself for a job with the California Fruit Canning Association. Elizabeth van Kaathoven was born in Leiden, Holland, and came to America in 1889 with her mother and two brothers. They were married in San Jose in 1895 and moved to Evergreen, where their two eldest children were born. Martin Jongeneel was a horticulturist and worked on the development of varieties of seeds suitable for canneries. They continued to move around before settling in Aptos in 1927. Martin passed away in 1931. In 1934, Elizabeth started a new career, giving piano lessons. She taught up to 20 lessons per week and even gave recitals at her home. She passed away in 1958 at the age of 83.

In 1927, Martin Jongeneel built his family a home on three acres of land, which today is used as a commercial building located at 9051 Soquel Drive. It was one of very few buildings along Soquel Drive in the 1920s. It had a circular driveway and a large basement. The home was called Beth-Mar. They had a rhododendron and azalea nursery on the property. There was a greenhouse where the front office building now sits. There was an orchard to the west and a fox farm to the east. Before his death in 1931, Martin developed one of the most extensive rhododendron gardens in the county, and his wife had gratified a long-standing wish to have a house surrounded by trees and shrubs, as in her native Holland. One pine tree, which they planted when they first moved, now towers over the house. After serving as a private home, it next was a nursing home. However, J.D. Jacobsen purchased it in 1965, and it was a church until 1969, when it was converted to commercial use as a restaurant.

Not so long ago, there were a good number of Aptos Indians still living and working in this area. By 1945, only two remained. As the story goes, one day, in a heated argument, one killed the other by the side of Freedom Road. Jim, the remaining Indian, continued to work on the Hihn Ranch until he became ill and died in 1951. He was a very quiet person and would never think of disturbing someone by knocking on the door. He would just look in the window until someone saw him. Since people never knew when he was coming, it never failed to scare the daylights out of them. Whether or not Jim really was the last Aptos Indian is a bit of a discussion point. Jim went by the name of Castro. There is a 1901 marriage license between Peter Castro, a native of the South Sea Islands, and Encarnacion Cañada, a native of California, both residents of Aptos. If these people were Jim's parents, the last Aptos Indian was not an Indian at all!

Paul Woodside, who built his cabin about halfway up the cliff at Seacliff Beach, was a hermit. He had been pressured to sell his land to the Seacliff Company, which was developing the surrounding area. He not only refused to sell but also threatened anybody who set foot on his property. On September 5, 1925, Sheriff Howard Trafton and Undersheriff R.H. Roundtree attempted to deliver a warrant for Paul Woodside's arrest. Gunfire broke out and resulted in the deaths of all three men. A search of Woodside's cabin turned up 12 homemade bombs, about a dozen sticks of dynamite, and a bloody hatchet that was used in the deadly struggle.

Before Sheriff Trafton died from his injuries, he was able to report on the details of the struggle in Woodside's cabin. As reported in the *Santa Cruz Sentinel* on Sunday, September 6, 1925: "Armed with a warrant, we went to Woodside's cabin and found him inside sitting on the edge of the bed with a sawed-off shotgun . . . we grappled with him trying to put the handcuffs on him. We got one on, but in the mix-up he grabbed my gun out of the holster and shot me, and then shot Dick twice. Then I got my gun back and shot him through the head."

Lou Harrison, a longtime resident of Aptos, was instrumental in launching the Cabrillo Music Festival. Opening night was in 1963. It has become the only music festival in America that is strictly dedicated to the performance of new orchestral music. Lou was a student of Henry Cowell, Arnold Schoenberg, and K.P.H. Notoprojo. Harrison was called the "dean of west coast classical composers" and "one of America's most colorful and important musical mavericks," by the *Los Angeles Times* after his death in 2003, aged 85. He was an accomplished musician who had written 63 compositions before the age of 21. Harrison and his partner for 33 years, William Colvig, helped construct the so-called American Gamelan. Harrison is remembered most for blending the musical traditions of Asia and the west, a process he called "trans-ethnicism." He was also a poet, calligrapher, painter, essayist, and political activist, particularly influential on gay-rights issues. (Courtesy of Eva Soltes.)

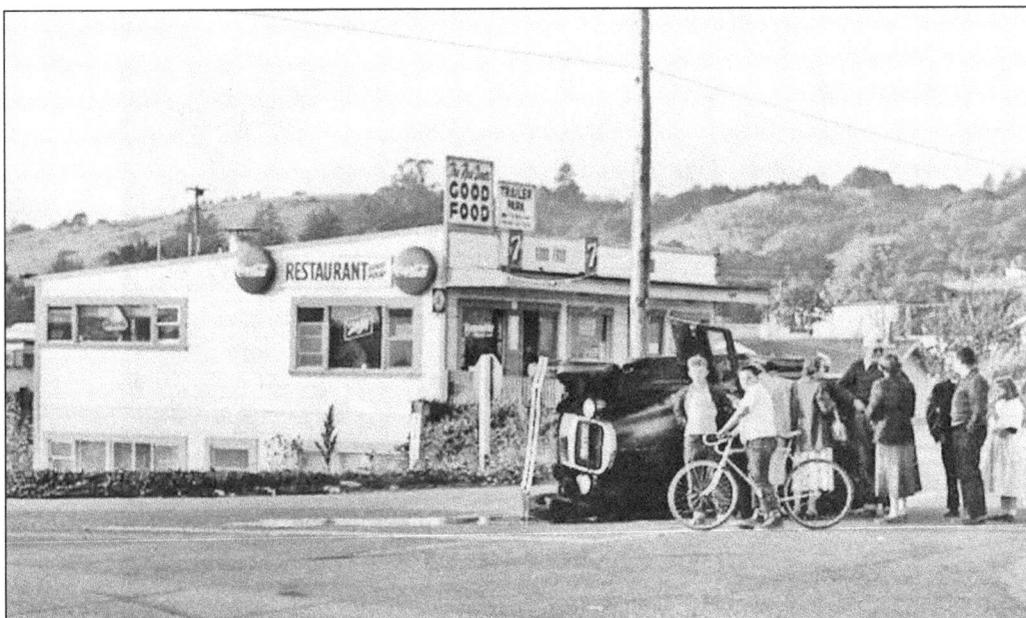

The Red Door restaurant was the scene of this 1953 auto accident, which occurred when Arna Boehle attempted to cross Highway 1 on Mar Vista Avenue. Among those pictured is John Sinclair, a descendant of Martina Castro. He is the tall, white-haired man standing beside the car. (Courtesy of Covello and Covello Photography.)

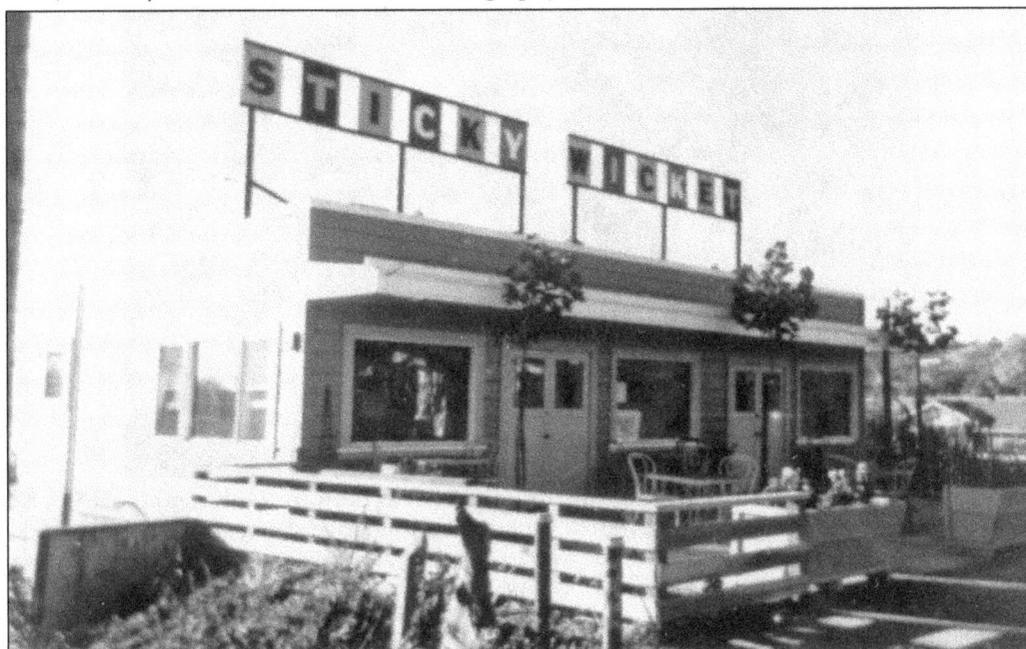

In 1959, Londoner Vic Jowers and his wife, Sydney, opened the Sticky Wicket at the former Red Door restaurant. Shortly after opening, they began staging artistic productions at what was called the "New Vic Theatre." It is widely believed that those productions were the predecessors of the Cabrillo Music Festival, which began after Cabrillo moved to Aptos in 1962. (Courtesy of Sam Vestal/*Register-Pajaronian*.)

Paul Johnston was one of Aptos's most interesting citizens. Born in Washington in 1889, he moved to Capitola a decade later. He started working at a young age, doing an assortment of odd jobs with F.A. Hihn's summer campground and beachside amusements. One of his early tasks was to kill gophers in the sugar beet fields. He would collect the tails in slated Mason jars to be turned in for a nickel each to the Hihn Company. He first real job was the sale of popcorn from a vending wagon at the beach. He would also make extra cash by selling salmon for 10¢ each at the wharf. Of course in those days, it was hardly any effort to catch a 30-to-40-pound salmon. He was a champion in the statewide apple box–building contest at the Watsonville Apple Annual in 1912 and was also known as one of the best rifle shots in the nation by 1918. He also worked in the fruit-packing industry, spending almost 10 years at the Hihn Apple Packing Plant in Aptos. (Courtesy of Paul Johnston.)

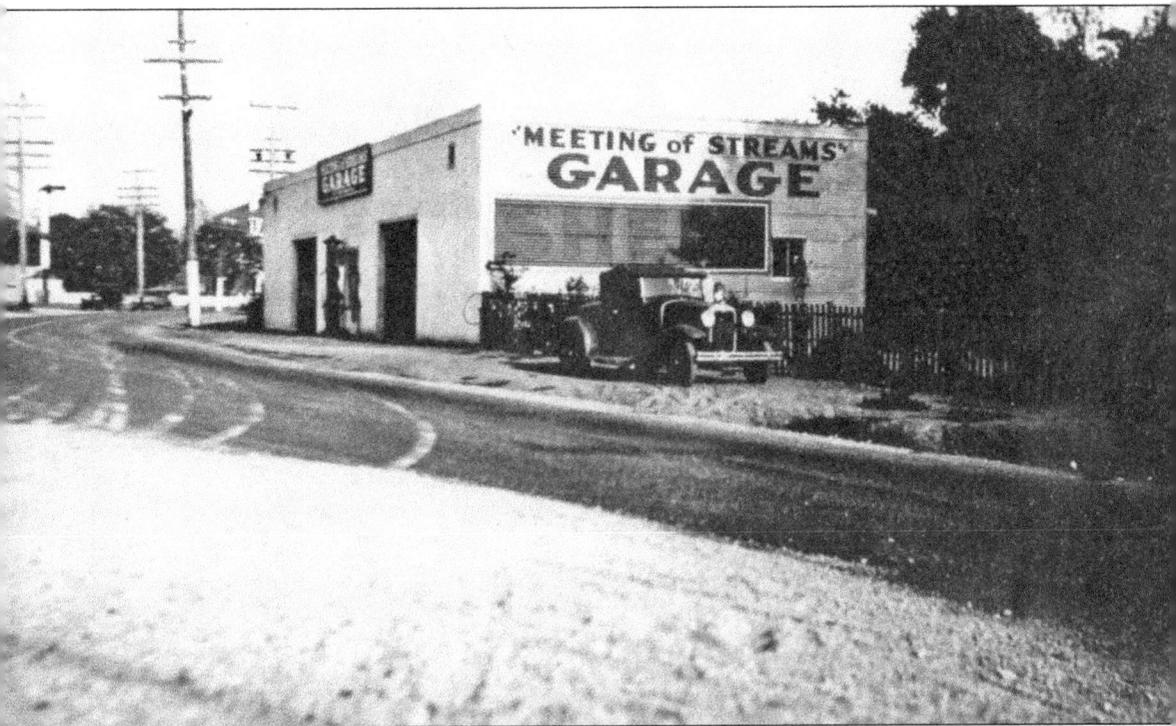

Johnston also drove the jitney and provided carpentry service for the Loma Prieta Lumber Camp. After a boy he knew in Soquel was killed in battle, Paul Johnston enlisted in World War I in 1918. After the war, Johnston returned to Aptos and was offered a job at the Ewell Fruit Company. He was making vinegar for the company but quit when his success did not result in a raise. Johnston moved on to become a sign painter in Santa Cruz. He purchased a house in Aptos and was appointed a rural mail carrier, which he worked at from 1922 until he retired in 1945. He did not stop working, though! He ran the garage next to his home, called the Meeting of Streams, and provided AAA service for the next 26 years. Even with his busy life, Johnston managed to find time for his hobbies, which included semiprofessional baseball. He passed away in 1991 at the age of 101. His house is now a furniture store, and the garage next door is still in business, under a different name. (Courtesy of Paul Johnston.)

In 1961, Lucille Aldrich (right) and Anne Isaacs (left), along with Babe Toney and others, formed the Aptos Ladies Tuesday Evening Society. They organized to defeat a proposed zoning change that would have allowed a cement batching plant to be built in the center of Aptos Village. Their efforts were successful. A celebratory barbecue was held on Memorial Day. The event was so popular that a parade and potluck were planned to follow on the Fourth of July. Everyone turned out in old-fashioned clothes, and the Monterey Bay Antique Car Club brought 18 vintage cars. A number of visitors stopped to view the parade when the "Sun Tan Special," the train that once transported visitors from the San Francisco peninsula to Santa Cruz, passed through Aptos Village. "It was a happy coincidence that the parade coincided with the train passing through," recalled Lucile Aldrich.

Once again, the Aptos Ladies Tuesday Evening Society took action when the Southern Pacific Railroad tried to close the crossing in front of the Bay View Hotel. Having invited the press, the ladies, dressed in their finest Victorian clothes, laid themselves down upon the rails. And once again, they were victorious. Their second victory was all the momentum they needed to continue with the second annual Fourth of July parade.

In 1992, after 30 years of successful organization, the Aptos Ladies Tuesday Evening Society retired from the job and turned the parade over to the Aptos Chamber of Commerce. The truth of the matter is the parade on the Fourth of July originally had nothing to do with Independence Day, although both events had acts of rebellion in common.

Originally, the parade route was from the Driftwood gas station at Trout Gulch Road, which became Terrible Herbst gas station and is now the site of Bay Federal Credit Union, to the Pop Inn restaurant, now known as the recently closed Britannia Arms restaurant, and back to the Bay View Hotel. It lasted less than 10 minutes. Soon, food booths were set up to help raise money for Mar Vista School, and ears of corn were sold. Children's games and contests were added, including a cow-milking contest. The pancake breakfast was added in 1987 and is a cooperative venture between the Aptos Chamber of Commerce and the Aptos Lions Club. The route today starts at the opposite end of the original route at the intersection of Soquel Drive and State Park Drive and ends at the Bay View Hotel. Although the parade lasts much longer than the original 10-minute event, it is in no danger of losing its title as the "world's shortest parade," as it is named not for its duration but for its distance, approximately six tenths of a mile.

The Fourth of July parade not only celebrates the success of the Aptos Ladies Tuesday Evening Society's protest against the building of a cement batching plant in Aptos Village but also, of course, the country's independence. The first documented Fourth of July celebration in Aptos occurred in 1875. According to the *Santa Cruz Sentinel* of July 10, 1875, "For the first time in its history, Aptos was the scene of a Fourth of July celebration, last Monday. The guests at the Aptos Hotel, in conjunction with the ready assistance of Mr. Claus Spreckels, on that day arranged a celebration in honor of Independence Day, which was a very pleasant affair. The day and night were filled with events, such as speeches, music, dancing, a performance by the Aptos militia showcasing their skills with maneuvering wooden guns, and a fictional reading of what Aptos would be like in 1975, which was apparently very entertaining! The night ended with a fireworks show, which was a "fit termination for the grand time undergone during the day."

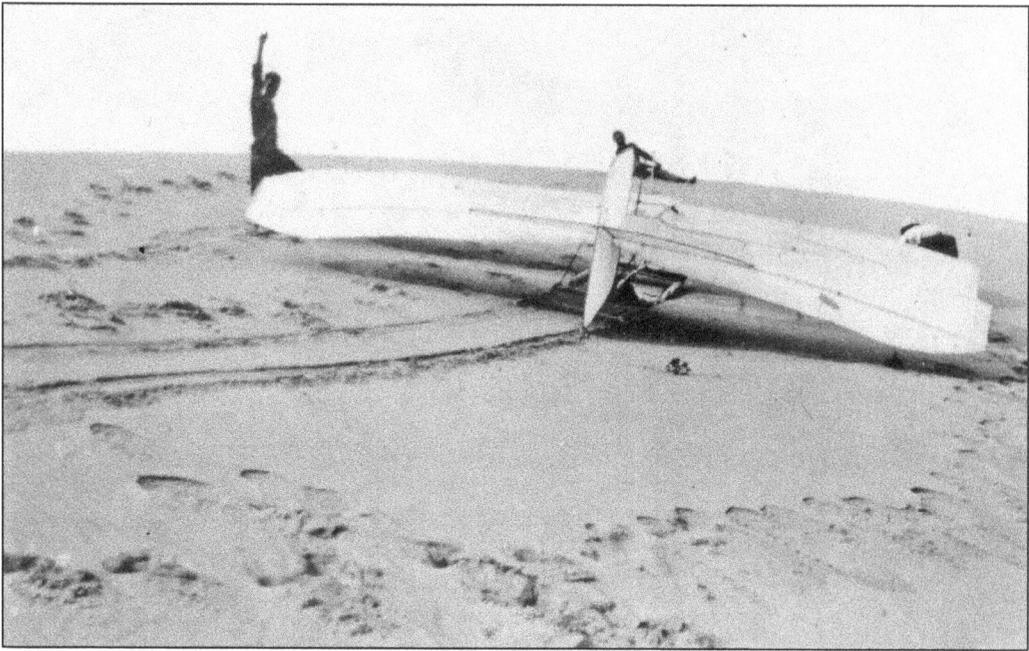

John Montgomery, an aeronautical innovator, is credited with the first public flight in a fixed-wing aircraft. He conducted test flights of gliders at the Leonard Ranch in Aptos from 1896 to 1905. In 1905, Montgomery used a hot-air balloon to lift his newly designed aeroplane into the sky and cut it loose over Aptos at heights of 800 to 3,000 feet. On October 31, 1911, just south of San Jose, California, Montgomery was flying a new glider, which had already had more than 50 successful glides, each at an altitude of approximately 785 feet. But on this day, the glider stalled at an altitude of less than 20 feet and landed on the right wingtip. Montgomery hit his head on an exposed bolt and died from this injury two hours later. The remains of Montgomery's gliders are on display at the Smithsonian Institution.

Roy "Butch" Voris, first leader of the Blue Angels, was raised in Aptos. He entered the Navy in 1941 and became a naval aviator. He fought in World War II and earned fighter ace status while recording eight confirmed fighter-to-fighter kills. He was shot down once and later stated, "Those things happen. But I shot down eight of them, so I call it a net of seven." In 1946, a handful of Navy fighter pilots were selected to demonstrate precision fighter maneuvers at air shows and public events. Butch was selected as officer-in-charge and flight leader. The Blue Angels' first show was in June 1946. They continued to perform until the start of the Korean War in 1950, when team members were ordered to combat duty. Voris was inducted into the International Council of Air Shows Foundation's Air Show Hall of Fame in December 2001. In 2002, he was inducted into the Naval Aviation Hall of Honor, a privilege shared by only 60 people. He passed away in 2005 at the age of 85.

Trent Dilfer was the winning quarterback of the Super Bowl XXXV champion Baltimore Ravens. He was drafted by the Tampa Bay Buccaneers sixth overall in the 1994 draft. He went on to play for the Baltimore Ravens, Seattle Seahawks, Cleveland Browns, and San Francisco 49ers. He played in a total of 130 NFL games, with 113 touchdowns and 20,518 passing yards. In 1993 he was awarded the Sammie Baugh Trophy, an award given to the nation's top college passer. While at Aptos High School, Trent was All-League in football, basketball, and golf, leading all three teams into Central Coast Section playoffs. Aptos High School's Trevin Dilfer Field was named in honor of Trent's son, who passed away at the age of five after contracting a virus that attacked his heart. (Both courtesy of Bill Lovejoy, *Santa Cruz Sentinel*.)

*Five*

# FUTURE HISTORY
## THE MODERN ERA

The past has already happened, and the future cannot be predicted. The present is the only thing available. However, what occurs today will affect the future and will one day be history. The funny thing is, one does not know what significance today holds. There are events in the world that will instantly and forever be recorded and remembered (the moon landing, the 9/11 attacks, Martin Luther King's "I have a dream" speech, and so on), but it is the seemingly non-monumental events that also make history. When Lucille Aldridge decided to protest the development of a cement plant in Aptos Village, she did not know that she was giving life to a parade that would be celebrated annually for the next 50 years. Sometimes, it takes a long time to know when an event has left a mark on history. The town of Aptos is relatively young, but there has been a lot of history in the 180 years since Castro's land grant.

In the early 1970s, the easy-going beach community of Santa Cruz County became a place of fear, paranoia, and horror as 25 people were horribly murdered. Santa Cruz became known as the "murder capital of the world" largely due to three men who have been classified as serial killers. John Linley Frazier, Herbert Mullin, and Edmund Kemper were responsible for the majority of these killings. The final murder of the killing spree occurred on April 21, 1973, when Kemper slaughtered his mother and her friend in their Aptos apartment.

Kemper murdered eight women in total; most were young students he picked up hitchhiking from the University of California, Santa Cruz, campus where his mother was employed. He would often decapitate his victims and bury their heads in the backyard of their Aptos apartment (pictured) beneath his mother's window so they could watch her. On Easter weekend 1973, he placed a call to the Santa Cruz sheriff and confessed his crimes. He was found guilty of eight counts of murder and found to be sane. He is currently serving a life sentence at the Vacaville Penitentiary.

**Aptos S&S Ranch**

THOROUGHBRED HORSES
PUREBRED HEREFORDS

ERIK KRAG · OWNER
APTOS · CALIFORNIA

Erik Krag was born in Denmark in 1891. Around 1913, he was sent to San Francisco to open an office for a Danish shipping company. He was introduced to Aptos in 1937. He began buying property in Aptos for a ranch he named S&S for his son Scott and daughter Sally. He eventually had almost 500 acres, including the Williams and the M&K Ranches, which had been part of Spreckels's Aptos ranch. The ranch was on the bluff where Seascape is now and extended back to San Andreas Road. S&S was a working ranch. At first, it raised sheep. In 1943, it switched to raising cattle. Later, corn and other crops were planted. Krag's real success, however, came with Thoroughbred horses. He established a reputation as one of the most knowledgeable breeders not only in California but also in the United States. Krag's interest in Thoroughbreds led him to become one of the founders of Golden Gate Fields racetrack near San Francisco.

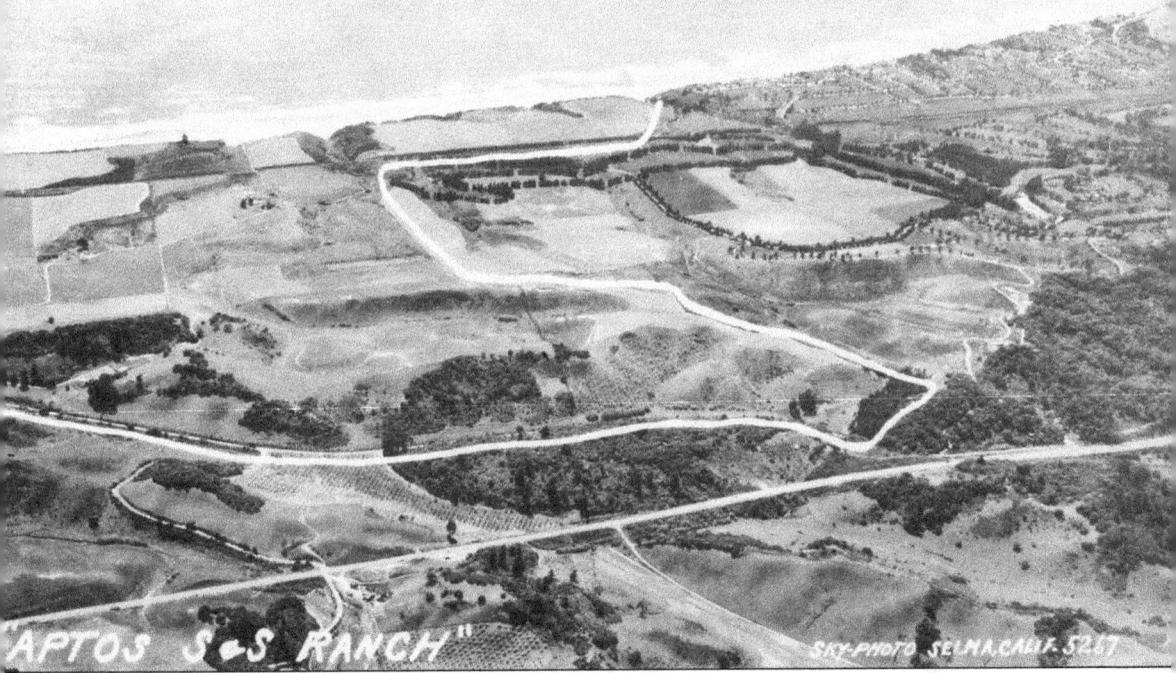

APTOS S•S RANCH
SKY-PHOTO SELMA,CALIF. 5267

The S&S Ranch manager lived in a house about a quarter mile from San Andreas Road. There was a second house about where the tennis club is now. There were stables between the second house and the railroad tracks. The terrain near the stables was hilly. That area has since been filled in. The ranch road was roughly where Seascape Boulevard is now. Krag considered the idea of developing the land; however, as property taxes in Aptos increased, he abandoned those thoughts and never got around to doing it. He eventually sold the land in 1963 to Irving Kahn, a developer who formed the Aptos Seascape Corporation. Kahn had his own problems with developing the land, mostly financial. He died in 1973 at the age of 58. Although he never got to see the Seascape he envisioned, this was the beginning of the Seascape of today.

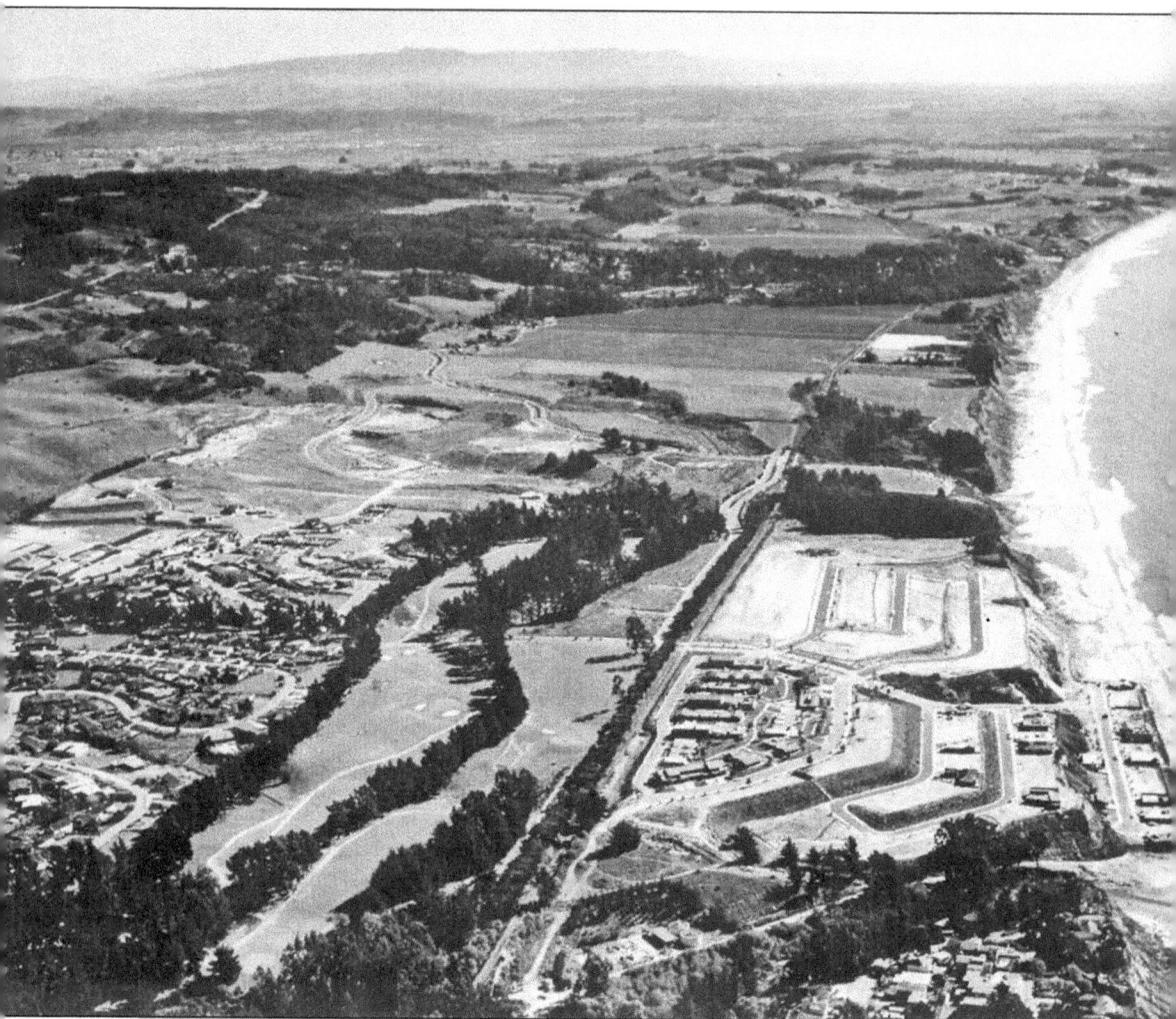

This photograph from early 1970s shows a nearly undeveloped Seascape. The portion of land on the right is known as "Beer Can Beach." On the cliffs just above Beer Can Beach is where the Seascape Resort was built. A portion of the Seascape Golf Course is in the center. The development of Seascape occurred in a rather short time. Rafael Castro's Rancho Aptos included nearly all of what became Seascape. The portion of Seascape that was not part of Rancho Aptos was part of Rancho San Andreas and belonged to Rafael's father, Joaquin Castro. Ownership of the land had changed hands but remained largely undeveloped until 1963, when the land comprising Krag Ranch and Aptos Beach golf course was sold to Aptos Seascape Corp. for $3,750,000. Construction of housing developments began, although not without political battles and community protest. Today, Seascape is comprised of residential, commercial, and hospitality developments. Greenbelts separate the residential units. The cliffs and beaches remain accessible for public use.

The Seascape Resort is the largest single private development project in all of Aptos. Its development was highly protested, but the large upscale condominium hotel was approved, and the first condos opened in July 1993. The final condominium buildings were completed in 1998. The concept of condominiums where owners can spend no more than 90 days a year in the unit they own was appealing to the county because it allowed the government to receive the transient occupancy taxes, sales tax revenue, and property taxes without having to provide services that a full-time resident would require, such as schools, police, and fire. The resort not only provides amenities to businesses and families from outside the area but also to local businesses and organizations, offering space to have meetings, luncheons, and dinners. Locals also enjoy the dining and entertainment provided by the Seascape Resort.

At one point, the Irvin J. Kahn Organization had considered the ambitious project of developing Seascape as a lakeside community, as shown in this illustration. The 88-acre site, adjacent to the homes that had already been built, would be developed for a new community of condominiums and other homes, bordered by three freshwater lagoons. The development would have been known as Seascape Lagoon Estates. The lagoons would cover 23 acres of the site and would wind throughout the development. All residents would have a view of and direct access to the lakes. Cascading waterfalls would have connected the lagoons. Boyd Lang, Seascape's project manager, commented, "The lake and surrounding homes will permit a totally new dimension of vacation living here on Monterey Bay. Where else will freshwater boating, fishing, swimming and other activities be enjoyed and yet still be immediately accessible to the majestic Pacific Ocean?"

118

In 1958, Santa Cruz County voters overwhelmingly approved a junior college district because they no longer wanted their taxes going to Hartnell and Monterey Peninsula College. To achieve agreement, it was promised that the new college would have a neutral name and be located midway between Santa Cruz and Watsonville. *Santa Cruz Sentinel* columnist Wally Trabing is credited with suggesting the name Cabrillo College in honor or Joao Rodrigues Cabrilho, a Portuguese navigator and the leader of the 1542 Spanish expedition that first sailed along the coast. There were 789 students enrolled in the first semester, taught by a 15-member faculty, and the college spent its first three years in the old Watsonville High School building. Cabrillo College moved to its new 126-acre campus in 1962, and about 2,000 students enrolled. While there is still debate over how the name Cabrillo should be pronounced, it was pretty clear to the truck driver who nailed the college's first Aptos sign to the telephone pole alongside the soon-to-be-widened Soquel Drive in December 1959. (Courtesy of Sam Vestal/*Register-Pajaronian.*)

After much debate over the selection of a site, Aptos High School opened in 1969 near the intersection of Highway 1 and Freedom Boulevard in the beautiful hills of the Aptos community, located between the cities of Watsonville to the south and Santa Cruz to the north. It is one of three comprehensive high schools in the Pajaro Valley Unified School District. In 1995, it was suggested that Aptos High School secede from Pajaro Valley Unified School District and form a district of its own. There was a belief that a new Aptos School District would be a prelude to Aptos's incorporation, using the boundaries of the new district as the boundaries for a future city. After much debate, it was decided that Aptos would stay a part of Pajaro Valley Unified School District. Notable alumni include Super Bowl–winning quarterback Trent Dilfer, professional model Marisa Miller, and professional jazz musician Donny McCaslin. Pictured is the first graduating class of Aptos High School, the class of 1970.

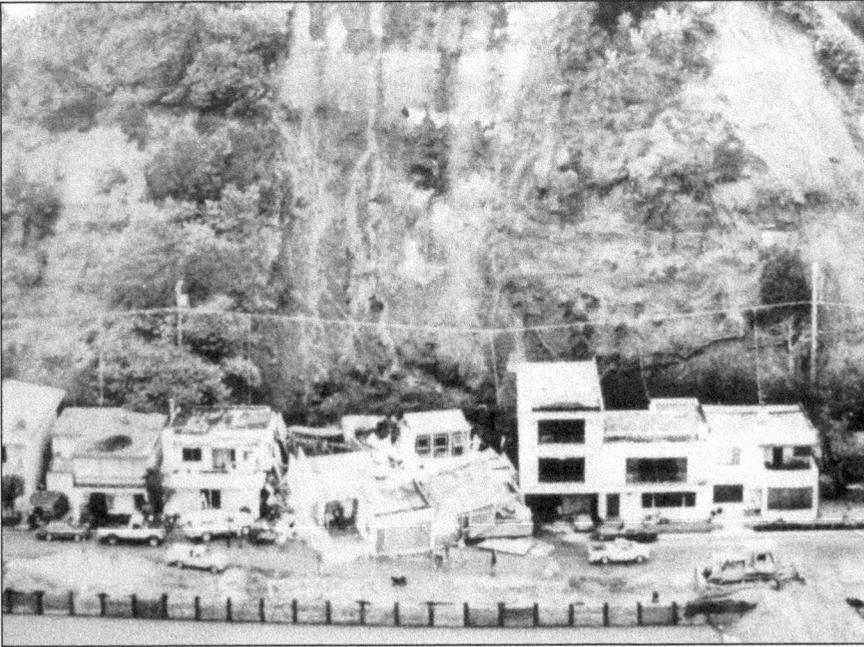

The history of Aptos and the surrounding area has been shaped, in large part, by many severe storms over the years. Weather records gathered since the 1870s recount the flooding, mudslides, downed trees, washed-out roads and bridges, and numerous deaths that have occurred. The 1926 storm that destroyed the seawall at the real estate development known as Seacliff Park (now Seacliff Beach State Park) just a month after it was completed was a primary factor in the failure of that ambitious project. The 1932 storms that cracked *Palo Alto* and destroyed the dam at the Aptos Creek Bathing Pavilion spelled doom for both of those enterprises. These photographs show some of the damage from the storms of 1982 and 1983. (Both, courtesy of the *Santa Cruz Sentinel*.)

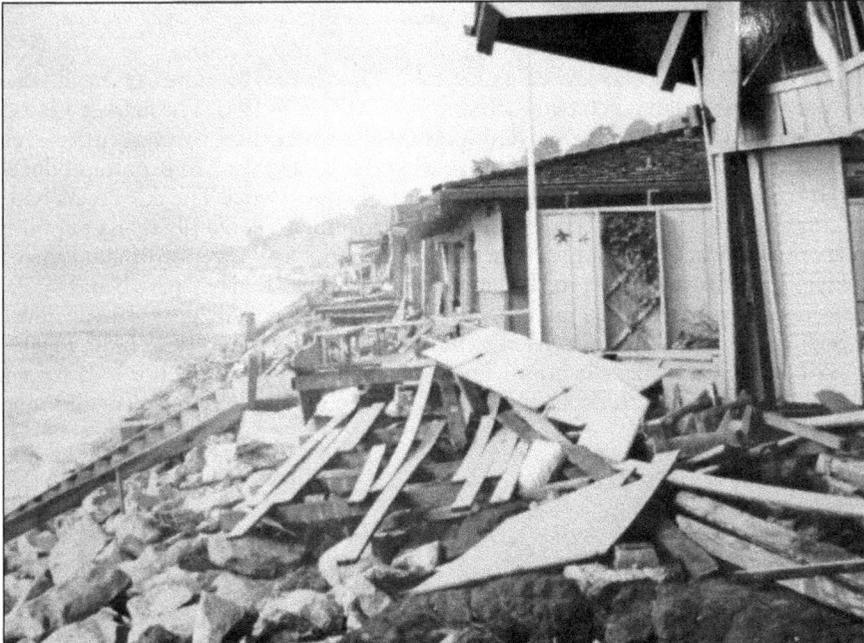

Norm and Mary Ann Kaplan purchased Rich's Farmers' Market in 1973. The market was located on Soquel Drive between Aptos Village and Redwood Village, where there was very little development at the time. The building was a four-car garage with the doors raised to expose produce stands; there were also five parking spaces that backed out to Soquel Drive. The customers had already started calling the market "Pig's" because Rich had installed a large fiberglass pig on the roof several years prior. Mary Ann had convinced Norm that "Pig's" was not in good taste, and so they settled on changing the name to "Piggie Market." Business had prospered, and by 1979, they realized they needed more parking. Just down the street, Redwood Village was being developed as a quaint shopping center. They proceeded to build a new store, and in June 1980, Piggie Market was open for business in its new location. The Piggie Market was an anchor in the community until it closed its doors in 2009. Erika and Doug Glaum purchased the business and reopened it as the Palm Deli.

EPICENTER
Loma Prieta Earthquake
MAGNITUDE: 6.9
DATE: 10/17/89
TIME: 5:04 PM
LONGITUDE: 121.88°W
LATITUDE: 37.03°N

The Loma Prieta earthquake occurred on October 17, 1989, at 5:04 p.m. The magnitude has been reported between 6.9 and 7.1 and the duration between 15 and 20 seconds. The earthquake occurred on the San Andreas Fault, and although many referred to the event as the "Bay Area earthquake," the epicenter was located in Nisene Marks State Park, just three miles up from Aptos Village. The earthquake interrupted game three of baseball's World Series between the San Francisco Giants and the Oakland Athletics. A total of 63 people died as a result of the quake, six being Santa Cruz County residents. Approximately 3,757 people were injured, and there was an estimated $6 billion in property damage. Over 1,000 landslides and rock-falls occurred in the Santa Cruz Mountains. The Highway 1 bridge over Harkins Slough in Watsonville collapsed. It was the largest earthquake to occur on the San Andreas Fault since April 1906.

A historic piece of Aptos was lost as a result of the Loma Prieta earthquake. On November 8, 1989, two buildings, which had been sitting atop damaged piers, collapsed into the deep ravine of Aptos Creek. The Colonial Barbershop was one of the businesses lost in the tumbled building. This building was originally the first telephone exchange in Aptos.

Paul Johnston, a longtime Aptos resident, owned the two buildings that collapsed into the ravine. He was 100 years old at the time of the quake and living in a convalescent home. According to his daughter Anne Bass, when she showed him pictures of the damaged buildings, "He just shook his head and said he guesses he'll have to start over."

GLAUM EGG RANCH

The Glaum Egg Ranch is a well-known staple in Aptos and might be best known for its Egg Vending Machine, one of Marvin Glaum's many inventions. Not only does one get a flat of 21 eggs from the machine, he or she also gets a song and dance performed by costumed mechanical chickens! The entertaining show is created and changed seasonally by Sherrie Glaum, Marvin's daughter. The Egg Ranch started in a small town in Nebraska in the early 1920s by John H. Glaum. He and his wife, Pearl, moved to California in 1946 to be closer to their children who had previously moved west. John died in 1952, and his youngest son Marvin returned home from the Korean War to continue the family business. The Glaum Ranch was moved to Aptos from nearby Live Oak in 1957. Marvin and his wife, Dorothy, who worked as a bookkeeper, were believers in the importance of commitment and dedication to their ranch and involvement in their community. They taught these beliefs to their four children who continue run the family-owned business today.

This photograph, taken in 1930, shows an overhead view of the Vicente Castro house. The open field at the bottom is today's Rancho Del Mar shopping center. Aptos Village is to the right, and the Highway 1 on-ramp is to the left. (Courtesy of George Garcia.)

# ABOUT THE APTOS HISTORY MUSEUM

The Aptos History Museum is focused on the incredibly rich and fascinating history of a relatively compact area—the few square miles that make up Aptos Village, Rio Del Mar, Seacliff, Seascape, and the surrounding hills and beaches. The Aptos History Museum is a wonderful community asset with a fantastic collection of local artifacts, photographs, and information. It is made possible by the many volunteers who continue to donate their time and talent. The museum operates financially solely from memberships and donations, and if you have not already done so, I encourage you to become a museum member and/or volunteer with us in any capacity that you can. Your comments, ideas, or suggestions are always welcome.

The Aptos History Museum began in 1985 when John Hibble was given a photograph of the Aptos Railroad Station. John and his wife, Karen, were executive directors of the Aptos Chamber of Commerce, which was then located in Redwood Village. Community members donated other historical items, and John's collection began to grow. This collection was displayed at the chamber of commerce. When the Aptos Chamber of Commerce moved to its current location at 7605 Old Dominion Court, the collection expanded somewhat and was displayed within the chamber office, but most of John's collection remained in storage.

In 2005, additional office space in the chamber's building became available, and Karen Hibble determined that the Aptos History Museum deserved to have its own larger facility and become a real museum. She and John appealed to the community, and an advisory committee was formed. The new space was repainted and made ready, and new display cases were built. John's now sizable collection was retrieved from storage and dusted off, and a crew of volunteers worked for many months to set up and organize the new museum. The Aptos History Museum opened its expanded facility on May 24, 2006, and it has since garnered enthusiastic reviews and numerous citations of merit. Most notably, the museum received the Aptos Community Achievement Award in 2006.

For more information about Aptos History and museum-sponsored events, please visit us at: www.aptoshistory.org

Visit us at
arcadiapublishing.com

www.ingramcontent.com/pod-product-compliance
Lightning Source LLC
Chambersburg PA
CBHW080549110426
42813CB00006B/1258